H^{ri} Vever

A JEWELER'S EYE

Islamic Arts of the Book
from the

VEVER COLLECTION

Glenn D. Lowry
with Susan Nemazee

ARTHUR M. SACKLER GALLERY
Smithsonian Institution, Washington, D.C.

in association with
UNIVERSITY OF WASHINGTON PRESS
Seattle and London

The purchase of the Vever Collection was made possible by
Smithsonian Unrestricted Trust Funds, Smithsonian Collections Acquisition Program,
and Dr. Arthur M. Sackler.

The Arthur M. Sackler Gallery is indebted to an anonymous donor
for funds given in generous support of this publication.

Cover: *A Reclining Prince*, ca. 1530, color plate 65

Photographic credits
Cooper-Hewitt Museum, Smithsonian Institution, New York, New York: fig. 7;
Harvard University Art Museums, Cambridge, Massachusetts: fig. 19;
François Mautin: pp. 11, 220; figs. 1–3, 8; Musée des Arts Décoratifs, Paris: figs. 5, 6;
National Gallery of Art, Washington, D.C.: fig. 9; Sterling and Francine Clark Art Institute,
Williamstown, Massachusetts: fig. 10

Map p. 40 by Molly Ryan

Library of Congress Cataloging-in-Publication Data
Arthur M. Sackler Gallery (Smithsonian Institution)
A jeweler's eye : Islamic arts of the book from the Vever
Collection / Glenn D. Lowry with Susan Nemazee.
p. cm.
Includes bibliographies and index.
ISBN 0–295–96676–9 (alk. paper). ISBN 0–295–96677–7 (pbk. : alk. paper)
1. Illumination of books and manuscripts, Islamic. 2. Calligraphy, Islamic.
3. Miniature painting, Islamic. 4. Bookbinding, Islamic.
5. Vever, Henri, 1854–1942—Art collections. 6. Illumination of books and manuscripts
—Private collections—Washington (D.C.)
7. Arthur M. Sackler Gallery (Smithsonian Institution)
I. Lowry, Glenn D. II. Nemazee, Susan. III. Title.
ND2955.A78 1988a
745.6'7'0917671—dc 19
88–14550
CIP

Contents

For François and Laure

Foreword

THE CALLIGRAPHY, ILLUSTRATIONS, and decorations that embellish the great books of the Islamic world comprise one of the finest artistic traditions of humankind. Elegance, expressive intimacy, and technical brilliance are basic characteristics of the works. For these reasons they appealed deeply to Henri Vever, well known to the artistic world of Paris in the early twentieth century as a jeweler, collector, and painter.

Vever amassed some five hundred Persian, Arabic, Turkish, and Indian manuscripts, paintings, albums, bookbindings, and examples of calligraphy as well as small groups of lithographs, printed books, textiles, nineteenth-century Burmese and Indonesian works, and Armenian paintings. This material now comprises the Vever Collection in the Arthur M. Sackler Gallery. Vever was so perceptive and thorough a collector and connoisseur that the unexpected, intact reappearance of the collection he amassed is not only a breakthrough in the study of Persian and Indian art but also greatly expands our understanding of French taste and culture.

During his lifetime Vever was eager for these works to become better known. Items from his Islamic collections were widely shown in Europe early in this century, especially at the influential exhibitions held in Paris in 1912 and London in 1931, and he generously encouraged their publication. The collection disappeared following Vever's death in 1942, and many thought the entire group was destroyed in World War II. A chance encounter between the owner of the works and Laure Lowry—whose son, Glenn D. Lowry, is curator of Near Eastern art at the Arthur M. Sackler Gallery and Freer Gallery of Art—led to information that the collection had indeed survived. Learning the owner's identity was extraordinary serendipity, especially for a new museum, and it set off a remarkable campaign to purchase a body of material that Secretary of the Smithsonian Institution, Robert McCormick Adams, termed "perhaps the most important acquisition in the history of the Smithsonian Institution."

Throughout negotiations for the collection Glenn Lowry and I dealt with the owner, an American who lives in Paris. When we first spoke with him he had not considered selling the collection, which had long been kept in storage in New York. Persuaded by our intention to keep the group intact and attracted by the idea that it would be housed in a new museum in Washington, D.C., he sent the manuscripts and paintings to London to be catalogued and appraised. From there word of their existence passed to various museums and private collectors in Europe and the United States, unleashing an inventive and amusing series of intrigues. The owner's unwavering support for, and patience with, the Smithsonian's efforts to acquire the collection, together with the involvement of Secretary Adams and the late Arthur Sackler, made our negotiations

successful. In particular it was Dr. Sackler's enthusiasm and personal commitment that ultimately assured the collection a place in the gallery that bears his name.

In recognition of the spirit of Henri Vever's generosity to scholars, this publication and *An Annotated and Illustrated Checklist of the Vever Collection*, published simultaneously, are presented. A thorough examination of the Vever Collection could be a lifetime's effort. The Sackler Gallery chose, however, to publish in as timely a manner as possible a general study of Vever and the place of Islamic art in the Paris of his time, together with an essay describing current ideas about the arts of the Islamic book. In addition, a selection of the greatest works in the collection is illustrated in color. The companion volume, *An Annotated and Illustrated Checklist*, represents a preliminary cataloguing of the works, most of which are illustrated in black and white. Not meant as an exhaustive study, it is instead published with the intention of encouraging students and scholars to share in the museum's excitement by becoming immediately familiar and involved with the material, most of it unknown and unpublished. We look forward to having many scholars refine and amplify this preliminary information.

It is my hope that this publication and the checklist will simply be the first of many new and diverse studies of the manuscripts and paintings from the collection of Henri Vever in the Arthur M. Sackler Gallery.

MILO CLEVELAND BEACH
Acting Director
Arthur M. Sackler Gallery and Freer Gallery of Art

Acknowledgments

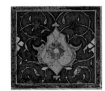

I AM DEEPLY GRATEFUL to the many friends and colleagues who have shared with me their knowledge of late nineteenth-century France, Henri Vever, and Persian and Indian painting. Timothy J. Clark made many valuable suggestions concerning the social and artistic issues that affected Vever's world. Debora Silverman kindly gave me access to her research on art nouveau and the Union Centrale des Arts Décoratifs; her advice and comments have been invaluable. Ralph Esmerian, Lilian Nassau, and especially Evelyne Possémé graciously provided important information about Vever's activities as a jeweler. I sincerely appreciate the involvement of Wheeler Thackston and Roya Marefat, who contributed their extensive expertise on Islamic literature to the descriptions accompanying the color plates. Lisa Golombek, Oleg Grabar, Thomas Lentz, Basil Robinson, and Marianna Shreve Simpson kindly commented on many of the ideas presented here concerning the Islamic arts of the book and late nineteenth-century French collectors of Persian and Indian painting; I am particularly indebted to them for their insights into this material. Susan Nemazee undertook a great deal of the research on Vever's life, and worked as well on the recent provenance of the Islamic objects in the collection; this publication would not have been possible without her diligence and energy. The skillful editing of the text is thanks to the combined efforts of Jane McAllister, who oversaw the publication, and Kathleen Preciado, both of whom expertly revised the manuscript through many evolutions. The editors were assisted by Nancy Lutz and Nancy Eickel, and Beverly Haynes was invaluable as typist. Carol Beehler's appreciation of the dynamic images of Persian manuscripts is revealed in a sensitive design, which is enhanced by the fine color photography of Jeffrey Crespi.

Finally, I wish to acknowledge the strange confluence of events that brought together François Mautin and Laure Lowry. The results of their meeting have provided a unique opportunity to gain a better understanding of Persian and Indian manuscripts and paintings.

GLENN D. LOWRY
Curator of Near Eastern Art
Arthur M. Sackler Gallery and Freer Gallery of Art

A Remembrance

MY GRANDFATHER, Henri Vever, lived in an exceptional but turbulent era. In spite of the three wars that directly affected his life, he avidly pursued his passion for acquiring beautiful objects while continuing to create lovely jewelry of his own design. During the peaceful intervals at the end of the nineteenth century and between the two world wars, the arts flourished. Prosperous and cultivated businesspeople in Europe appreciated and could afford beautiful objects. Homes were large, and the fashion was to fill them with works of art of all sorts, good and bad. Henri Vever had a background in the arts, a yen for acquiring objects, and exquisite taste. He was an extremely active and passionate person as were many of his friends.

The Persian and Indian manuscripts and paintings my grandfather collected had been produced primarily for rich and powerful individuals, sometimes ruling potentates. The Vever Collection includes historical chronicles as well as paintings describing commonplace events, both important in documenting a culture that many of us know little about.

The original patrons of these works took pride in their collections and cared for them. After their owners' deaths such belongings often began an arduous journey—surviving wars, fires, earthquakes, theft, rodents, and vandalism—before reaching safe harbor. Once in the hands of a sensitive caretaker like my grandfather, such risks were by no means over.

During World War I, Vever moved most of his collections as far away as possible from the invading forces. With the zeppelins and early flyers raiding Paris, bombings were feared. But World War II was much more devastating. Destruction hit quickly, and my grandfather again immediately moved his collections out of harm's way, to his country home in Normandy, forty-seven miles northwest of Paris.

The German invasion soon engulfed the countryside, and occupying troops were billeted in my grandfather's seventeenth-century château. He and my grandmother, Jeanne Monthiers, and their collections remained in one part of the house, while the German army stayed in another. Fortunately, no one was interested in what my grandparents had in their part of the house, and almost all their possessions—except for a fine collection of antique gold coins, which disappeared—remained untouched.

During that time in Paris all personal bank vaults were examined, supposedly for foreign currencies, precious metals, or whatever else could be used for the German war effort. In spite of a legal requirement that a representative of the owner be present, many valuables were removed, never to be seen again by their rightful owners. At the inspection of his bank vault in

Paris, my grandfather, unable to leave the country home, was represented by my sister.

The Germans opened the vault and handled its contents. They discovered etchings—one by Rembrandt, two by Rembrandt, five, ten, twenty—an endless cache. They looked at the prints and declared, "There are too many to be originals. They must be reproductions." Everything was put back, and the safe closed. How difficult it must have been for my sister to remain nonchalant during those moments that seemed like hours!

Having inherited my grandfather's Near Eastern collection, I felt that it should remain together for future generations as testimony to the achievement of human civilization. Today the collection is housed in the Arthur M. Sackler Gallery of the Smithsonian Institution in Washington, D.C. Let us hope the risky adventures of these priceless objects are over forever.

FRANÇOIS MAUTIN

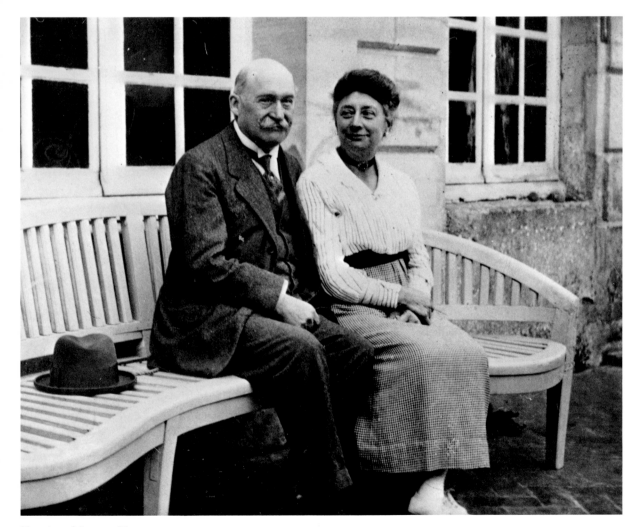

Henri and Jeanne Vever, ca. 1930

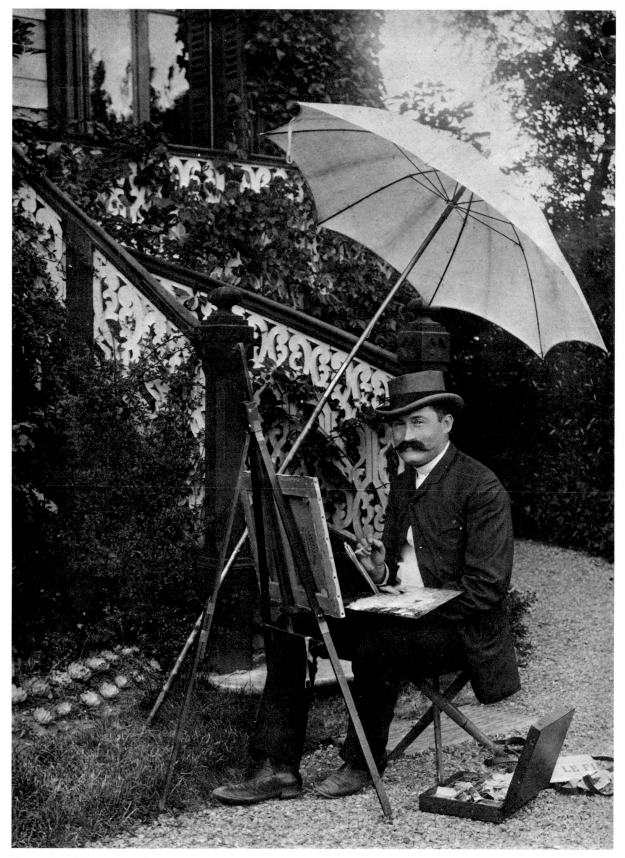

Fig. 1. Henri Vever, ca. 1895

Henri Vever, Art Nouveau, and Islamic Art

We can, . . . I believe, give ourselves credit for having on the whole accomplished our task as *amateurs*. Beautiful works of art appeared, so new to our way of seeing, yet we were able to appreciate them and immediately find a place for them in our collections. The objects that we sought came from Japan and China . . . as well as Egypt . . . and the Muslim world . . . [and were] almost simultaneously unveiled before our eyes.

WRITTEN BY THE NOTED critic and collector Raymond Koechlin in 1930, these reminiscences evoke the fervor generated by Asian and Islamic art in turn-of-the-century Paris.[1] As the unrivaled center for the study and collection of such material, Paris was home to a number of outstanding connoisseurs and collectors. Among the most celebrated was Henri Vever (1854–1942).

Like many important collectors, Vever was an extremely complex man. A highly successful jeweler, amateur painter, author, and enthusiastic sportsman, Vever possessed wide-ranging tastes and interests. In addition to Persian and Indian paintings, manuscripts, bookbindings, and calligraphy, Vever assembled major collections of nineteenth-century French paintings, drawings, and sculptures; old master prints; European books and bindings; classical coins; Chinese paintings and bronzes; and Japanese prints, screens, sword guards, lacquer ware, and *netsuke*.

The creation of any collection is by definition arbitrary, the result of a variety of circumstances governed by the availability of objects, chance encounters, personal taste, and social and economic forces. While the relative importance of each factor is often difficult to gauge, it is impossible to appreciate the significance of Vever's achievements without seeing these elements as thoroughly interconnected. Given the breadth of Vever's activities, his collecting can be examined from many perspectives. At the broadest level his purchases reflect interests shared by a small group of people of similar education, occupation, and class. Within that context Vever's collecting is neither unique nor unprecedented. At another level his acquisitions were discrete acts, reflecting individual choices and commitments. As such, they are singular affirmations of his taste and, by extension, his social and economic position. The interaction of the various dimensions of Vever's interests in the context of turn-of-the-century France forms the basis of this essay.

Vever lived through most of the third and fourth republics of France (1871–1959), and his artistic sensitivity was shaped by the aesthetics of the art nouveau movement, whose adherents sought to reunite art and craft, discover a distinctively modern design style, and assert the primacy of individual vision over the function of materials.[2] With its strangely conservative yet progressive

tendencies, the Third Republic sought an aristocratic rapprochement—realized through the institutionalization of the splendors of the eighteenth century—while encouraging artists to draw inspiration from the unity of all the arts. The underlying tenets of this complicated cultural position were formulated by Edmond and Jules de Goncourt, who promoted a revival of eighteenth-century rococo interests as a means to establish an aristocratic patrimony for the arts.[3] For the Goncourts and men like Vever the essence and function of art centered around the creation of complicated sensory impressions for a refined elite.[4] Following the example of the Goncourts and the influential critic and theoretician Phillipe Burty, Vever saw the practice, study, and collection of art as a single continuum that enriched and enlivened his life:

> Does one ever realize the ideal in this world? Fortunate are those who come close, who catch a glimpse of it! Only art can impart a sensation of the ideal, beyond which is absolute nothingness. No, there is still kindness, benevolence, charity . . . duty, . . . but duty is not always happiness—that I know—despite the satisfaction of the conscience, for deep down one must do one's duty, *dutifully, without discussion*, without telling oneself that an inner voice will give the reward of softly saying, "Well done." . . . Art, whether one practices it or likes it, gives gratifications that directly refresh and delight the soul.[5]

A man of passionate interests, Vever epitomized the nineteenth-century French notion of the *amateur*, or connoisseur of the fine arts. The antithesis of the *nouveau riche* acquisitive elite of the Second Empire (1852–70), connoisseurs such as Vever prided themselves on their sensitivity, erudition, and social distinction. Specialists in a particular period or medium, they actively sought to re-create the past through their scholarly endeavors and discriminating tastes. For such individuals collecting was a lifelong activity filled with creative possibilities. The building of a collection was analogous to constructing a great monument, an affirmation of the connoisseur's exquisite sensibility and understanding of the past.[6]

Seeking to refine his aesthetic awareness and acquire fine objects, Vever first collected European works of art before becoming fascinated at the end of the nineteenth century with Asian and then Islamic art. His longevity permitted him to continue developing his collections throughout the first half of the twentieth century, years after his closest colleagues had died. Possessed with the discriminating eye of a jeweler, Vever responded foremost to craftsmanship and quality of line. His ability to discern technical and aesthetic refinement resulted in his creation of an unrivaled collection of Japanese prints and Persian and Indian paintings and manuscripts.

———

Trained as a draftsman and jeweler, Vever painted in the impressionist manner, with an intensity equal to that which guided his collecting. Extremely observant (his diaries are full of meticulous notes often describing in careful detail the quality of a wine or beauty of a floral arrangement), he was also highly energetic. During the course of a typical day he would go for an early-morning bicycle ride, arriving at his jewelry shop, the Maison Vever, around eight. He would lunch with acquaintances, then visit his favorite art dealers (Siegfried Bing, Georges Demotte, and Georges

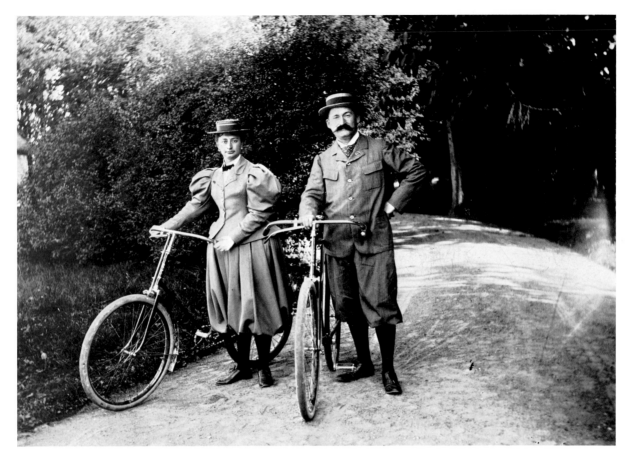

Fig. 2. Henri and Jeanne Vever, ca. 1895–1900

Petit) or attend auctions at the Hôtel Drouot before dining with his wife or with friends. When the weather was pleasant he often rode his bicycle from Paris—his primary residence from 1871 until his death in 1942—to his country house in Noyers, covering the forty-seven miles in less than four hours. Vever's favorite activity was scouring galleries, and he would frequently visit the same dealer day after day to look at a work of art that he found particularly interesting. Koechlin noted that whenever Japanese prints were on display Vever would be in attendance. His passion for seeking fine examples of Asian art was, however, intensely private, rarely discussed with his family and shared only with a small circle of equally enthusiastic friends.

The bookbindings Vever commissioned for his collection of rare books and manuscripts are witness to his delight in his acquisitions. Vever carefully selected for each volume the leather or skin to be used and theme to be illustrated. After acquiring a fifteenth-century illustrated Book of Hours, for example, Vever designed an enameled cover in the style of the manuscript's paintings; it was executed for him by the engraver and medalist Séraphin Vernier and the enamelist Etienne Tourette (see fig. 3). Similarly for Rudyard Kipling's *Jungle Book* illustrated by the artist Paul Jouve, Vever traveled to London to find a snakeskin for a bookbinding that would evoke the flavor of the text.

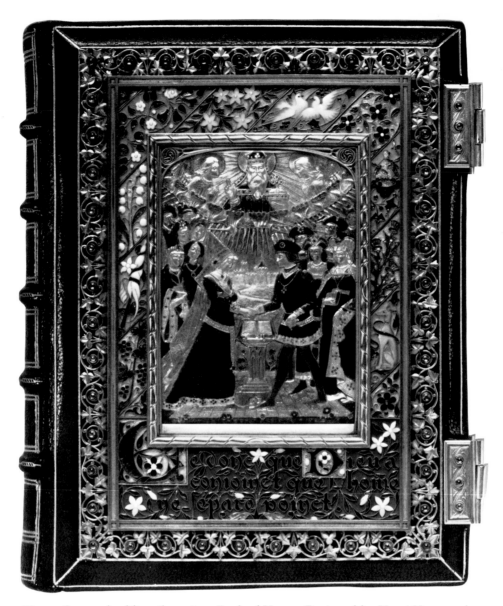

Fig. 3. Cover of a fifteenth-century Book of Hours. Designed by Henri Vever and executed in gold and enamel by Séraphin Vernier and Etienne Tourette, 1899. Private collection.

In addition to valuing works of art for their purely visceral and aesthetic qualities, Vever, like all good *amateurs*, was also attentive to their historical context. That interest led him to analyze and describe the objects he acquired or made. On the flyleaves of his Persian manuscripts and backs of his paintings, Vever often made elaborate notations indicating how much he paid for the work (always given in code), from whom he bought it, and his observations regarding the date of execution, artist, and provenance. Vever brought the same intensity of observation and concern for detail to his own work. He recorded in his diaries who was designing and manufacturing jewelry in Paris, how much preparatory drawings cost the Maison Vever, and how long it

took to have a piece made. The meticulous notes that he developed on his collection and trade ultimately provided him with the information necessary to write a number of articles and the three-volume *Bijouterie française au xix^e siècle* (1906–08), a seminal study of French jewelry that remains an important source for the period, as well as *Miniatures persanes*, the catalogue of the exhibition of Persian and Indian paintings held in 1912 at the Musée des Arts Décoratifs, Paris, coauthored with fellow collector Georges Marteau.

Born in 1854 in the town of Metz in northeastern France, Vever was a third-generation jeweler. His grandfather, Pierre-Paul Vever (1794–1853), started the firm in 1821 and quickly developed a regional clientele. After Pierre-Paul's retirement in 1848, his elder son, Jean-Jacques Ernest (1823–1884), assumed control of the business, which had grown to include a salesroom and series of ateliers. The firm continued to prosper, but with the capture of Metz by the Germans during the Franco-Prussian war Ernest, his wife, and two sons, Paul (1851–1915) and Henri, fled to Luxembourg. From there the family went to Paris, where Ernest purchased Gustave Baugrand's well-known jewelry atelier.

Henri, like his brother Paul, was trained to enter the family business. He apprenticed at various ateliers in Paris and took courses in drawing, first at the Ecole des Arts Décoratifs and then at the Ecole des Beaux-Arts, where he studied in the studio of M. A. Millet. Paul, who attended the Ecole Polytechnique, seems to have been more interested in administration.

The two brothers assumed control of the firm in 1881. By the end of the decade they had clearly established the Maison Vever as one of the leading jewelers in Paris on a par with the firms of Gustave Boucheron and Louis Cartier, whose shop was located across the street from the Maison Vever on the rue de la Paix. In 1889 an entry from the Maison Vever won one of the two Grand Prix awarded at the *Exposition Universelle* in Paris (the other was given to Boucheron). The Maison Vever received similar honors in Brussels in 1897 and again in Paris at the *Exposition Universelle* of 1900. As the artistic preeminence of the Maison Vever gained wider recognition, its clientele expanded to include members of the European aristocracy, particularly the Russian court. In addition to titled clients, whose patronage was sporadic at best, wealthy Americans and Japanese made major purchases from the Maison Vever. Vever's diaries show that for the most part, however, the Maison Vever relied on the patronage of the Parisian bourgeoisie (see fig. 4).[7]

Although during the 1880s many of the Maison Vever's designs were highly traditional, by the beginning of the 1890s the firm was at the vanguard of the art nouveau movement (see figs. 5, 6). Writing in 1898, Vever summed up his feelings for the new style and the need to break away from the past.

I am convinced that we are in a very rare period, I should say unique, for the production of new works of art. Everyone is saturated, disgusted, nauseated to see the eternal repetition of the hackneyed pieces in the style of Louis xv. . . . No matter what, one really wants new things. New works of art are beginning to appear. The movement is taking shape with an extraordinary rapidity, especially in the last two or three years (Liberty, Lalique, Tiffany,

Grasset, Chéret, Gallé, etc., etc.). . . . In 1900 we shall see the whole of this movement of renewal in all branches of the arts.[8]

These comments clearly position Vever in the orbit of Raymond Poincaré, minister of public instruction and the fine arts and later the ninth president of the Republic; Gustave Larroumet, professor of modern literature at the Sorbonne; and Roger Marx, inspector general of provincial museums, all of whom acted as official spokesmen for the art nouveau movement.[9] Through the Union Centrale des Arts Décoratifs—an association of like-minded individuals dedicated to affirm-

Fig. 4. Vever's diary entry for December 29, 1898, showing a typical day's business at the Maison Vever. Private collection.

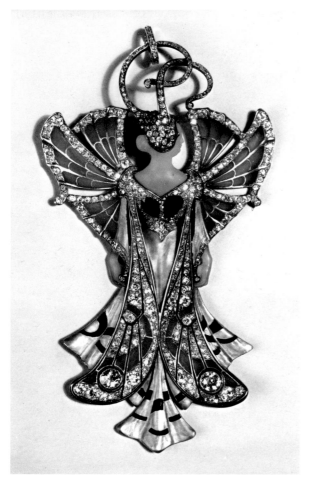

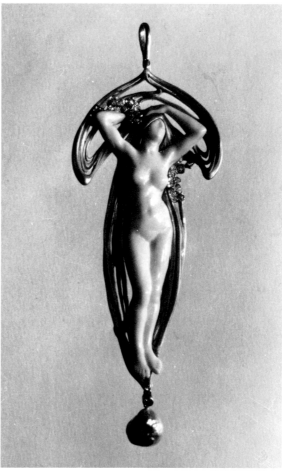

Fig. 5. *Pendentif Sylvia*, designed by the Maison Vever, 1900. Gold and enamel set with diamonds, rubies, and agates. Musée des Arts Décoratifs, Paris, 20715.

Fig. 6. *Vénus Dormante (Sleeping Venus)*, designed by the Maison Vever, 1900. Carved ivory, gold, and enamel set with diamonds and a baroque pearl. Musée des Arts Décoratifs, Paris, 24524.

ing the prestige of French craftsmanship—these ideas were formulated and given a national mandate. Originally established in 1864 as the Union Centrale pour les Arts Appliqués à l'Industrie, the Union Centrale was closely linked with French efforts to keep pace with British sponsorship of the industrial arts. By the 1890s the Union Centrale had undergone a profound change, having become a center for those interested in the cultivated refinement of the decorative arts. Politicians, cultural officials, collectors, historians, and luxury craftsmen like Vever joined in the Union Centrale's attempts to revitalize the prestige of French crafts. In an effort to affirm French cultural supremacy the Union Centrale became a centralized forum for the exchange of ideas about art. The organization encouraged the collecting and producing of luxury objects, published a journal—*Revue des arts décoratifs*—maintained a library, and helped establish a museum—the Musée des Arts Décoratifs. Despite claims to the contrary, the orientation of the Union Centrale was inherently elitist, its practitioners solid members of the establishment. Louis de Fourcard, for example, proclaimed that the reintegration of art and craft would not mean that the arts would

descend to the popular level but that craftsmen would be elevated to an aristocracy based on artistry.[10]

Vever's interest in the art nouveau movement and Japanese art must have been heightened through his friendship with the art dealer Siegfried Bing, who in 1883 opened a gallery at 19, rue de la Paix, in the same building occupied by the Maison Vever.[11] Around that time, Vever also became interested in Chinese and Japanese jewelry. He began experimenting in his own work with different techniques and materials, often using multicolored and translucent enamels.[12] Those experiments led him to collaborate on a number of occasions with such artists as Eugène Grasset—in anticipation of the *Exposition Universelle* to be held in Paris in 1900, the Maison Vever commissioned ten drawings from the artist (see fig. 7), which inspired the production of enamel and gold *fantaisies*—and René Lalique, who is often singled out in Vever's diaries for the originality and boldness of his work.[13]

In 1881, Vever married Jeanne Louise Monthiers (1861–1947), whose family had major land-holdings in Normandy. The marriage enhanced Vever's social and financial position, giving him access to a broader and more affluent group of people. In 1892, Madame Vever inherited the Château de Noyers (fig. 8), which her family had purchased in 1829 from descendants of François de Barbé-Marboi, Napoleon's finance minister who negotiated the sale of Louisiana to the United States. Possibly built by the seventeenth-century architect Nicolas-François Mansart, the foremost proponent of French classicism in architecture, the château was remodeled around 1715. With

Fig. 7. Sketch by Eugène Grasset for *Poésie*, a pendant executed by the Maison Vever for the *Exposition Universelle*, 1900. Watercolor, gouache, and pencil on paper. Cooper-Hewitt Museum, the Smithsonian Institution's National Museum of Design, New York, New York, 1958–13–1.

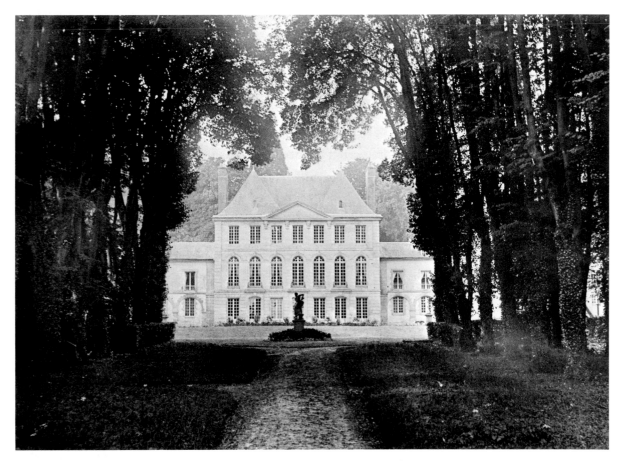

Fig. 8. Château de Noyers, Eure

its 741 acres, Noyers provided the Vevers with a spacious country retreat.

As the Maison Vever became increasingly successful Henri began to receive numerous awards and honors. He was appointed to the commission that organized French participation in the 1893 *World's Columbian Exposition* in Chicago. In 1898 he (as well as Lalique) was made a Chevalier de la Légion d'Honneur, an award of which he was extremely proud; and in 1899 he was elected to the administrative council of the Union Centrale. He was also an active member of a number of boards, including the Société Franco-Japonaise of Paris, Conseil des Musée Nationaux, and Les Amis du Louvre.[14] While these positions were for the most part honorary, they gave Vever the opportunity to participate in the development of projects that would influence European understanding and appreciation of Japanese and Islamic art. One outcome of that growing awareness of Asian art was the celebrated exhibition series held at the Musée des Arts Décoratifs on the evolution of the Japanese print, beginning in 1909 with a display of the *"primitives"* and ending five years later with the presentation of the work of Toyokuni 1 and Hiroshige. No less important were the exhibitions of Islamic art organized by the museum in 1903 and 1912. The success of the Japanese and Islamic exhibitions depended to a large extent on the numerous loans made from Vever's collections.

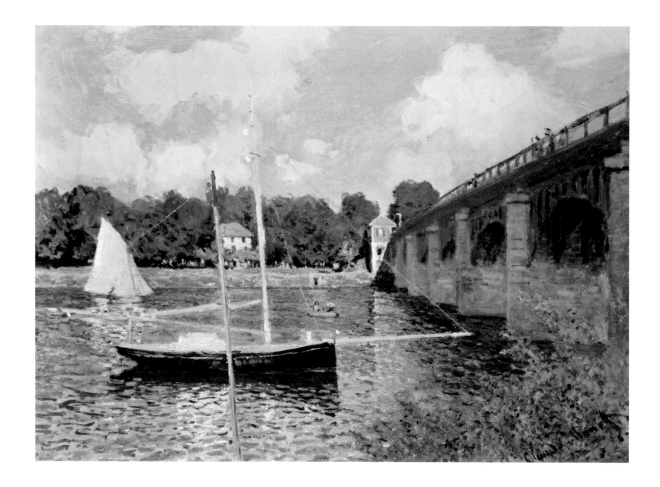

Fig. 9. Claude Monet, *The Bridge at Argenteuil*, 1874. Oil on canvas. National Gallery of Art, Washington, D.C.; Collection of Mr. and Mrs. Paul Mellon, 1983.1.24.

Fig. 10. Pierre-Auguste Renoir, *Blonde Bather*, 1881. Oil on canvas. Sterling and Francine Clark Art Institute, Williamstown, Massachusetts, 609.

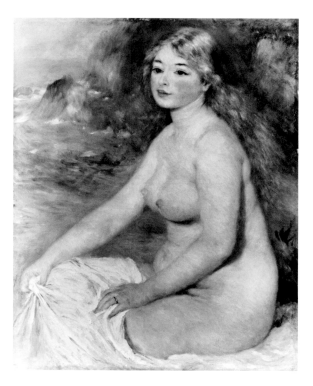

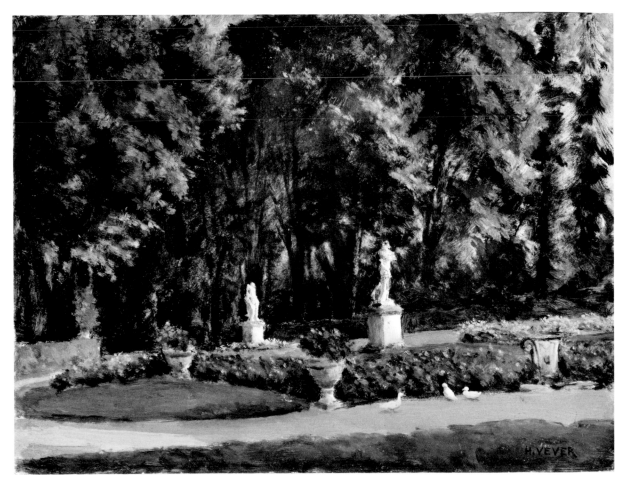

Fig. 11. Henri Vever, *Château de Noyers (Eure)*, September 1915. Oil on wood. Arthur M. Sackler Gallery, s86.0006.

The pivotal moment in Vever's development as a collector came in February 1897, when he sold his collection of modern paintings, drawings, and sculptures at the Galerie Georges Petit. His decision to do so must have been motivated in part by his wife's concern regarding his financial affairs.[15] The sale, which drew large crowds and was reported in the major newspapers, included seventeen paintings by Alfred Sisley, fourteen by Camille Corot, nine by Claude Monet (see fig. 9), and four by Pierre-Auguste Renoir (see fig. 10) as well as four sculptures by Auguste Rodin. At the time, Vever was forty-three years old and at the height of his career as a jeweler and collector, but his interests had clearly and dramatically shifted from European to Asian and Islamic works of art. In the preface to the lavishly produced sales catalogue, L. Roger-Miles left a vivid account of the rich mix of objects Vever assembled in his studio.

A loft! Oh yes, the most hospitable of lofts. One went there to talk, to discuss painting and painters; it was a large studio, in the heart of Paris. One reached it through two small rooms, with low ceilings, and walls covered with drawings by old masters and fine prints by Rembrandt, Albrecht Dürer, and others.
Then the door opened, and the feast for the eyes (that had already begun) expanded, a

feast so much more sensitive that it had the scope of a bountiful demonstration.

There, indeed, the glorious school of 1830 mixed with the masters of the impressionist school. Against a backdrop of old tapestries in muted tones, on a base of period furniture, dressers, and étagères with shelves laden with pottery and sculpture, landscape art appeared as part of an intense flavor. . . . One felt full of emotion, seized with an equal affection for objects of the past and of the present, for objects in which one could never have imagined such perfect and absolute accord if the audacity of a connoisseur such as the host had not so well demonstrated.[16]

Despite the sale of his European collection Vever remained interested in nineteenth-century French painting and continued to purchase works by Corot and Sisley as well as works by minor artists, including Gaston LaTouche, Albert Lebourg, and Louis Legrand. Vever's interest in Corot is revealing. A brilliant draftsman, Corot painted richly textured canvases that present nature in the most traditional manner.[17] Inherently conservative, his art is conceptually and aesthetically linked to the past. Modern painting, with its search for a new definition of class and culture, was of little concern to Vever, and the work of artists like Edouard Manet, who so consciously set out to define and explore totally new aesthetic concepts, did not appeal to him. Not surprisingly, the impressionist paintings that he collected were either landscapes or portraits, not cityscapes or depictions of urban life.

Indeed, Vever's continued longing after 1897 for works by Corot—in whose style he often painted (see fig. 11)—can be seen as an affirmation of his own position in the Parisian haute bourgeoisie. The following description from his diary of a painting that he tried to buy in 1899 is typical of his assessment of Corot and his art.

Corot's *La Toilette* is one of the paintings that I like absolutely the most of the contemporary school. It is one of Corot's most perfect works for which I have a real obsession. His strongest handling of figures is summed up in this work; there is a young nude woman, another dressed, a charming landscape and above all an incomparable poetry.[18]

———————

Although it is not clear precisely when Vever's fascination with Asian art began, he was acquiring Japanese prints in the 1880s (see fig. 12) and was a member of Les Amis de l'Art Japonais as early as 1892. This small group of collectors met once a month at dinner, often at the Restaurant Cardinal, to discuss Japanese art and their most recent acquisitions. According to Koechlin, the dinners were originally hosted by Bing and Tadamasa Hayashi, another important dealer of Japanese art, who supplied Vever with many of his finest acquisitions. After Bing's death in 1905, Vever continued the tradition of the *diners japonisants*.[19] In addition to Bing, Koechlin, and Hayashi, early members of Les Amis included the printer Charles Gillot, the writer Louis Gonse, the curator Gaston Migeon, and the painter Monet.

Interest in Asian art had been steadily developing in France since the mid-nineteenth century. With the opening of Japanese ports to foreign trade in 1854 and subsequent participation of Japan and China in the international exhibitions of the 1860s and 1870s, a wide variety of works from

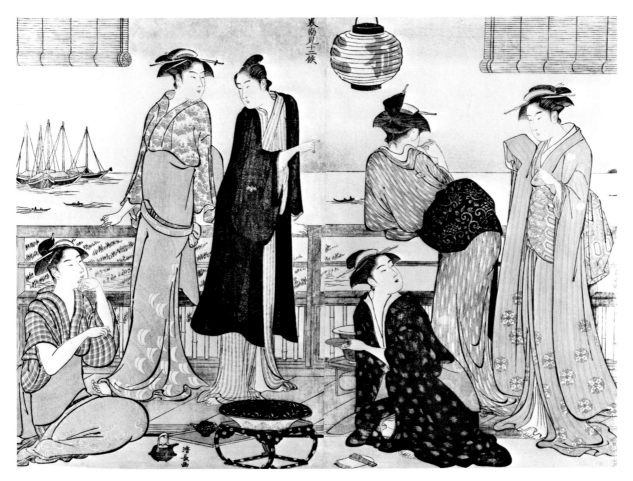

Fig. 12. Torii Kiyonaga, *The Sixth Month* from the series "The Twelve Months of the South" (*"Minami juniko"*). Woodcut (diptych); ink and color on paper. Private collection.

the Far East became available in Europe. Among the early enthusiasts of Chinese and Japanese objects were writers such as Burty, the Goncourts, Gonse, and Emile Zola as well as artists like Félix Braquemond, Henri de Toulouse-Lautrec, and Vincent van Gogh.[20] By the end of the century, when the collections assembled by the great nineteenth-century pioneers of Japonisme were sold at auction, interest in Asian art had reached a fevered pitch in Paris.[21]

Like other members of Les Amis, Vever belonged to the second generation of French collectors of Japanese art, many of whom were also active participants in the art nouveau movement and the Union Centrale. For the Goncourts—who linked nineteenth-century interests in the technical and formal qualities of the rococo with an affirmation of the role of art as craft—Japanese screens and lacquer ware, carved boxes, and painted porcelains represented an affinity with the traditions of the era of Louis xv (r. 1715–74), when Japanese art was collected by the aristocracy. Japan became for them the "country of truth and dreams," and they found in the accoutrements of Japanese feudal society (swords, *netsuke*, and the like) imported by Bing and others the perfect analogs to their own interests.[22] It was Burty who made the appreciation of Japanese art central to the art nouveau movement. In a series of lectures to members of the Union Centrale he argued

that the visual grammar of all Japanese crafts was based on the ability of the Japanese artist to record nature in a unique manner that infused even the smallest objects with a moral, symbolic, and ritualistic power. To the Union Centrale elite he suggested that the vitalism of the Japanese aesthetic, like that of the rococo, could be used to develop a new decorative ensemble.[23] This sentiment was in keeping with the Union Centrale's own interests, and the study and collection of Japanese art became integral to its program. Perhaps more than any other member, Vever immersed himself in collecting the finest examples of Japanese art. The extent to which he had become interested in Japanese prints by the late 1890s is clear from Roger-Miles, who lamented:

> The Japanese masters have taken over with their prints and their paintings and have slowly conquered their host. They are the invasion of the Far East in the West. . . . And so has this host felt in itself the flutterings of a new passion.[24]

Several aspects of Japanese art excited Vever as a jeweler and undoubtedly motivated him as a collector. He found the Japanese concern for nature an important source of inspiration, admiring how an insect, flower, or blade of grass could be drawn with the most precise simplicity. The Japanese sense of decorative design, however, most impressed him.

> Their ability to reproduce nature is nothing in comparison to their innate sense for using the reproduction of nature for decorative purposes.
> The ingenuity, variety, and taste of their arrangements are admirable. Equally adroit at combining lines as associating colors, they have greatly contributed, albeit indirectly, to the evolution of modern decoration, and it is not daring to think that, without the example of these masters, the fabrics of Liberty, the wallpapers of Walter Crane, the porcelains of Copenhagen would probably not have existed.[25]

In his admiration for the Japanese understanding of nature, Vever was echoing the words of Burty, who argued that French craftsmen should learn from the Japanese a scrupulous attention to nature and draw inspiration from it.[26] For Burty and Vever the artifacts of this highly stratified society were to be the vehicles for French "modernity."[27] While inherently paradoxical, this position explains in part why Vever so immersed himself in collecting Japanese objects. By the first years of the twentieth century his collection of Japanese art had become among the most important in Europe if not the world. Through numerous publications and exhibitions it rapidly acquired an international reputation that culminated in the 1920s when Vever sold a number of his prints (possibly as many as three thousand) through the art dealer Yamanaka to Japanese businessman Kojiro Matsukata. The latter subsequently donated the group to a Japanese bank, which presented the collection to the Ministry of the Imperial Household. The prints were transferred in 1943 to the Tokyo National Museum, where they now form the core of that institution's ukiyo-e holdings.[28] The breadth of Vever's collection of Japanese prints was not realized, however, until the mid-1970s, when a series of sales at Sotheby's revealed that he had retained for himself three thousand superb impressions while continuing to augment his personal collection.[29]

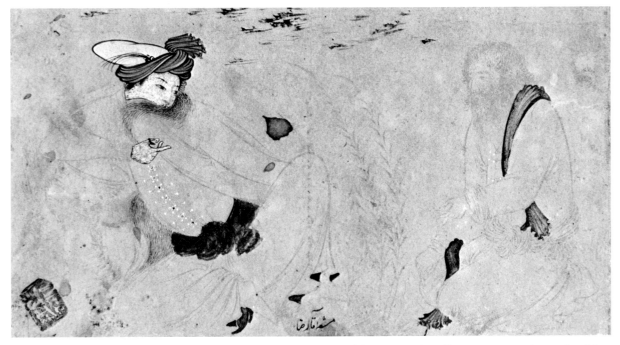

Fig. 13. *A Youth and an Old Man,* inscribed by Aqa Riza. Iran (Isfahan), ca. 1605. Opaque watercolor and gold on paper. Arthur M. Sackler Gallery, s86.0292. (Reproduced in color, pl. 66)

The earliest nineteenth-century French collectors of Islamic art, such as Piet-Lataudrie and Albert Goupil, concentrated on metalwork and ceramics, although some, like Gelis-Didot and the influential Burty, were also interested in paintings. Goupil, perhaps the most important of these collectors, displayed his extremely fine objects in elaborately furnished "Islamic" rooms (see fig. 14); such integrated environments were in keeping with the Goncourts' idea of authentic ensembles. Several exhibitions of Islamic art in Paris (1878, 1893, 1903), London (1885, 1906), Stockholm (1897), and Berlin (1899) contributed to a general awareness of the material. The Musée des Arts Décoratif's exhibition in 1903, which included more than one hundred Persian and Indian paintings and manuscripts, provided collectors with their first opportunity to examine in detail the relationship between Islamic painting and decorative arts. Among others, Charles Lang Freer, founder of the Freer Gallery of Art in Washington, D.C., noted the comprehensiveness of the exhibition and its reliance on loans from leading Parisian collections, including Vever's.[30] Victor Goloubew, a Russian aristocrat who spent most of his life in France and Indo-China, described the fervor generated by the "discovery" of Islamic art at the time.

> It was like the discovery in the middle of Muslim Asia of a new quattrocento, totally unsuspected until now, and which seems to have recognized the same ideal of beauty and vernal elegance as the Pre-Raphaelite quattrocento of Ruskin. In other words it was as though Florence, the Florence of Lorenzo the Magnificent and Botticelli, was converted to Islam and surrounded by tile kiosks and white minarets.[31]

Vever's first sustained contact with Islamic art must have come in 1891, when he attended in Moscow an exhibition of French jewelry, which had been made possible by the Franco-Russian alliance of 1891–94. This political and military pact brought together members of the liberal Third Republic of France and the absolutist autocracy of czarist Russia. The luxury crafts formed one of many bridges between the two politically distinct nations, both of which found common ground by invoking their shared cultural heritage of the mid-eighteenth century.[32] Although the Maison Vever was not awarded any prizes at the exhibition, Czar Alexander III bought an enamel piece from the Vevers, and later, in 1898, the Grand Duke Alexis Aleksandrovich bought a choker.[33] Accompanied by his wife, Vever traveled to Tiflis, Baku, Samarqand, and Bukhara, then visited Istanbul, where he saw some of the Ottoman treasury. Vever recorded in his travel diary that while in Samarqand he and his wife saw the tomb of Timur and the great Masjid-i Jami. They also visited bazaars, where they acquired textiles and other items. Vever lent several of those purchases—textiles, carpets, ceramics, and embroidered bags—to the exhibition of Islamic art held in 1893 at the Palais de l'Industrie in Paris.

During the 1890s, Vever's taste in Islamic art gradually shifted from the modest acquisitions of a tourist to fine Persian and Indian paintings and illuminations. In 1894, for instance, he purchased four Persian paintings from Michel Manzi, an artist, printer, and sometime art dealer (see Appendix 2). By the end of the century he had begun acquiring manuscripts such as an early seventeenth-century poetic anthology, formerly in the collection of the diplomat and writer Joseph-Arthur Comte de Gobineau. Except for some minor purchases of textiles in 1910 and ceramics in 1911, Vever continued until his death to acquire only Islamic works related to the arts of the book.

Vever shared his interest in Islamic art with many of the same people who collected Japanese and Chinese art. In his diaries for the years 1898–1901, he recorded that when he went to look at Persian and Indian paintings he was usually in the company of Bing, Gillot, Gonse, Koechlin, Manzi, Migeon, the painter Albert Besnard, and the art dealer Charles Vignier. In 1899, for instance, Vever wrote:

> Afternoon at the Hôtel Drouot [at a] sale of Persian miniatures. I am next to Besnard, and we chat a bit. He has bought a few pieces and me too . . . there are so many beautiful ones. Gillot, Koechlin, Gonse, Manzi, etc., are there. . . . The miniatures were sold for twenty to eighty francs; a very beautiful anthology of poetry made twelve hundred. I bought a Koran [for] two hundred.[34]

The same group often met at Vever's atelier, located on the sixth floor of the apartment building in which he lived. A large skylit room with display cases and long tables, the atelier provided an ideal setting for the study of Vever's collections. Most of the men who shared his passion for Asian and Islamic art were either prosperous merchants or artists comfortably situated within the Parisian upper middle class. Many, like Besnard, Bing, and Migeon, were also deeply involved with the art nouveau movement and the Union Centrale. Bing commissioned the artist Besnard, for instance, to paint murals for Bing's shop, l'Art Nouveau, while Migeon, a descendant of Madame de Pompadour's personal cabinetmaker, was instrumental in the creation of a series of rococo rooms at the Musée du Louvre.[35] An extremely influential and persuasive writer,

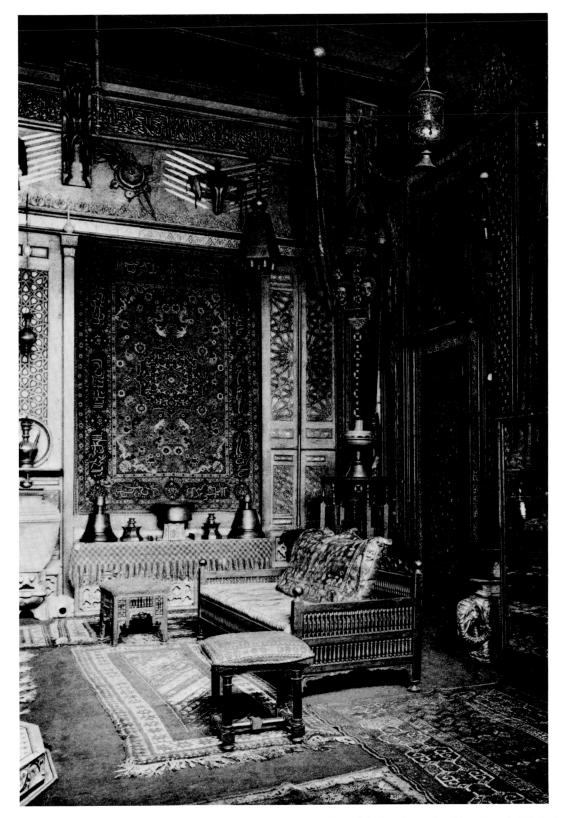

Fig. 14. Dealer Albert Goupil's "Islamic room," ca. 1900. From his *Catalogue des objets d'art de l'Orient et de l'Occident, tableaux, dessins, composant la collection de feu M. Albert Goupil*. Paris, 1888.

Migeon believed in the "exquisite . . . distinction and good taste" of prerevolutionary craftsmen and hoped that direct contact with the great objects of the past would generate artistic renewal.[36] To craftsmen like Vever and Gillot—who inherited from his father, Firmin, the originator of the gillotype, one of the finest printing shops in France—Migeon's appeal was great. These individuals were of decided but conservative taste and had learned to recognize in Islamic art a sense of craftsmanship and design in keeping with the interests of the art nouveau movement and the Union Centrale. In the charged atmosphere of early twentieth-century Paris these collectors vied among themselves and with the nobility for major acquisitions. While their motives were many (personal vision, financial speculation, social standing), their audience was limited to one another. Despite their insularity they did not shun public exhibitions and often lent generously to them. Whatever satisfaction they derived from public acclaim was secondary to the approval they sought from each other. Vever's diaries record in detail visits to his friends to view their recent acquisitions and their calls on him to see his latest purchases. Writing in 1899, for example, Vever noted with pleasure:

> Saw Gillot during the day. I bring him to the studio, and he goes into ecstasy over my latest acquisitions: masks, potteries, lacquers. He is convinced that my two masks are of the seventeenth century.[37]

Vever's willingness to rush back to his atelier to show his friend his most recent purchases underscores Gillot's importance in the formation of Vever's taste. In terms of Persian painting Gillot's influence is made particularly clear in another passage from the diaries.

> I go to lunch at Gillot's to meet there with Grasset. I go early because Gillot just telephoned me to come immediately and bring my beautiful Persian book. All three of us examine it with great interest, and Gillot gets [excited] at seeing the animals in the margins, which are "not at all natural."[38]

A year older than Vever, Gillot began collecting Japanese prints and lacquer ware shortly before Vever. He was among the first *amateurs* to become interested in Islamic ceramics and metalware as well as medieval European art. He traveled several times to the Near East and Asia, broadening his knowledge and finding objects that had been ignored by other European collectors. Willing to take risks that other *amateurs* avoided, Gillot became, according to Koechlin, the "spiritual" guide for the close-knit group of collectors.[39] Although his taste was highly personal, his interest in the decorative effect of a work of art profoundly influenced Vever and his circle.[40] Gillot often introduced Vever to new galleries and art dealers and to new artists and works of art. An early supporter of the artist Grasset, Gillot commissioned him to decorate his studio on the rue Madame and to illustrate his copy of *L'Histoire des quatre fils Aymon*.[41] When the book was published in 1883, Gillot had Vever create for it an enameled bookbinding based on Grasset's designs.

Gillot often showed Vever his most recent and interesting acquisitions. In October 1898, for instance, on the eve of Gillot's departure for Japan, a trip Vever longed to make with him, Vever recorded that Gillot

shows me a marvelous Japanese painting, which Hayashi just brought back for him from Japan. It is the life-size portrait of a seated priest, drawn in the manner of Holbein, of an admirable style, and which dates from approximately the eleventh century. It is a real revelation for me, and never before have we had such a capital morsel. I am seized with admiration. . . . Then we toured the gallery. There one makes discoveries each time one visits.[42]

Several events during the first decades of the twentieth century made the regular acquisition of major works of Islamic art possible in Europe. The most important of these was the almost simultaneous collapse of the Qajar (1779–1924) and Ottoman (1281–1924) dynasties. In the chaos that surrounded the fall of these courts rare Arabic and Persian manuscripts and paintings, among other objects, appeared on the market in great quantity. Other equally important events were the invention of the steam engine and extension of the European rail system through Turkey to Iran, facilitating the transportation of goods and people throughout that hitherto remote part of the world.[43] Among the first to take advantage of this new accessibility was F. R. Martin, a Swedish connoisseur and art dealer who traveled extensively in Turkey, often returning to his villa in Florence with important paintings and manuscripts removed surreptitiously or with the tacit approval of unscrupulous librarians from the libraries of Istanbul.[44] The folio containing the painting *Mechanical Device for Pouring a Drink* (color pl. 6), for instance, is one of many that Martin acquired on one of his trips and subsequently sold to European collectors.[45] Martin was also responsible for dispersing more than thirty folios from a copy dated 1224 of the *Materia medica*; Vever purchased two of these (color pls. 4, 5) through the dealer Demotte in 1912.

Martin was not the only person engaged in such activity, although he was one of the few to so thoroughly mix scholarly and commercial interests. His *Miniature Painting and Painters of Persia, India, and Turkey from the Eighth to the Eighteenth Century* (1912) cleverly combined those two aspects of his work. On the one hand it was carefully researched, relying on current scholarship to date and attribute paintings. On the other hand it promoted his finest pieces; Martin owned and then sold more than one third of the objects illustrated. By introducing connoisseurship as a means of examining Islamic art and linking it to the sale of objects, Martin established an approach to Islamic material that has only recently begun to be questioned. Martin's awareness of the techniques of connoisseurship was presumably influenced by his contacts with Bernard Berenson, the celebrated historian of the Italian Renaissance, whose major studies on Venetian and Florentine painters first appeared in 1894 and to whom Martin sold a number of objects.[46]

The German Walter Philipp Schulz was another early scholar who worked in the same vein as Martin. His *Persische-islamische Miniaturmalerei* (1914) elaborated on many of Martin's findings. Schulz included in his publication a number of otherwise unknown paintings and manuscripts that became key to the understanding of Persian art. The most important of these was the great fourteenth-century Ilkhanid copy of the *Shahnama* (Book of Kings) popularly known as the Demotte *Shahnama* after the dealer responsible for its dispersal in the West. Like Martin, Schulz also used his study to present a large number of paintings and manuscripts from his own collection, which was then sold. Vever subsequently purchased several of these, such as a copy dated 1509/1527–28 of the *Khamsa* (Quintet) of the twelfth-century Persian poet Nizami (see fig. 15).

The publications by Martin and Schulz as well as the exhibitions held in Munich in 1910 and at the Musée des Arts Décoratifs in 1912 heightened European awareness of Islamic art and

intensified competition among collectors. As the first major exhibition devoted entirely to the arts of the book, the 1912 Paris exhibition, for which Marteau and Vever wrote the catalogue, was critical in evolving interest in this material. The exhibition was made possible when Goloubew, during one of his many trips abroad, left on deposit at the Musée des Arts Décoratifs his extensive collection of Persian and Indian paintings and manuscripts. Responding to the occasion, the museum called on other Parisian collectors to lend objects for exhibition. In the preface to the catalogue of his collection, published nearly two decades after the exhibition, Goloubew described the excitement created by the event.

> The year 1912 undoubtedly marks an apogee—so many priceless illuminated manuscripts, albums with paintings and drawings, precious Korans, and bindings had never before been seen together. It was the fairyland of the book, *The Thousand and One Nights* of Orientalist bibliophiles. It is equally true that the dazzling gathering at the Pavillon des Arts-Décoratifs represents for many of us the end of an ephemeral springtime, which must necessarily be succeeded by a period of calm and reaction.[47]

In the wake of this exhibition Goloubew and Léonce Rosenberg, another major art dealer and collector, chose to sell their collections, the former en masse in 1914 to the Museum of Fine Arts in Boston, the latter individually in 1913.[48] As the market became more active many works of art changed hands several times in the span of several years. The double-page frontispiece *A Prince Enthroned* (color pl. 47) and the painting *A Reclining Prince* (color pl. 65) were among the most sought after "trophies." When the frontispiece was published in 1912 in *Miniature Painting and Painters* it belonged to Martin. By June of that year it had been acquired by Demotte, who appears to have sold it almost immediately to Goloubew. By the time Schulz published the painting in *Persische-islamische Miniaturmalerei,* it had been repurchased by Demotte, who had given half of it to Vever in July 1913 as partial repayment of a loan. Vever subsequently obtained the other half of the painting from Demotte in December of that year. Vever also acquired in 1913 the superb painting *A Reclining Prince.* Although its provenance is less convoluted than that of the frontispiece, its ownership changed four times between 1910, when it belonged to the collector Stéphane Bourgeois, and May 1913, when Vever purchased it from Rosenberg (see Appendix 2).

Most of Vever's acquisitions during this time came from art dealers. Between 1907 and the end of World War I he bought sixty-three paintings and manuscripts from Demotte, eighteen from Reza Khan Monif, and eleven from Vignier. Of these dealers Demotte was clearly the most important, and it was through him that Vever acquired many of his finest pieces. A Belgian born in Paris, Demotte began his professional life as a diamond merchant. Around 1900 he started trading in Islamic art, and he continued to sell the material in Paris and New York, where he opened a gallery in 1921. After his death in 1923, a large part of his stock was transferred to his son Lucien, who took over the New York gallery.[49] Demotte's most significant coup as a dealer in Islamic art came around 1910, when he obtained from Shemavan Malayan, the brother-in-law of another dealer in Islamic art, an Ilkhanid copy of the *Shahnama* containing at least fifty-eight of the most exciting and important Persian paintings known to date. Demotte first attempted to sell the manuscript intact to museums. When that effort proved unsuccessful, he had the manuscript dismembered and began offering individual folios to discerning collectors. Vever, whose

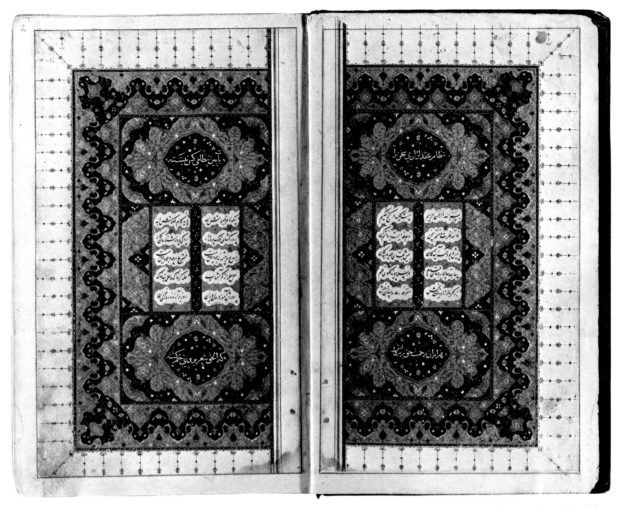

Fig. 15. Folios 1b-2a from a *Khamsa* of Nizami, Iran (Isfahan), 1509/27–28. Opaque watercolor, ink, and gold on paper. Arthur M. Sackler Gallery, s86.0037. (Purchased by Vever from the Schulz Collection.)

financial dealings with Demotte had substantially grown since his first recorded purchase from him in 1909, was one of the first, if not the first, client to be shown folios from the *Shahnama*. On June 27, 1913, Vever purchased three paintings from the manuscript (*Zal Approaches Shah Minuchihr, Iskandar Builds the Iron Rampart* [color pl. 12], *Ardawan Captured by Ardashir* [color pl. 13]). In an extremely complicated series of transactions over the next eight months, Vever acquired four more paintings from the manuscript.[50] It appears from his ledger that he paid a total of thirty-five thousand francs for these seven folios, but he received at least the first three as partial repayment of a loan of forty thousand francs that he had made to Demotte. Regardless of the difficulties in ascertaining the exact price Vever paid for these paintings, the works represented a substantial investment, given the fact that his paintings by Monet realized an average of nine thousand francs each when they were sold in 1897.

Vever often entered into extensive negotiations with Demotte over the price of a painting. In September 1912, for instance, he purchased eight paintings from the dealer, including *A Prince and a Princess Embrace* inscribed to the sixteenth-century artist Abdullah (color pl. 63). The initial

asking price for these items was 23,700 francs, which was reduced to 21,750 and then to 19,000 before a final price of 15,000 francs was accepted.[51] Another aspect of Vever's dealing with Demotte is revealed by a notation in his ledger indicating that on June 6, 1914, he bought a small painting of a seated prince by the celebrated artist Riza Abbasi.[52] Baron Maurice de Rothschild, however, took a fancy to the painting before Vever took possession of it, and Demotte interceded on the baron's behalf, arranging on July 8 to exchange the painting with Vever for the painting *Nushirwan Listens to the Owls* (color pl. 45). Demotte's actions and Vever's willingness to relinquish his acquisition highlight the importance attached to the baron's social position. It was permissible for Vever and his friends to compete with the aristocratic elite in the salons of the Hôtel Drouot but not in the intimate surroundings of a private gallery.

While it is easy to disparage Demotte and other dealers for dismembering manuscripts, it must be remembered that most connoisseurs of the period disregarded the texts of the works they acquired. Unable to read Persian or Arabic, they were almost solely interested in the paintings and illuminations contained in the manuscripts. Seymour de Ricci, who catalogued Léonce Rosenberg's collection, summed up their interest succinctly if not crudely:

> In the first place one cannot properly look at a miniature unless it is detached. What benefit would the well-informed public gain from the forty Fouquet de Chantilly [miniatures] if they were still imprisoned in the Book of Hours of Etienne Chevalier? . . . For almost all collectors the text is unimportant, only the miniatures count. Are there not enough calligraphied examples of the *Shahnama* and al-Hariri's *Séances* [*Maqamat*] in the world? In addition the mutilation of these volumes began well before our era. Twenty years ago when F. R. Martin discovered the *Automata* manuscript in Constantinople it was no more than a fragment; but that fragment cut up into about ten pieces today gives joy to as many different collectors.[53]

The development of Vever's Islamic collection can be divided into two periods interrupted by World War I. Judging by his expenditures, the great exhibition of 1912 at the Musée des Arts Décoratifs clearly provided a central focus to his prewar activities. In 1907 he purchased no Persian or Indian works of art, whereas in 1908 and 1909, according to his own reckoning (see Appendix 2, Addendum), he spent 11,735 and 7,426 francs, respectively, on this material. Vever's acquisitions increased to 65,550 francs in 1910, fell to 22,300 in 1911, and escalated to 36,942 francs in 1912. The heightened interest in Islamic art following the exhibition in 1912, combined with the dispersal of the Rosenberg Collection and appearance of the Demotte *Shahnama*, resulted in Vever's spending 68,300 francs in 1913,[54] his last major expenditure before the 1920s. During the early 1910s, Vever's purchases of Islamic art, totaling 143,953 francs, exceeded all his other acquisitions, except those of European books and bindings, for which he spent 180,646 francs.

Vever purchased only fourteen paintings and bookbindings in 1914, spending a total of 16,550 francs (see Appendix 2). He made no other purchases of Islamic material through July 1917, the last entry in his ledger. Like most Parisians, Vever was unsure of the duration of the war, and consequently avoided making any major financial commitments during that time. He could not, however, resist buying objects that appealed to him; several entries in his ledger (such as that for June 18, 1914, documenting a purchase from Rosenberg) record payments deferred until after the war.

With the resumption of normal activities in France during the 1920s, a major shift in the sources Vever relied on for his collecting appears to have occurred. Instead of buying primarily from dealers like Demotte he turned to auctions for the majority of his acquisitions. The most important of these involved the collections of Rudolph Meyer-Riefstahl (1923), Octave Homberg (1931), Indjoudjian (1932), Sevadjian (1932), and Emile Tabbagh (1935). During the 1930s, Vever also made purchases from the collections acquired by his old friends, either directly, as in the case of Vignier, or through estate sales like those of Besnard and Migeon. Since Vever's ledger ends, unfortunately, in 1917, it is impossible to know the precise cost of these acquisitions.

Although the number of objects Vever bought from these sales is modest compared to his prewar acquisitions, the purchases significantly increased the quality of his collection. From the Meyer-Riefstahl sale he obtained the 1437 *Khamsa* of the Ilkhanid court poet Khwaju Kirmani (see color pl. 40) and a *Khamsa* of Nizami (see fig. 15). From the Homberg sale he purchased the Timurid poet Jami's *Tuhfat al-ahrar* (Gift of the Free) formerly in Martin's collection; it contains a double-page frontispiece by Mahmud Mudhahhib, an artist active in Bukhara during the 1540s and 1550s (see fig. 16). He also obtained a copy of Jami's *Silsilat al-dhahab* (Chain of Gold) dated 1549–50 (see color pl. 34).

The developing size and importance of Vever's collection can also be gauged by the number of loans he made to exhibitions of Islamic art. In an exhibition held in 1903 at the Musée des Arts Décoratifs, eight of the 114 entries of paintings and manuscripts were from Vever; in another exhibition held at the museum in 1912, forty-nine of the 277 entries were from Vever. Fifteen years later, in 1927, thirty-two of the fifty-one entries from the section on paintings and bookbind-ings in an exhibition held at the Hague were from Vever. In 1931, fifty-five of some of his finest pieces, including all his Demotte *Shahnama* paintings, were selected for an exhibition of Persian painting held at Burlington House in London. At the Bibliothèque Nationale in 1938, in the last public display of his Islamic collection during his lifetime, fourteen of the ninety-eight entries in the section on paintings and manuscripts were Vever's.

By the time Vever died in 1942, his collection of Persian and Indian works of art had grown to include forty-four manuscripts, twenty-nine bookbindings, and more than four hundred paint-ings and examples of calligraphy. Several patterns can be discerned in the way he collected. The most obvious is that he did not limit himself to any one aspect of the Islamic arts of the book. He purchased complete manuscripts, detached folios from dispersed manuscripts, individual paintings, bookbindings, and calligraphy—from Egypt, Iraq, Syria, Iran, and India. The only major region Vever neglected was Turkey, presumably reflecting the fact that Ottoman paintings and manuscripts were neither readily available nor particularly appreciated in Europe during the first half of the twentieth century.

Many objects that Vever acquired—like the double-page frontispiece to a *Khamsa* of Amir Khusraw Dihlawi copied for Bahram Mirza (color pl. 37) and the double-page painting *A Prince Enthroned Surrounded by Attendants* (color pl. 46)—were clearly purchased for their quality, but others—such as the folios from a *Shahnama* of Firdawsi copied in 1341—were chosen for their historical significance. Vever seems to have preferred to buy in clusters, often acquiring numerous folios from a single manuscript or album, although not necessarily at the same time. He pur-chased, for example, eight paintings from the Demotte *Shahnama* (color pls. 7–14); three folios of text and nine paintings from a *Shahnama* of 1341; seven paintings from the *Shahnama* copied

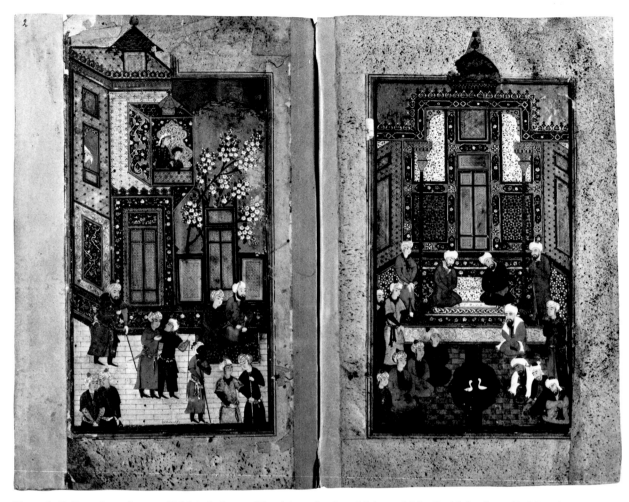

Fig. 16. Folios 1b-2a from a *Tuhfat al-ahrar* of Jami inscribed to Mahmud Mudhahhib, Iran (Bukhara), ca. 1540. Opaque watercolor, ink, and gold on paper. Arthur M. Sackler Gallery, s86.0046. (Purchased by Vever from the Homberg Collection.)

for Sultan-Ali Mirza of Gilan (color pls. 17–23); five from a Safavid copy of the *Falnama* (color pls. 29–33); three from a *Baburnama* of circa 1589 (see color pls. 49, 50); and five works of calligraphy, eight paintings (see color pls. 51–57), and an illuminated rosette from the Late Shahjahan Album. Vever also seems to have been interested in certain themes, such as the story of Sulayman (Solomon) and Bilqis (Sheba) of which he obtained numerous illustrations depicting them enthroned (see color pl. 60).

Like many of his contemporaries involved with the Union Centrale, Vever sought to form a collection representative of all the major periods of Persian and Indian painting from the fourteenth through the eighteenth century. His ability to acquire a critical mass of material for any given period as well as key images and manuscripts distinguishes his activities. At the core of Vever's acquisitions are his sixteenth- and seventeenth-century Safavid holdings. One reason for the excellence of his collection in this area is that more works of art were readily available from that period. Vever's interest in painting and calligraphy from the sixteenth and seventeenth centuries was also based on their aesthetic qualities. The brilliant colors, sinuous lines, and

intricate compositions of paintings such as *A School Scene* (color pl. 59) or *A Reclining Prince* (color pl. 65) were in keeping with similar qualities paralleled in art nouveau. Within the movement's context he must have found the richly illuminated frontispieces (see color pls. 1–3) and boldly patterned bookbindings (see color pls. 73–76) particularly appealing. The drawings and paintings of artists like Riza Abbasi (also known as Aqa Riza) most interested Vever. *A Youth and an Old Man* (color pl. 66), for instance, with its shimmering gold lines, pulsating rhythms, and finely textured details, conveys much of the same feeling that is generated by the dynamic designs of Vever's finest pieces of jewelry. The relationship, however, between Vever's own work and the paintings and illuminations that he collected was never direct. He did not turn to Islamic objects as sources for his own designs but rather found in them an analogous interest in technical refinement and the expressive use of line. Given the affinity between Vever's own taste and the images produced during the reign of Shah Abbas I (r. 1588–1629), it is not surprising that such works of art are among the best represented in the collection.

The one area in which the collection does not excel is India. Despite several superb Mughal paintings and album pages, his Indian holdings are surprisingly weak. Indeed, most of his Mughal and Rajput paintings are either relatively uninspired late eighteenth-century works or modern copies. It seems unlikely that Vever simply did not appreciate the difference between important and minor Indian paintings. More probable is that he suffered from the relative unavailability in France of Indian material, which did not enter the Western market in large supply until after 1925 and then primarily in London. He certainly saw his Mughal and Rajput paintings as a subset of his Islamic collection, an assessment reinforced by the term *Indo-Persan*, which he and others often used to describe these paintings. Not until the late 1920s and 1930s, with the publications of the noted scholar Ananda K. Coomaraswamy, did Indian painting begin to be fully appreciated. By then Vever had already established the principal focus and direction of his collection.

With the German occupation of France in 1942 and Vever's retreat to the country, his collecting came to an end. His death that same year went almost unnoticed, recorded only by a few brief lines in *Le Matin* and other Parisian newspapers. All his friends and colleagues had long since passed away, and his objects were stored in various locations. The gradual dispersal of his Japanese material and disappearance from public view of his Persian and Indian works of art obscured the magnitude of his achievement.

Vever dedicated himself, and his resources, to a lifelong pursuit of the ideal in art. For him collecting was not a gentlemanly avocation but rather a creative expression of his interests as an *amateur* and connoisseur. To that end he sought not only to refine his sensibilities but also to share with others his profound belief in the power of art to delight the mind and renew the spirit. While the collections he formed were highly personal, reflecting his unique interests and taste, they were also part of a broader movement. Like Gillot, Koechlin, Migeon, and others, Vever was among those French collectors of Asian and Islamic art whose aesthetic sensibility had been profoundly affected by the art nouveau movement and the Union Centrale des Arts Décoratifs. It is against this background that Vever's accomplishments assume their greatest resonance.

Notes

1. Raymond Koechlin, *Souvenirs d'un vieil amateur d'art de l'Extrême-Orient* (Chalon-sur-Saone: Bertrand, 1930), p. 111.

2. Debora Silverman, "The Origins of 'Art Nouveau' in France, 1889–1900: Nature, Nobility, and Neurology" (Berkeley: University of California Press, forthcoming), MS. p. 1.

3. Ibid., p. 47.

4. Ibid., p. 50.

5. Diary of Henry Vever, August 10, 1898. Private collection.

6. Silverman, "Origins of 'Art Nouveau,'" pp. 172–74.

7. Vever recorded in his diary that on December 29, 1898, he sold to "M. Boutry a necklace for 1,375 fr and a comb for 85 fr / Mme Lucien Delatre a brooch for 790 fr / M. Larsonnier two cut diamonds for 6,700 fr / Mme Huet a brooch for 1,100 [fr] / M. Hallez a brooch and a letter opener for 105 fr / M. Godet [Vever's notary] a ring and two cut diamonds for 2,200 [fr] / Others for 600 fr."

8. Diary, August 3, 1898.

9. Silverman, "Origins of 'Art Nouveau,'" p. 214.

10. Ibid., pp. 168, 257.

11. Gabriel Weisberg, *Art Nouveau Bing: Paris Style 1900* (New York: Abrams, 1986), p. 22.

12. Evelyne Possémé, "Henri Vever (1854–1942): Collectionneur, bijoutier-joaillier-orfèvre, et historien" (Master's thesis, Sorbonne, 1984), p. 80.

13. Regarding the artist, Vever wrote, "Lalique is always splendid and the others very mediocre" (diary, May 20, 1898).

14. Possémé, "Henri Vever," p. 41.

15. Regarding his wife's interest in his finances, Vever wrote, "I have already sold my collection of paintings because she reproached me with them constantly" (diary, October 8, 1898). On another occasion Vever refrained from purchasing a collection of sword guards from the Japanese art dealer Haghiwara after having a conversation with his wife over the state of his *compte capital.* Her worries may not have been unfounded. From 1907 to 1912, Vever's purchases of Asian, Islamic, and European art totaled 577,130 francs.

16. *Collection H. V.: Catalogue de tableaux modernes* (Paris: Galerie Georges Petit, 1897), p. 10.

17. Timothy J. Clark, *The Painting of Modern Life: Paris in the Art of Manet and His Followers* (New York: Knopf, 1984), p. 183.

18. Diary, August 24, 1899. Corot's painting *La Toilette* is reproduced in Germaine Bazin, *Corot* (Paris: Tisné, 1951), pl. 102.

19. Koechlin, *Souvenirs,* pp. 21–22.

20. Siegfried Wichmann, *Japonisme: The Japanese Influence on Western Art in the Nineteenth and Twentieth Centuries* (New York: Harmony, 1980), p. 9.

21. Phillipe Burty's collection was sold after his death in 1891; the Goncourts' in 1897 after the death of Edmond; and Tadamasa Hayashi's in 1902 and 1903.

22. Cited in Silverman, "Origins of 'Art Nouveau,'" p. 147.

23. Ibid., p. 203.

24. *Collection H. V.,* p. 12.

25. Henri Vever, "L'Influence de l'art japonais sur l'art décoratif moderne," *Bulletin de la Société franco-japonaise de Paris* 22 (June 1911): 112.

26. Silverman, "Origins of 'Art Nouveau,'" p. 204.

27. Cited ibid., p. 204.

28. There is some confusion concerning the number of prints Vever sold to Kojiro Matsukata. Jack Hillier, in "The Henri Vever Collection of Japanese Prints, Illustrated Books, and Drawings," *Art at Auction* (1974–75): 433, states that Vever may have sold Matsukata as many as eight thousand. According to members of Vever's family, Vever only sold Matsukata around three thousand, and the art dealer Yamanaka added several thousand of his own prints to the lot, claiming that they too belonged to Vever.

29. Auction sales of Vever's Japanese collection were held at Sotheby's, London, March 26, 1974; March 26, 1975; and March 24, 1977.

30. Charles Lang Freer to Colonel Frank J. Hecker, June 22, 1903, Freer Gallery of Art Archives.

31. Cited in Ananda K. Coomaraswamy, *Les miniatures orientales de la collection Goloubew au Museum of Fine Arts de Boston* (Brussels: van Oest, 1929), p. 6.

32. Silverman, "Origins of 'Art Nouveau,'" p. 260.

33. Possémé, "Henri Vever," p. 71.

34. Diary, May 9, 1899. The "Koran" presumably is the Ottoman book of prayers (Arthur M. Sackler Gallery, s86.0482) copied by Ali al-Hamdi in August–September 1715 with the date 1899 inscribed on the flyleaf by Vever.

35. Silverman, "Origins of 'Art Nouveau,'" pp. 225, 251–57.

36. Cited ibid., pp. 251, 253.

37. Diary, June 21, 1899.

38. Ibid., October 16, 1899.

39. Koechlin, *Souvenirs,* p. iv–v.

40. Ibid., p. v.

41. Victor Arwas, *Berthon and Grasset* (London: Academy, 1978), pp. 12–13.

42. Diary, October 27, 1898.

43. Much of this material, which began leaving Iran in substantial quantity around 1906–08, was sent via Tabriz to Europe through the Russian postal system, considered an extremely secure means of transportation.

44. Stuart Cary Welch, "Private Collectors and Islamic Arts of the Book," in *Treasures of Islam,* ed. Toby Falk (Geneva: Musée d'art et d'histoire, 1985), p. 26.

45. Seymour de Ricci, *Catalogue d'une collection de miniatures gothiques et persanes appartenent à Léonce Rosenberg* (Paris, 1913), p. 35.

46. Martin sold to Bernard Berenson a page from the *Materia medica* of Dioscorides, which Berenson left in his will to J. Carter Brown, director of the National Gallery of Art in Washington, D.C. Since Martin did not move to Florence until after the First World War, it is unclear when he first came into contact with the historian. The author is grateful to Basil Gray for this information.

47. Cited in Coomaraswamy, *Les miniatures orientales,* p. 9.

48. Vever bought at least twenty-four paintings from Rosenberg's collection, beginning in 1909 and culminating in eleven purchases in 1913 (see Appendix 2).

49. Lucien Demotte organized many important exhibitions of Islamic art in New York. After his death in 1937 the art dealers Parrish Watson and Nasli Heeramaneck purchased most of his stock.

50. The four paintings were *Faridun Mourns at the Arrival of the Coffin of Iraj* (color pl. 7), *Faridun Goes to Iraj's Palace and Mourns* (color pl. 8), *Sindukht Becomes Aware of Rudaba's Actions* (color pl. 9), and *Ardashir with His Wife, Who Throws Down the Cup of Poison* (color pl. 14). Sometime after 1917, Vever purchased one more painting from the manuscript.

 A sales receipt dated July 4, 1913, from Demotte states that Vever purchased *Zal Approaches Shah Minuchihr* (now in the Chester Beatty Library and Gallery of Oriental Art in Dublin; Pers. MS. 111). It is not clear whether Demotte mistook the painting for *Shah Zav, Son of Tahmasp, Enthroned* (color pl. 10) or whether Vever, having purchased *Zal Approaches Shah Minuchihr,* decided at a later date to dispose of it.

51. These figures are from Vever's notations on a separate sheet inserted into the ledger. They differ slightly from the figures given in the transcription entry for September 1912 and delineate the various stages of negotiation.

52. The painting by Riza Abbasi is now in the collection of Abolala Soudavar (reproduced in *Persian and Mughal Painting* [London: Colnaghi, 1976], no. 40).

53. Ricci, *Catalogue d'une collection,* pp. 3–4.

54. Owing to the complexity of the financial dealings between Demotte and Vever in 1913, it is not always clear when Vever paid for goods received and when he received items in lieu of cash repayment for outstanding loans. The figures for 1913 are therefore subject to interpretation.

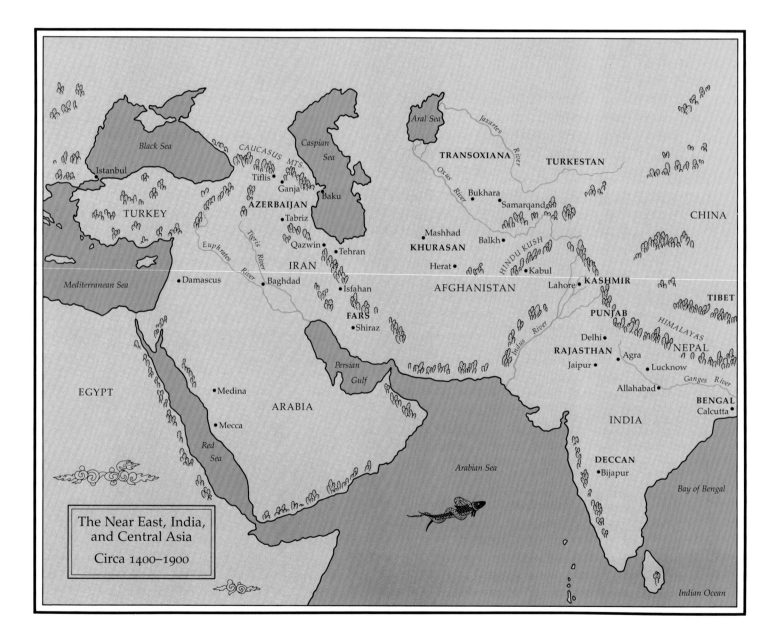

The Near East, India, and Central Asia

Circa 1400–1900

Persian and Indian Painting

OFTEN SMALL IN SCALE, with finely detailed compositions, extensive use of gold, and brilliant colors, Persian and Indian paintings present an abstracted and idealized world. The Islamic artist's avoidance of perspective and limited use of light and shade allow the images to exist outside the normal constraints of temporal reality.[1] Bold designs and complicated patterns reinforce their rich effect, while stories of princes and princesses, feasts and battles, evoke images of royal activities and aristocratic pursuits. Despite the inherent attraction of these objects and after almost a century of serious study, many questions remain about their structure, function, and use. Discussions pertaining to the Islamic arts of the book were until very recently restricted to the traditional interests of Western art historians. Scholars generally approached the material in three ways. First, they stressed the primacy of painting over all other aspects of the arts of the book, often disregarding the relationship of the images to the texts they illustrate. Second, they concentrated on providing a taxonomy of style based on regional and historical circumstances. Third, they focused on identifying individual artists in an effort to demonstrate that the same idea of artistic genius applies to Islamic as well as to European art.

While these standard approaches developed for many reasons, they all depended to a degree on the interests and tastes of the early twentieth-century collectors and dealers of Persian and Indian paintings. The decisions these individuals made about which paintings and manuscripts to collect, and how to interpret and display them, directly affected the availability of objects for study and how the works were perceived. Indeed, except for a few notable discoveries, no significant additions have been made to the corpus of Persian and Indian material assembled in the West during the first three decades of this century.

For most early enthusiasts of Islamic art two aspects of Persian and Indian painting were particularly appealing. The first was the remarkable beauty and extraordinary technical refinement of the paintings and illuminations, and the second was their royal or imperial associations. The affinity between the sinuous lines, vibrant rhythms, and opulent colors of these works and the aesthetics of the art nouveau movement (see fig. 17), for instance, made them irresistible to collectors like Louis Cartier, Calouste Gulbenkian, Baron Maurice de Rothschild, and Henri Vever, who found in them an affirmation of their own highly refined sensibility. Moreover, because numerous paintings and manuscripts had been in imperial libraries and depicted princely activities, the images acquired an aristocratic aura confirming their intrinsic value and the social status of those who collected them. The association between such objects and the European aristocracy is made explicit by the connoisseur and art dealer F. R. Martin, who wrote in 1912,

Fig. 17. Page from volume 4 of Henri d'Allemagne, *Du Khorassan au pays des Bakchtiaris: Trois mois de voyage en Perse* (1911) set into half of a double-page frontispiece from a Koran. Turkey, second half sixteenth century. Opaque watercolor, ink, and gold on paper. Arthur M. Sackler Gallery, s86.0073.001.

"Everything that Shah Tahmasp had executed with the most critical taste, Shah Abbas wished to surpass and transcend, just in the same way as Ludwig of Bavaria wished to outvie Louis xiv of France."[2]

In their search for exquisite examples of courtly work, the late nineteenth- and early twentieth-century collectors of Islamic painting were concerned almost entirely with formal qualities. Unable to read Persian or Arabic, they had little interest in the context or subject of the images they acquired. Art dealers like Georges Demotte and Reza Khan Monif often obliged their clients' demand for fine paintings by dismembering the illustrated manuscripts and albums in their possession. By removing illustrations and illuminations from the manuscripts and discarding the text, dealers and collectors irrevocably altered if not destroyed the relationship of the images to one another and to the stories they illustrated. Consequently, paintings and illuminations were treated as individual works of art, analogous to eighteenth- or nineteenth-century European

paintings, rather than as part of larger ensembles with complicated internal rhythms, cadences, and relationships. A less-obvious result of such destruction is that it bound together the haute bourgeois and aristocratic collectors, who shared with one another folios from dispersed manuscripts and albums. Their alliance created an intimate circle, whose members competed with one another for the finest examples from each manuscript or album as it was unbound. As the most important paintings and manuscripts changed owners several times in the active market of the early twentieth century they acquired a new pedigree that became an essential component of their value for the next generation of collectors.

In organizing these Islamic paintings, subsequent scholars and collectors, with their European-oriented training and background, often ignored the fact that in many instances the original context of the works they were studying had either been totally obscured or conveniently forgotten, or had simply ceased to exist. While their attitude made it extremely difficult for them to see the pieces as anything more than exquisite works of art—a concept reinforced by calling them "miniature paintings" rather than "paintings" or "illustrations" and equating them with precious decorative objects—it did not prevent them from analyzing the works on the basis of their style and quality. For many scholars the paintings, even when found in bound manuscripts, were totally independent objects:

> Each miniature is a kind of painting, which remains indifferent to its insertion in the text, tends to have a total independence, and haughtily presents itself for view as a perfect object. For this reason it seemed good [to us] that the *amateur*, as yet unenlightened, immediately had the feeling that Muslim painting was not only an art of the book but also could admirably sustain the conditions inherent to an art sufficient unto itself according to the intentions of the creator.[3]

Once the paintings were no longer an integral part of a book, they were easily disassociated from the culture that produced them. Such separation led to a purely formal treatment of the paintings and to such statements as: "Perhaps the most exquisite manifestation of Muslim art, the miniature has a character that is not only profane but anti-Islamic."[4]

Most formal analyses of Persian and Indian paintings have set them within a relatively rigid historical framework beginning around 1300 and continuing through the end of the nineteenth century. The principal way in which that categorization was accomplished was to divide the period into a series of smaller moments through the mechanism of dynastic rule. Such classification provided a series of convenient, although not necessarily appropriate, dates and established a direct link between the objects and their perceived imperial or aristocratic origins. By emphasizing the importance of royal patrons in the creation of objects, the classification by dynasties made an appreciation of the character and feelings of the rulers intrinsic to any understanding of the material. Thus even as recently as the 1960s the art of Mughal India was explained in the following way:

> The Kings were romantics to the last, always reaching for the unattainable. Babur, the poet-conqueror, was possessed with the dream of an empire worthy of his ancestral glories. A utopian India for Hindus and Moslems alike was Akbar's idealistic obsession. . . . The

emperor's varying moods found expression at the hands of their artists and craftsmen, who gave tangible form to their flights of fancy.[5]

It was the role of the connoisseur and scholar as interpreters of royal aspirations to discern the intentions of sophisticated and enlightened patrons. The result of studying Persian painting from the perspective of dynastic rule has been the creation of a chronology that usually sees the tradition as starting under the Mongol rule of the Ilkhanids (1256–1353), undergoing a process of refinement during the Jalayirid period (1336–1432), and reaching a level of perfection under the Timurids (1370–1506) and Safavids (1501–1732) before declining under the Zands (1750–94) and Qajars (1779–1924). Islamic painting in India was traced in the same way, from its earliest appearance under the Sultanate dynasties of Bengal (1336–1576), the Deccan (1347–1527), and Gujarat (1391–1583) to its culmination under the Mughals (1526–1857). Within this context a series of key artists, manuscripts, and patrons emerged as important in shaping the evolution of this tradition. Among the manuscripts singled out for repeated attention are the early fourteenth-century Ilkhanid *Shahnama* (Book of Kings) of the eleventh-century poet Firdawsi (see color pls. 7–14); the *Diwan* (Collected Poems) of Khwaju Kirmani copied at Baghdad in 1396 for the Jalayirid ruler Ahmad Shah (r. 1382–1410); the *Shahnama* of Firdawsi copied in Herat in 1429–30 for the Timurid prince Baysunghur (1399–1433); the *Bustan* (a didactic and ethical work) of the great thirteenth-century poet Sa'di completed in 1488 for the Timurid Sultan-Husayn (r. 1470–1506); and the *Shahnama* of Firdawsi copied around 1530 for the Safavid ruler Shah Tahmasp (r. 1524–76).[6]

Although the study of individual artists is far more difficult than that of manuscripts because few artists consistently signed their work before the end of the sixteenth century, several artists are considered particularly important. Included among them are the fourteenth-century masters Ahmad Musa and Abdul-Hayy (whose works cannot be identified with any certainty but who are often cited in fifteenth- and sixteenth-century literary references), the late fifteenth-century painter Bihzad, and the Safavid artists Sultan-Muhammad and Riza Abbasi (see color pls. 62, 66).

What emerges from this examination is a linear history of Persian and Indian painting that postulates a direct relationship between a series of discrete works and a succession of talented artists and enlightened patrons. Continuous and coherent, the history is articulated in purely positivist terms by means of a narrow methodology that includes the study of patronage, attribution, technique, and iconography.[7] Its problems are self-defined and self-sustaining. Given the nature of this approach, its most characteristic manifestation is the compilation of detailed catalogues and checklists (such as *An Annotated and Illustrated Checklist of the Vever Collection*). The goal of such publications is to place whatever objects have been gathered together for consideration within the continuum of a self-perpetuating historical matrix. While the basic parameters of the linear approach were first introduced in the seminal publications of Edgar Blochet, Georges Marteau and Vever, and Martin, among others, it is with the monumental study of 1933 by Laurence Binyon, J. V. S. Wilkinson, and Basil Gray that they are fully developed. Ostensibly a critical and descriptive catalogue to the great exhibition of Persian paintings held in London at Burlington House in 1931, their work is a remarkable scholarly achievement that carefully documents the history of Persian and Indian painting, providing detailed comments about artists, patrons, and objects.[8] The chronology these authors established and the questions they raised

about artists, manuscripts, and schools of painting remain central to any discussion of the Islamic manuscript tradition. Indeed, it can be argued that B. W. Robinson's important catalogues and Ivan Stchoukine's admirable series on paintings in Turkish, Indian, and Persian manuscripts are only attempts to refine and elaborate on the basic history articulated by Binyon, Wilkinson, and Gray.[9]

Such empirical studies based on comparative principles of connoisseurship are primarily exercises in classification. Since relatively few works are signed or dated, much of the classification depends on attributions made by collectors, dealers, and scholars, derived from formal rather than historical or cultural considerations. The perceptiveness of the connoisseur thus becomes central to the identification and understanding of the images, creating a self-affirming relationship between the genius of the artist, patron, and connoisseur. By such a process a general framework is constructed in which individual objects are compared to others of similar date, quality, and provenance, permitting distinctions between metropolitan and provincial work and among individual patrons and artists. When a painting or manuscript does not appear to share the characteristics associated with a known period, region, artist, or patron, it is relegated to a group of objects whose specific features have yet to be well defined, or an entirely new category is invented for it. This is the case with a large number of paintings often attributed to fifteenth-century Sultanate India (see color pls. 15, 16). Irma Fraad and Richard Ettinghausen, for instance, noted that

> among the more provincial Iranian manuscripts were a few which fitted uneasily into any category. They furthermore seemed to combine elements of various schools in their paintings. Since all possible localities had been spoken for, they were by default labelled "Indian." . . . Now a sufficient number of additional dated and undated manuscripts and detached leaves of manuscripts have been collected by us which should be added to this so-called Indian group.[10]

Some illustrations attributed to India are relatively crude, with strong, almost garish colors and simple compositions recalling fourteenth-century Persian paintings; others are far more finished and complex, with elaborate details and inventive compositions. While several appear to have details not found in Persian paintings, many are equally distinct from the few securely dated and localized surviving Indian manuscripts, such as the *Bustan* (Orchard) of Sa'di copied for the Sultanate ruler Nasiruddin Khalji or the *Iskandarnama* (Account of Alexander) of the poet Nizami copied for the early sixteenth-century ruler of Bengal, Nusratshah.[11] Many attributions to Sultanate India consequently depend on negative deductions based on the fact that an image does not look like a typical Persian painting. The results of such reasoning are often misleading and confusing. For example, the attribution of the paintings from a copy of the *Shahnama* of Firdawsi to Delhi or Malwa during the first half of the fourteenth century presupposes that Muslim patrons desired a copy of the manuscript and artists were capable of producing it in those areas.[12] There is, however, no historical evidence that the early fourteenth-century sultans of Delhi or Malwa were interested in illustrated manuscripts of this type. In fact, no surviving illustrated Islamic manuscripts are known to have been produced in Delhi either in the fourteenth or fifteenth century, and the earliest Islamic manuscripts attributable to Malwa or its vicinity are from the second quarter of the fifteenth century.

Despite the problems associated with identifying Sultanate paintings, the taxonomic questions raised by the methodology of connoisseurship are clearly relevant to a formal classification of Persian and Indian paintings. Central to this analysis is the assumption that the same concepts of creativity apply to Islamic paintings as to European images made during and after the Renaissance. The origin of this assumption can be traced to the early twentieth-century collectors and dealers of Islamic art who sought to apply to Islamic art the principles of connoisseurship as defined by the art historian Bernard Berenson. The significance of such reasoning lies in the supposition that Islamic paintings reflect the unique vision of individual artists in a manner analogous to the way European works of art are believed to embody the vision of European artists. Creativity thus becomes a function of inventiveness, and both are seen to be essential to any understanding of artistic genius. The sixteenth century in India, for example, was seen as

> an age of individualism. Humanism had triumphed, even in India. After millennia of anonymity, Indian artists emerged as distinct entities. We know dozens of Mughal Old Masters by name and style, and we can speak of them as we do of Rembrandt and Dürer. [13]

Although conclusions formed by this kind of approach to Persian and Indian painting can be fascinating, they may not be particularly useful. The ability to distinguish between the work of two sixteenth-century Safavid artists may be a tour de force of connoisseurship but reveals little about the artistic and intellectual ideas that shaped the creation of images, the form and content of which were governed by strict codes and conventions. Moreover, the aesthetic range of most of the works is so limited that it is questionable whether certain distinctions, even when they can be made, are meaningful. At issue is the legitimacy of imposing European-oriented standards and art-historical techniques on the study and understanding of a non-European artistic tradition. This is not to disparage the role of the individual artist in the creation of Islamic painting but to suggest that both the process and results differ from those of European artists.

———

If traditional post-Renaissance models of painting and creativity, with their tendency to stress the synchronic significance of a work of art, are inappropriate for the study of Persian and Indian paintings, what approaches are? How were Persian and Indian paintings used? Did artistic conventions control subject matter, composition, and form, and if so, how did they affect the relationship of the images to the text and illuminations that often surrounded them? It is one of the peculiarities of the culture that produced these works that it tended to write very little about them. Any answers to such questions must consequently be found in the images themselves and the way in which they relate to each other and to external referents, such as texts. It is thus essential to see Persian and Indian painting as an integral part of the Islamic book. [14] As such they are usually small and intended for a limited audience and illustrate themes from the great Persianate literary tradition that dominated the eastern Islamic world after the eleventh century. Their principal format as images bound into manuscripts or albums imposes on them several conditions. They need, for instance, to be perceived sequentially and in relationship to each other as well as in relationship to the calligraphy, illuminations, marginal decoration, and binding of the book or

album in which they are contained. More important, these paintings, whether illustrating a poem or history or executed independently of a textual reference, constitute an art of performance in which the artist is primarily engaged in the interpretation of a set series of forms. The flowing lines and intricate compositions rely on the relationships between anticipation and response and repetition and refinement for their success.[15] Novelty and variation in this context are achieved through the manipulation of an established canon of imagery.[16] The creation of new types rarely occurs. The stability of traditional imagery is reflected in the absence between the fourteenth and nineteenth centuries of significant technical changes in the pigments or paper used.[17]

At their most basic, Persian and Indian paintings illustrate episodes from the standard works of Persian literature such as the *Shahnama* of Firdawsi or *Bustan* of Sa'di. The illustrations are narrative in the strictest sense. At their most complex, however, Persian and Indian paintings become autonomous expressions imbued with many levels of meaning. The images cease to be part of a literal narration and instead explore a poetic consciousness bound neither by time nor space.[18] Through the creation of brilliant, artificial settings and highly formalized compositions, they depict events that are removed from identifiable, historical time and are set instead into an unreal poetic time.[19] Pictorial reality is structured as a stage setting for the examination of the abstract and idealized. Actions invariably are presented as archetypes, while images include a limited number of stock figures and settings: rulers, attendants, musicians, and warriors; palaces, gardens, and battle scenes, for example. The extraordinary visual excitement found in these works is the result of the subtle interplay of rhythm (the measured recurrence of compositional elements, particularly color and detail) and pattern (realized through syncopation, accentuation, and opposition).

Three broad types of Persian painting and illumination can be tentatively identified: illustrative, pictorial, and decorative. Each treats the relationship of an image to its referent in a different way: the illustrative concretely, the pictorial generally, and the decorative abstractly. Although none was formally codified until the fifteenth century, each was employed as early as the mid-fourteenth century. Each type consists of a series of conventions affecting the subject of an image (a historical text or portrait, for instance) as well as its physical form (as an album or manuscript painting). While the structure of a painting type may not vary, its subjects are more flexible, adapting to changes in taste, patronage, and locale. The conventions that shape the formal expressions of the subjects are also relatively flexible: various effects can be created by using an image or series of images normally found in one context in a completely different context. When such transference occurs it is almost always the result of a decision to alter the relationship between the form and content of an image. For example, several spectacular drawings of mythical beasts and fantastic landscapes have been included among the narrative paintings in the *Habib al-siyar* of 1579–80 (see color pl. 39), a historical account of Iran written by the sixteenth-century author Ghiyathuddin Khwandamir. Its images provide a rich and surprising counterpoint to the historical paintings and suggest that distinctions between the real and imagined worlds are not always obvious.

Illustrative images interpret stories in a narrative context. The shape and size of a manuscript as well as the number of illustrations it contains and relationship of the images to the text usually vary according to the subject.[20] Historical manuscripts, such as the *Habib al-siyar* or *Baburnama*, the memoirs of Zahiruddin Babur, the founder of the Mughal dynasty, generally have large

Fig. 18. *A Man by the Edge of a Stream* from an *Aja'ib al-makhluqat wa-ghara'ib al-mawjudat* of al-Qazwini, Iran (Qazwin), ca. 1590–1600. Opaque watercolor, ink, and gold on paper. Arthur M. Sackler Gallery, s86.0178.

formats, many illustrations, and single unbroken lines of text written in prose (see color pls. 49, 50). The paintings in historical manuscripts often number in the hundreds and invariably are horizontal, relatively straightforward, and descriptive. The actions depicted are closely related to those described in the text. Hagiographical manuscripts and texts of popular piety, such as the *Falnama* ascribed to Shia Imam Ja'far al-Sadiq (see color pls. 29–33), also have many large, descriptive paintings and usually one column of text. Cosmological and scientific manuscripts, like the *Aja'ib al-makhluqat* (Wonders of Creation) of the thirteenth-century historian al-Qazwini (see fig. 18) or the *Materia medica* by the first-century B.C. Greek physician Dioscorides (see color pls. 4, 5), have many illustrations too, sometimes with several paintings to a page, but are generally limited to one or two figures schematically rendered. Poetic manuscripts, such as the *Mathnawi* of the great thirteenth-century mystic Jalaluddin Rumi, an encyclopedic work of Sufi philosophy and ethics (see color pl. 47), or *Khamsa* (Quintet) of Khwaju Kirmani (see color pl. 40), are smaller, with fewer illustrations and multiple columns of text written in rhyming couplets. The paintings in poetic manuscripts, which may fill an entire page, are usually vertical. Although they are obviously related to the texts they accompany, they frequently include a wealth of descriptive details and activities not found in the actual story. By changing the expected relationship of figures

to one another, emphasizing various gestures, and introducing minute details that often echo the central themes of an image, artists gave these works a lyricism and set of meanings that extend beyond the content of the stories they depict. Epics like the *Shahnama* of Firdawsi combine elements of historical and poetic manuscripts. Their format is generally large, with multiple columns of text and many illustrations. Their compositions, which tend to be dramatic are often, however, as richly layered with meaning as are images from poetic manuscripts. *Rustam Shoots Isfandiyar in the Eyes* from a fourteenth-century Ilkhanid *Shahnama* (fig. 19), for instance, depicts Rustam's slaying of his friend and rival. Although a relatively simple scene, a number of secondary motifs, such as the dead tree stump with its twisted branches in the foreground, are used to create a series of metaphors that amplify the meaning of the painting. In this example the dying Isfandiyar and decaying nature are related. The bent branch echoes the slumping body of Isfandiyar so that they become "paired forms like rhyme in poetry, calling upon the spectator to link two ideas, to show that the two ideas are related—death in man and death in nature."[21]

Pictorial imagery is concerned with individual paintings and drawings as they are found in albums, on walls, and as independent studies. Although at times taken from or related to the themes of Persian literature, they tend to generalize the relationship of the subject to its referent. Among the many kinds of pictorial images are portraits (see color pls. 68, 69), landscapes,

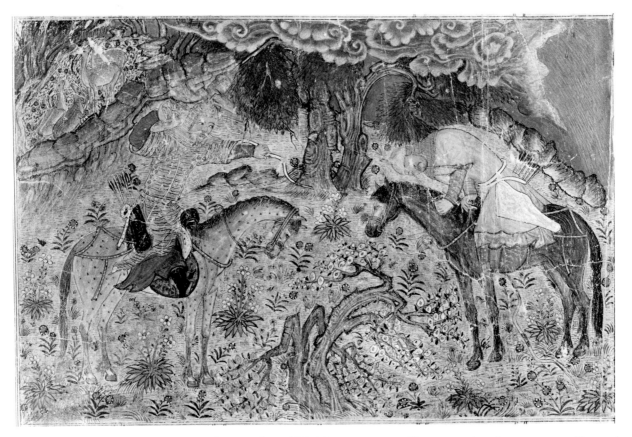

Fig. 19. *Rustam Shoots Isfandiyar in the Eyes,* Iran (Tabriz), ca. 1330–40. Opaque watercolor on paper. Harvard University Art Museums, Cambridge, Massachusetts; Gift of Edward W. Forbes, 1958.288.

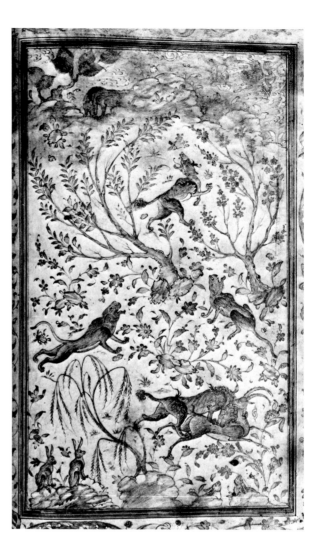

Fig. 20. Folio 203b from a *Habib al-siyar (Volume 3)* of
Khwandamir, Iran (Qazwin), ca. 1590–1600. Opaque
watercolor, ink, and gold on paper. Arthur M. Sackler
Gallery, s86.0027.

fantasies (see fig. 20), and adaptations after foreign sources, usually Chinese. The conventions
defining individual works are distinct from those of manuscript illustration. There is a greater
emphasis, for instance, on expression, three-dimensionality, and artistic individuality. The bal-
ance, restraint, and control characterizing manuscript illustrations at times give way to illusionism
in pictorial painting. The images are relatively free from the restrictions of having to be seen in
relationship to a specific referent, thereby allowing greater innovation in form and content. Where
variations of artistic individuality are suppressed in illustrative images, they become more evident
and consequential in pictorial images. The rounded body, well-modeled features, and carefully
studied expression exhibited in *A Bearded Man Leans on a Stick* of circa 1630–40 (color pl. 71) or
A Seated Youth of circa 1540 (color pl. 64), for instance, are clearly distinct from the flatter, more
conventionalized figures encountered in manuscripts like the *Falnama* ascribed to Ja'far al-Sadiq
or *Khamsa* of Nizami. In both instances, however, creativity was tempered by the limits imposed
on the artist by the conventions and subject of the painting type in which he worked.

Decorative imagery was used to embellish manuscript pages, bookbindings, and other two-
dimensional surfaces such as wood and stone. Unlike illustrative or pictorial paintings, decorative

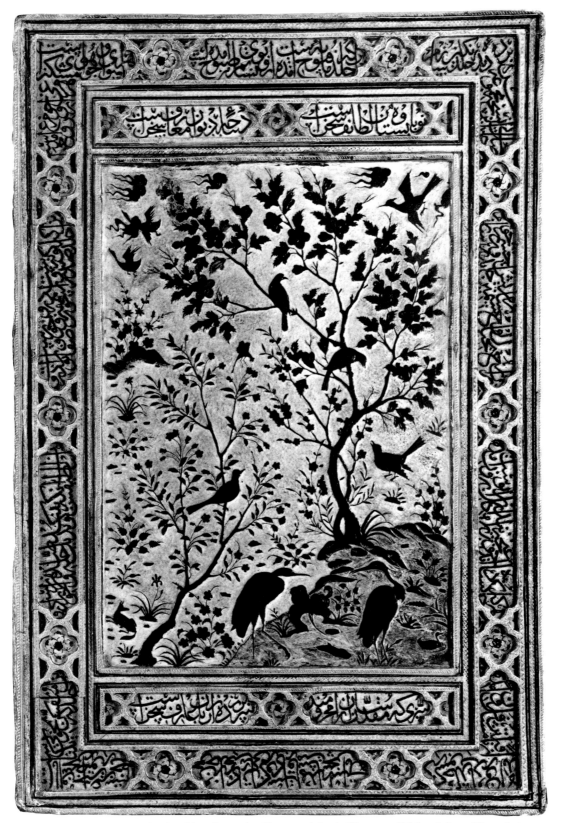

Fig. 21. Lower cover to the bookbinding of a *Khamsa* of Amir Khusraw Dihlawi, Iran (Qazwin), ca. 1575–1600. Leather over paper pasteboards with gold block-stamping. Arthur M. Sackler Gallery, s86.0472. (Reproduced in color, p. 215.)

images are completely removed from their external referents. They encompass nonfigural (see color pl. 76) as well as figural imagery (see fig. 21) and include geometric and vegetal designs, animal combats, mythical creatures, and stylized landscapes (see fig. 22). Furthermore, decorative images were not limited to painting; they were often executed in other media, such as carving, inlaying, and stamping. Heavily influenced by Chinese motifs and patterns, the elements of decorative imagery are often illusionistic and at times naturalistic. Through a process of reduction and repetition, an almost endless array of material was incorporated into their vocabulary. Once filtered and codified, the patterns became part of a standard design repertoire that, when charged with color, could be electrifyingly intense. The highly controlled, intricate floral and vegetal arabesques used to illuminate manuscript pages (see color pls. 1–3, 37, 44) and the complex landscapes and medallions applied as ornamentation on bookbindings (see color pl. 74) are the most obvious manifestations of the decorative type.

An understanding of these ahistorical types of visual conceptualization is as important to a full appreciation of Persian and Indian painting as an awareness of historical progressions and stylistic distinctions. Unless their structure and nature, conventions that shaped them, and social and cultural roles are taken into account, one cannot begin to interpret properly the significance of historical developments.

The mechanism that made the stratification of visual imagery possible seems to have been the *kitabkhana*, an institution that can be loosely defined as a library but could also serve as a workshop. The *kitabkhana* was responsible for a variety of functions including the collection, maintenance, and production of manuscripts and paintings. Supervised by a librarian, the staff of the *kitabkhana* often comprised calligraphers to copy texts, illuminators and gilders to illuminate pages, painters to illustrate stories, and binders to gather the folios of a manuscript and set them into protective covers. Operating as an atelier, the *kitabkhana* provided an environment in which the formal and conceptual categories of Persian and Indian painting could be developed and articulated.[22] Evidence suggests that the setting of the *kitabkhana* was relatively flexible: some were highly centralized, with a large permanent staff, while others consisted of groups of artists working in different locales for special projects. Using drawings, sketches, and pounces, artists made designs and compositions that were systematically reproduced and disseminated, guaranteeing a uniformity of appearance and approach. Yet the system was not totally rigid and the iconography of an image—as well as the visual program of a manuscript—remained adaptable to the needs and desires of the patron and artist.

Although few fourteenth- to seventeenth-century sources discuss in detail the manufacture of Persian and Indian painting, several later fifteenth- and sixteenth-century accounts provide valuable insights into the workings of the tradition of the *kitabkhana*. The sources substantiate in part the theoretical model suggested by the preceding discussion. A report prepared around 1430 by the head of the *kitabkhana* of Baysunghur, for instance, clearly confirms the *kitabkhana*'s central role in the production of images and designs for manuscripts and various other media.[23] Among the objects produced by the *kitabkhana* and itemized in this document are bookbindings, boxes, door panels, tents, and saddles. Several Safavid treatises on calligraphy and painting, most notably those by the late sixteenth-century artists Sadiqi Beg and Qadi Ahmad, indicate that visual material was divided into a series of categories.[24] Among the best defined are decorative and figural painting for which various genres are identified. For decorative art seven basic patterns

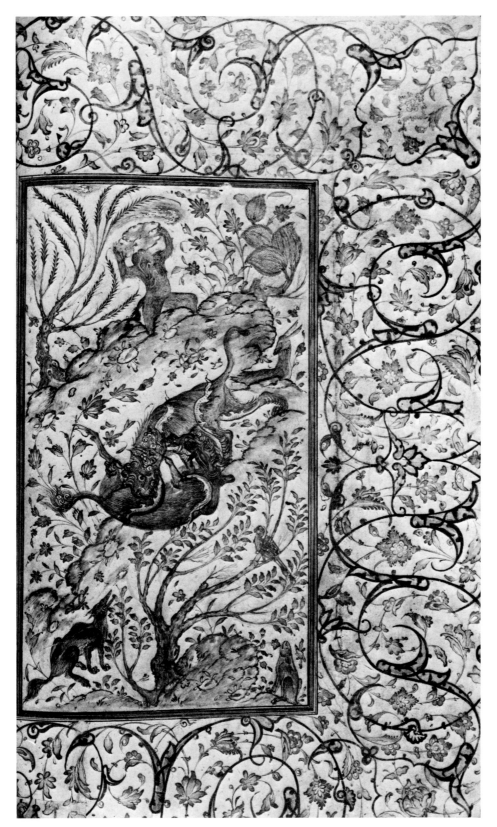

Fig. 22. Folio 35b of a *Habib al-siyar (Volume 3)* of Khwandamir, Iran (Qazwin), ca. 1590–1600. Opaque watercolor, ink, and gold on paper. Arthur M. Sackler Gallery, s86.0057.

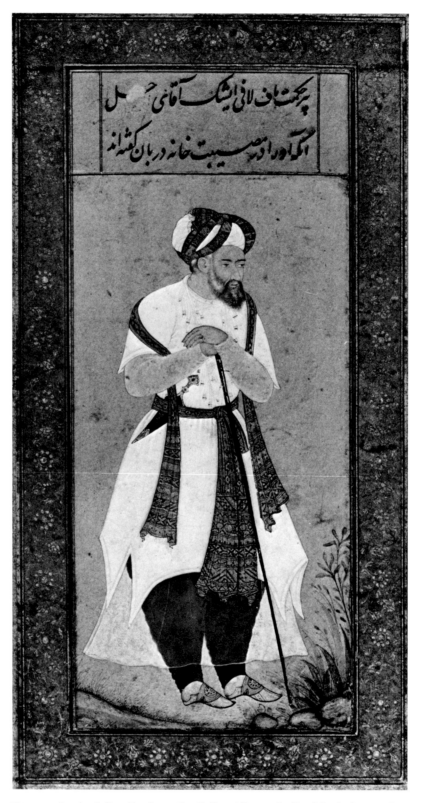

Fig. 23. *An Aged Courtier* from the Salim Album, India; Mughal, ca. 1603. Opaque watercolor, ink, and gold on paper. Arthur M. Sackler Gallery, s86.0422.

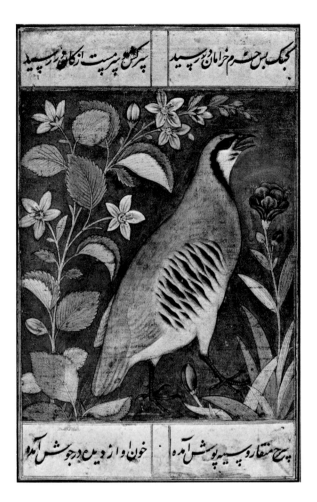

Fig. 24. *A Chukar Partridge*, India, mid-sixteenth century. Opaque watercolor and ink on cloth. Arthur M. Sackler Gallery, s86.0413.

or motifs are mentioned, including *islimi* (ivy and spiral pattern), *khata'i* (Chinese floral pattern), *vaq* (tree with human head), and *band-i rumi* (Anatolian knot pattern).[25]

Two aspects of painting in Iran are worth noting in light of the preceding comments: the conservatism of the tradition and the generic treatment of images. Through the processes of literal reproduction and selective adaptation—the principal methods used in the teaching of painting throughout the Muslim world—the forms and techniques of the past continued to be employed and adhered to generation after generation.[26] This is not to say that Persian painting was incapable of radical shifts in form, but that it did so rarely. The great experiments with Chinese and European forms and techniques at the beginning of the fourteenth century under the Ilkhanids, for instance, took almost one hundred years to become fully assimilated into the mainstream of Persian painting. Moreover, it can be argued that after the creation of the striking paintings of the great Ilkhanid *Shahnama* sometime during the 1330s, all subsequent painting in Iran simply became an internal dialogue based on the forms and conventions first articulated in that manuscript. Although shifts in taste and emphasis occurred especially after the fifteenth century, they never altered the basic structure or focus of illustrative or pictorial painting types.

Formal modifications are most notable in sixteenth- and seventeenth-century Indian painting under the Mughals. By using a number of techniques such as shading and modeling, Mughal

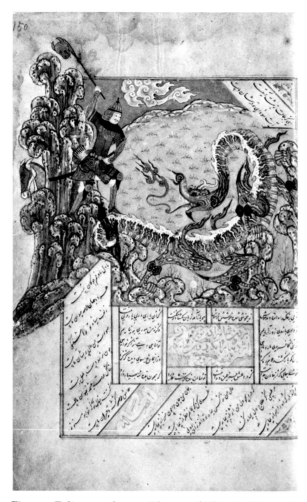

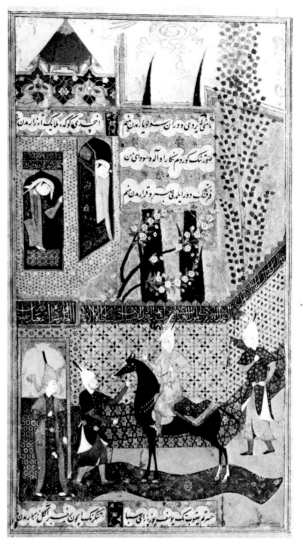

Fig. 25. Folio 150a from a *Khamsa* of Khwaju Kirmani, Iran (Shiraz), 1437. Opaque watercolor, ink, and gold on paper. Arthur M. Sackler Gallery, s86.0034.

Fig. 26. Folio 23b from a *Diwan* of Shah Isma 'il, Iran (Tabriz), ca. 1520. Opaque watercolor, ink, and gold on paper. Arthur M. Sackler Gallery, s86.0060.

artists transformed the generic vocabulary of Persian painting into a means of describing specific features of the observable world (see color pls. 49, 50, 72). Individual details are often rendered with a striking exactness that can easily be interpreted as naturalism. Faces in particular come alive to reveal remarkable characterizations. The portrait of a standing courtier (fig. 23), for instance, with his stern gaze, sharp jaw, and muscular limbs, is a subtle but dramatic study in restrained power. The portraits are, however, rarely drawn completely from life. Instead they are usually derived from stock types, the generalized qualities of which have been altered by the techniques of naturalism to create an impression of direct observation. *A Chukar Partridge* (fig. 24), for example, despite its carefully rendered features and engaging expression, was almost certainly derived from another painting of the same subject rather than from life. While the interest in naturalism led to a much greater emphasis on the exploration of shapes and textures,

feelings and character, the codes and conventions governing manuscript illustration and individual paintings did not change.

The use of similar if not identical compositions to illustrate completely different scenes is one of the most striking characteristics of Persian painting. Images that appear in the context of one manuscript are not only repeated within that manuscript but are often employed in others that have nothing to do with the original text. *Nawroz Fights the Dragon* from a *Khamsa* of Khwaju Kirmani (fig. 25), for instance, is virtually identical to *Bahram Gur Kills a Dragon* from a copy made in 1435–36 of a *Khamsa* of Nizami.[27] Similarly, the prince before a palace from a *Diwan* of Shah Isma'il, or Khata'i (fig. 26), is clearly modeled on such fifteenth-century paintings as *Khusraw before Shirin's Palace* from a *Khamsa* of Nizami dated 1445–46, which in turn may be derived from the fourteenth-century *Humay before Humayun's Palace*.[28] Illustrations do not consequently "belong" to given texts but are part of a collective series of forms accessible to artists.[29] In individual paintings executed in the pictorial manner figures and compositions frequently are also treated generically (a prince reclining, a mounted rider hunting, a woman with a fan). By adding details or emphasizing certain actions, an artist can make these images more or less lively, but they are always conceived of in the abstract.

This generic use of images is directly paralleled in the typological treatment of experience characteristic of Persian literature.[30] This process is most easily evidenced in Persian poetry, where figures are constantly idealized and transformed into stock characters so that they become indistinguishable from one author to the next. The similarity between painting and literature in this regard is not accidental, for illustrative painting is dependent on texts, and pictorial painting often derives its inspiration and subjects from them. Furthermore, the internal mechanisms that shape the appearance of paintings, such as rhythm and pattern, are essentially the same as those that govern literature and especially poetry. Indeed, it is impossible to understand the idealized elements of Persian painting without appreciating the conventions and texture of Persian poetry. By examining the interaction between these means of expression, Persian and Indian paintings gain their broadest meaning and allow one to penetrate beyond the sheer brilliance and complexity of their formal qualities. The process depends on the viewer's ability to decode the images through an intimate understanding of contemporary social and cultural values. Without such an awareness, only the descriptive or narrative aspects of Persian and Indian painting can be appreciated. Once aware of these nuances, however, the viewer becomes an active participant in the comprehension and interpretation of the works, engaging in an associative and symbolic dialogue with the artist.[31] Seen within this context, artistic originality is a function of interpretation and not invention, as the formal and conceptual possibilities available to artists were shaped by the type of painting in which their images were created.

———

Notes

1. Ehsan Yarshater, "Some Common Characteristics of Persian Poetry and Art," *Studia Islamica* 16 (1962): 63. Within carefully established conventions Mughal painting also employs a limited perspective and use of light and shade.

2. F. R. Martin, *The Miniature Painting and Painters of Persia, India, and Turkey from the Eighth to the Eighteenth Century* (London: Bernard Quaritch, 1912), vol. 1, p. 101.

3. Henri Corbin et al., *Les arts de l'Iran, l'ancienne Perse et Bagdad* (Paris: Bibliothèque Nationale, 1938), p. 107.

4. Armenag Bey Sakisian, *La miniature persane du XIXe siècle* (Paris and Brussels: van Oest, 1929), p. 11.

5. Stuart Cary Welch, *The Art of Mughal India: Painting and Precious Objects* (New York: Asia House, 1963), p. 11.

6. The 1396 *Diwan* is in the British Library, London (Add. 18 113); the 1429–30 *Shahnama* was formerly in the Gulistan Palace, Tehran (see Thomas W. Lentz, "Painting at Herat under Baysunghur ibn. Shahrukh" [Ph.D. diss., Harvard University, 1985], pp. 385–421); the 1488 *Bustan* is in the National Library, Cairo (Adab Farsi 908); the circa 1530 *Shahnama*, formerly in the collection of Arthur M. Houghton, is now partially dispersed. For a detailed study and facsimile reproduction of the paintings in this manuscript, see Martin Bernard Dickson and Stuart Cary Welch, *The Houghton "Shah Nameh,"* 2 vols. (Cambridge, Mass.: Fogg Art Museum, 1981).

7. For a detailed discussion of the problems posed by this approach, see Oleg Grabar, "On the Universality of the History of Art," *Art Journal* 42 (Winter 1982): 281–83.

8. Laurence Binyon, J. V. S. Wilkinson, and Basil Gray, *Persian Miniature Painting: A Descriptive Catalogue of the Miniatures Exhibited at Burlington House, January–March 1931* (Oxford: Oxford University Press, 1933).

9. Ivan Stchoukine, *La peinture indienne à l'époque des grands Moghols* (Paris: Leroux, 1929); idem, *La peinture iranienne sous les derniers Abbasides et les Il-Khans* (Bruges: Sainte Catherine, 1936); idem, *Les peintures des manuscrits de Safavis de 1502 à 1587* (Paris: Guethner, 1959); idem, *Les peintures des manuscrits de Shah Abbas Ier à la fin des Safavis* (Paris: Guethner, 1964); idem, *La peinture turque d'après les manuscrits illustrés,* 2 vols. (Paris: Guethner, 1966, 1971).
 B. W. Robinson, *A Descriptive Catalogue of the Persian Paintings in the Bodleian Library* (Oxford: Oxford University Press, 1958); idem, *Persian Paintings in the India Office Library: A Descriptive Catalogue* (London: Sotheby Parke Bernet, 1976); idem, *Persian Paintings in the John Rylands Library: A Descriptive Catalogue* (London: Sotheby Parke Bernet, 1980).
 Even more-recent attempts to study individual manuscripts, such as Dickson and Welch, *Houghton "Shah Nameh,"* have focused almost solely on formal questions first addressed in the early twentieth century.

10. Irma L. Fraad and Richard Ettinghausen, "Sultanate Painting in Persian Style," in *Chhavi: Golden Jubilee Volume of the Bharat Kala Bhavan,* ed. Anand Krishna (Varanasi: Bharat Kala Bhavan, 1971), p. 48. The authors were among the first to attempt a systematic survey of this material. Of the twenty-one manuscripts discussed, only eight are dated and none have colophons indicating where they were copied.

11. The *Bustan* is in the National Museum, New Delhi (48.6/4), and is discussed in Jeremiah P. Losty, *The Art of the Book in India* (London: British Library, 1982), pp. 67–68. The *Iskandarnama* is mentioned in *Persian and Mughal Art* (London: Colnaghi, 1976), pp. 133–53.

12. The *Shahnama* is in the Metropolitan Museum of Art, New York, and is known as the Schulz *Shahnama* after the German scholar and connoisseur who once owned it (Stuart Cary Welch, *India: Art and Culture, 1300–1900* [New York: Metropolitan Museum of Art, 1985], pp. 128–29).

13. Welch, *Art of Mughal India,* p. 12.

14. A number of studies have examined Persian and Indian paintings from this perspective. Among the most interesting are Lisa Golombek, "Toward a Classification of Islamic Painting," in *Islamic Art in the Metropolitan Museum of Art,* ed. Richard Ettinghausen (New York: Metropolitan Museum of Art, 1972), pp. 23–24; Marie Lukens Swietochowski, "The Development of Traditions of Book Illustration in Pre-Safavid Iran," *Iranian Studies* 7, no. 4 (1974): 49–71; Richard Ettinghausen, "The Categorization of Persian Painting," in *Studies in Judaism and Islam* (Jerusalem: Magnes, 1981), pp. 55–64; Grabar, "On the Universality of the History of Art"; Lentz, "Painting at Herat."

15. Yarshater, "Some Common Characteristics," pp. 61–71.

16. Golombek, "Toward a Classification," pp. 23–34.

17. Elisabeth West FitzHugh, "Study of Pigments on Selected Paintings from the Vever Collection," and Janet G. Snyder, "Study of the Paper of Selected Paintings from the Vever Collection," appendixes 9 and 10 in Glenn D. Lowry and Milo Cleveland Beach, *An Annotated and Illustrated Checklist of the Vever Collection* (Washington, D.C.: Arthur M. Sackler Gallery in association with University of Washington Press, 1988).

18. Lentz, "Painting at Herat," pp. 271.

19. Ibid., pp. 280–81.

20. Swietochowski, "Development of Traditions," pp. 49–72.

21. Golombek, "Toward a Classification," p. 27.

22. For more information on the methods of the *kitabkhana*, see Nora M. Titley, *Persian Miniature Paintings* (London: British Library, 1983), pp. 216–51; Michael Brand and Glenn D. Lowry, *Akbar's India: Art from the Mughal City of Victory* (New York: Asia Society Galleries, 1985), pp. 57–87; Marianna Shreve Simpson, "The Production and Patronage of the *Haft Awrang* by Jami in the Freer Gallery of Art," *Ars Orientalis* 13 (1982): 93–121.

23. For more information on this document, see Thomas W. Lentz and Glenn D. Lowry, forthcoming exhibition catalogue on Timurid art and culture (Los Angeles County Museum of Art and Arthur M. Sackler Gallery, 1989).

24. For Sadiqi Beg, see Dickson and Welch, *Houghton "Shah Nameh,"* vol. 1, pp. 259–69; for Qadi Ahmad, see Vladmir Minorsky, ed. and trans., "Calligraphers and Painters: A Treatise by Qadi Ahmad, Son of Mir-Munshi (Circa A.H. 1015/A.D. 1606)," *Freer Gallery of Art Occasional Papers* 3, no. 2 (1959): 174–201.

25. Dickson and Welch, *Houghton "Shah Nameh,"* vol. 1, p. 262.

26. Priscilla Soucek, "Comments on Persian Painting," *Iranian Studies* 7, nos. 1–2 (Winter/Spring 1974): 73.

27. *Bahram Gur Kills a Dragon* is in the British Library (Or. 12845, fol. 177a).

28. *Khusraw before Shirin's Palace* is in the Topkapı Sarayı Müzesi Kütüphanesi, Istanbul (H.781, fol. 73b). *Humay before Humayun's Palace* is in the British Library (Add. 18113, fol. 26b).

29. Soucek, "Comments on Persian Painting," pp. 76–77.

30. Yarshater, "Some Common Characteristics," p. 63.

31. Lentz, "Painting at Herat," p. 270.

COLOR PLATES

Entries are grouped by
manuscripts, albums, individual paintings and drawings, and bookbindings.
Strict chronological order is not followed.
Attributions to regional and local traditions are given within parentheses.
Measurements are given for height followed by width;
bookbinding dimensions are for a single cover.

1 *Page from a Koran*

Egypt, fourteenth century
Opaque watercolor, ink, and gold on paper mounted on board
Page: 41.6 x 31.6 cm
Text and illumination: 27.9 x 21.8 cm
s86.0066

The four verses on this finely illuminated page from a Mamluk (1250–1517) copy of the Koran are the opening lines of Sura II, "The Cow." They can be translated as follows:

Alif. Lam. Mim.
This is the Scripture whereof there is no doubt, a guidance unto those who ward off (evil).
Who believe in the Unseen, and establish worship, and spend of that We have bestowed upon them;
And who believe in that which is revealed unto thee (Muhammad) and that which was revealed before thee, and are certain of the Hereafter.

2 *Double-Page Illuminated Frontispiece from a Koran*

Iran, ca. 1550
Opaque watercolor, ink, and gold on paper
Page: 42.4 x 26.9 cm
s86.0082, s86.0083

The verses on these finely illuminated pages are from Sura 1, "The Opening" (verses 1–7):

In the name of Allah, the Beneficent, the Merciful.
Praise be to Allah, Lord of the Worlds,
The Beneficent, the Merciful.
Owner of the Day of Judgment,
Thee (alone) we worship; Thee (alone) we ask for help.
Show us the straight path,
The path of those whom Thou hast favoured; Not the (path) of those who earn Thine anger
nor of those who go astray.

Circular illuminated medallion (*dibacha*) from the reverse of the right-hand half of the double-page frontispiece.
Overleaf: the frontispiece.

3 Double-Page Illuminated Frontispiece

Folios 1b-2a from a copy of the *Kawakib al-durriya fi madh khayr al-bariyya*
made for the library of al-Malik al-Ashraf b. Abu'l-Nasr Qaytbay
Egypt, ca. 1470
Opaque watercolor, ink, and gold on paper
Page: 43.2 x 29.8 cm
Text and illumination per page: 28.2 x 19.6 cm
s86.0030

The manuscript, a lengthy encomium in praise of the prophet Muhammad, is popularly known as the *Burda* (Mantle of the Prophet). This copy has a dedicatory inscription to Abu'l-Nasr Qaytbay (r. 1468–96), a Mamluk sultan of Egypt:

> For the noble treasury of the Sultan, may God continue the reign of his kingdom. Our lord and master, the great lord of the kingdom. Sultan of the Arabs and non-Arabs, keeper of the two holy harems, the most noble monarch Abu'l-Nasr Qaytbay. May God preserve his kingdom and his victory and continue his glory.

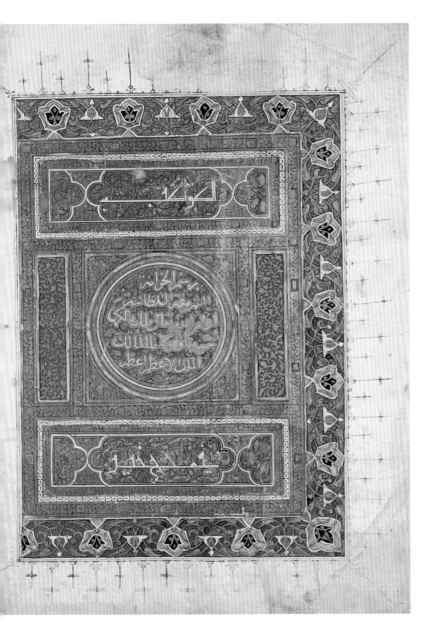

والسلول اذا وقعت في ما والآلا الذي يقطر من ولوب الحقنه اذا عقد فنو نافع لمن بناته

حصايفته يشفا منه شراب وهو يبرى الحنا والجرب اذا طلي به وقل طلابه بعسل

الموضع بنظر وتوصغه اذا خاط بنت كثر الشعر اذا دهن منه ورماد الزرجون

والعصارة اذا خاط خاط فنو نافع للقروح التي تخرج في ايد نو والبواسير الظاهره

الطحال اذا خاط مع الرماد وخل وفنجر ومزورد وتعصبنه ع ع

ذكر اسا ونزاغرا ع

4 *A Physician Treats a Blindfolded Man*

From a copy of the *Materia medica* of Pedanius Dioscorides
Iraq, A.H. Rajab 621 (June–July 1224)
Opaque watercolor, ink, and gold on paper
Page: 33.1 x 24.3 cm
s86.0097

The *Materia medica* is a lengthy study on the history and pharmaceutical uses of various plants. Originally written in Greek by Dioscorides, a physician attached to the Roman army in the first century B.C., the manuscript was translated into Arabic in the ninth century A.D. This page is from a section of the text that describes the preparation of a medication made from a substance combined with water distilled from grape pits. When the mixture is added to wine it alleviates grief and scabies. It can also be used in combination with other substances to increase hair growth and cure arm wounds, visible hemorrhoids, and inflammation of the spleen.

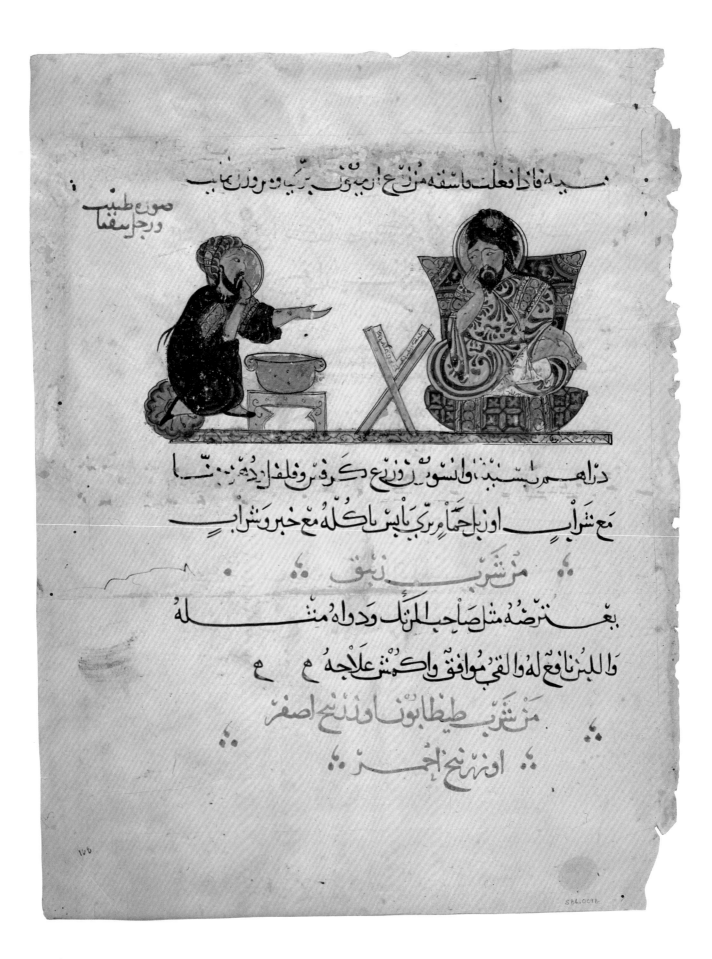

5 *A Physician and an Ill Man*

From a copy of the *Materia medica* of Pedanius Dioscorides
Iraq, A.H. Rajab 621 (June–July 1224)
Opaque watercolor, ink, and gold on paper
Page: 33.1 x 25.1 cm
s86.0098

This page is from one of the appendixes on poisonous medicines that was added to the *Materia medica* after the death of Dioscorides. The text discusses the effects and treatment of vitrified lead poisoning.

6 *Mechanical Device for Pouring a Drink*

From a copy of the *Kitab fi ma'rifat al-hiyal al-handasiyya* of Badi'uzzaman b. al-Razzaz al-Jazari
made for the treasury of Amir Nasruddin Muhammad
Egypt, A.H. Safar 755 (February–March 1354)
Opaque watercolor, ink, and gold on paper
Page: 39.8 x 27.5 cm
s86.0108

The *Kitab fi ma'rifat al-hiyal al-handasiyya* (Book of Knowledge of Ingenious Mechanical Devices), popularly called the *Automata*, is devoted to the explanation and construction of fifty mechanical devices, or automatons. Divided into chapters and sections, each part of the book describes the various functions and components necessary for their construction. This page is from the section of the manuscript that discusses the construction of vessels and figures suitable for drinking sessions. According to the text, the automaton depicted here is to be used for entertainment at formal gatherings. When the man's cap is removed, wine is poured into a reservoir in his head. When the cap is replaced, the automaton is brought before the guests. After several minutes the liquid, flowing through a series of concealed tubes, begins to fill the goblet held in the figure's left hand, entertaining those assembled. The detailed drawings at the bottom of the page describe the construction of various components of the device.

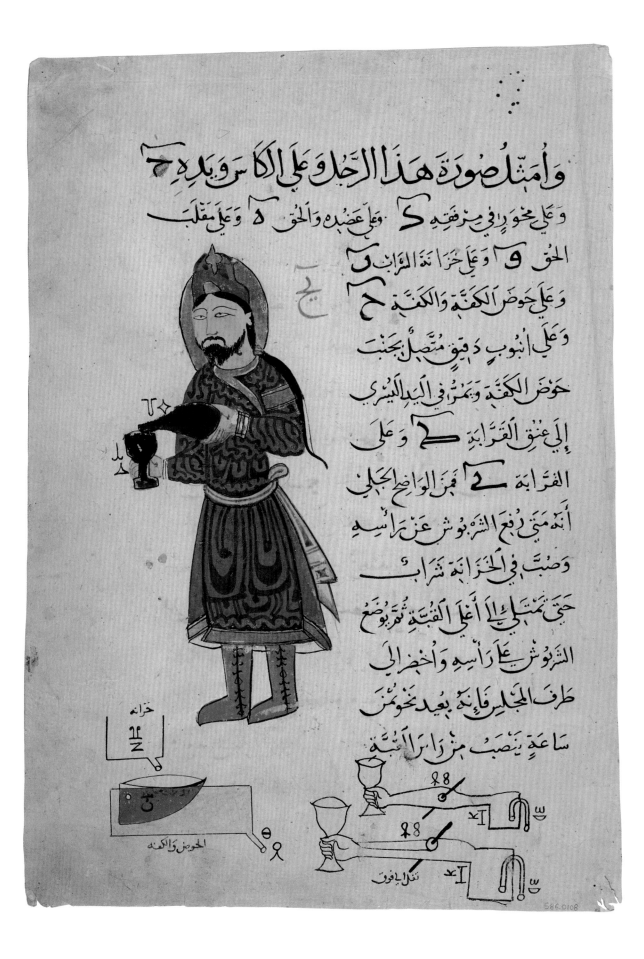

وَأُمَثِّلُ صُورَةَ هَذَا الرَّجُلِ وَعَلَى الكَاسِ وَبِيَدِهِ حـ

وَعَلَى مَحْوَرِ الرَّحَى فِي مِزْرَقَتِهِ كـ وَعَلَى عَضُدِهِ وَالحَقِّ لـ وَعَلَى مَقْلَبِ

الحَقِّ قـ وَعَلَى خَزَانَةِ الشَّرَابِ ك

وَعَلَى حَوْضِ الكَفَّةِ وَالكَفَّةِ حـ

وَعَلَى أُنْبُوبٍ دَقِيقٍ مُتَّصِلٍ بِجَنْبِ

حَوْضِ الكَفَّةِ وَيَمُرُّ فِي اليَدِ اليُسْرَى

إِلَى عُنُقِ القَرَابَةِ كـ وَعَلَى

القَرَابَةِ كـ مِنَ الوَاضِحِ الجَلِيِّ

أَنَّهُ مَتَى رُفِعَ الشَّرْبُوشُ عَنْ رَأْسِهِ

وَصُبَّ فِي الخَزَانَةِ شَرَابٌ

حَتَّى تَمْتَلِئَ إِلَى أَعْلَى القُبَّةِ ثُمَّ يُوضَعُ

الشَّرْبُوشُ عَلَى رَأْسِهِ وَأُحْضِرَ إِلَى

طَرَفِ المَجْلِسِ فَإِنَّهُ بَعِيدٌ بِخَوْفِ مِنْ

سَاعَةٍ يَنْصَبُّ مِنْ زَرَابِ الآنِيَةِ

7 *Faridun Mourns at the Arrival of the Coffin of Iraj*

From a copy of the *Shahnama* of Abu'l-Qasim Firdawsi known as the Demotte *Shahnama*
Iran, ca. 1335–40
Opaque watercolor, ink, and gold on paper
Text and illustration: 40.5 x 28.9 cm
s86.0101

Abu'l-Qasim Firdawsi's *Shahnama* (Book of Kings) is an epic poem of approximately fifty thousand rhyming couplets. Completed in A.D. 1010, the *Shahnama* describes the history of Iran's great rulers, beginning with the first mythical kings of Iran and continuing until the downfall of the Sasanians in the mid-seventh century.

Emphasizing legitimacy and good and evil, illustrated copies of the *Shahnama* became the foremost vehicle for expressing princely dreams and aspirations in the Iranian world. This painting depicts the story of Faridun and Iraj. The youngest son of the Iranian ruler Faridun, Iraj was stabbed to death by his two older brothers. His father, unaware of the murder of his favorite son, was preparing to greet him on his return from a voyage. As Iraj's caravan approached, the king saw a camel bearing his son's head in a golden casket. The distraught Faridun fell from his horse, while his troops began to tear their robes in grief and horror. Closely following Firdawsi's text, the painting focuses on the traumatic nature of the scene. The white faces, disheveled clothes, and bereaved expressions of the figures emphasize the horror of the event.

detail

بەسرخسروتاجدار

أوخواستأبج‌جازڧهاد

ایبایدکتانج‌مزانخای

بەشرمازبیدخودعبراستار

مکرمزمراکەسراجام‌ازر

بیاندازخورمزرزدک

پنجدیوهمودااستانی‌کین

کجان‌داری‌جازنیارکین

میازارمروزی‌کداه‌کتراست

کەجان‌جازداردوجارخورش

مکنخویش‌تراروسمه‌مکان

کەبزینشانوتاوندارمزنیان

بسندەکم‌زینجهان‌کشه

بکوشیفرازنواورم‌توسنه

چوسوری‌لیه‌بکشتهبذر

جهان‌خواستی‌توخورمزریز

مکراباهماندابیدوازسینه

مینجندشیندباجخنداد

همانخشم‌بودوهمان‌زدیار

سلایای‌جادنخورکشید

بلان‌بیرزهراک‌برخرش

هسی‌کجداک‌ازکانی‌بین

بودآمدازبای‌نبدسینه

کست‌ازنیکزندشاه‌منشی

شدازناموزشهرزمانجهان

ستاجوردزان‌زبیل‌واز

بمخنداک‌دودبکشت‌ه‌وار

جهانرابردبیدشرپدکار

وزان‌پیربادی‌جازنیاد

برایشکارت‌بایدکریست

نوبیزرای‌بخربمعرفه‌کشه‌مرد

زبعه‌جهانی‌بارداعوفدورد

وشاهان‌کشی‌یکداجترش

ازینرمسوتاکاره‌انلان‌کن

جنین‌کت‌کت‌سران‌نیار

نوبیزرای‌دودبنیه‌نهادبراه

کنج‌بناکیان‌بنوکشناک

نوخواه‌تلخترهدومغوانقت

شدآرزبادهکن‌نیازحد

فریدوندودنیه‌نهادسوروم

شاهوکلاداوردومندشاه

نمایه‌سنان‌وربدهتالیج‌راودتنو

سمیه‌زرمیبرورهاندرنشاه

کمنکام‌برکشتن‌شاه‌بود

پندراندرخودخوداکاه‌بود

هیچ‌شاهراتاختبزدوردخت

بستندآذرمرهمکونوکرش

بزینون‌اندرونبودشاه‌وشاه

بیشدنرانیاز‌زانسند

میخوی‌زنخودکان‌خوانند

بخوری‌مونزاندامدازبتره‌کرد

نشستەبروسوکوازبزی‌درد

بیکردبەبرامدذدای

بکفناداوخیرومبنداستنا

اکەکفناداوخیرومبنداستنا

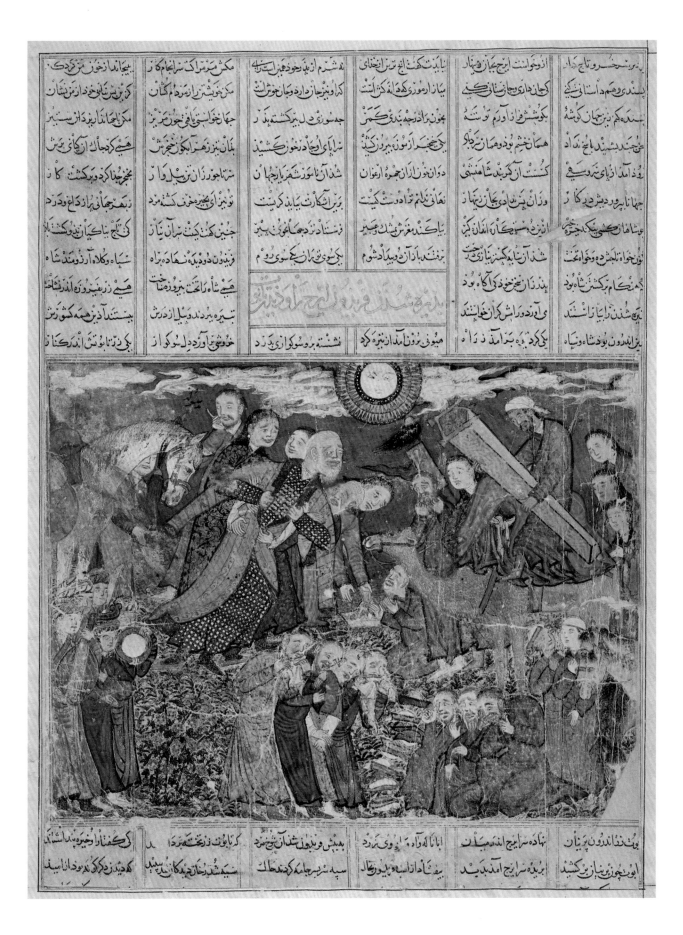

کریایوت‌زنتحەمردا

بمیش‌وربنوی‌شدان‌بخ‌مرد

ابابالەاوادەبه‌اوی‌مردد

نهادەسراییج‌اندهمبلان

بی‌بذذاندرونپریان

کدیدکزرکارکنبودازابیند

سیدشدرنرانج‌جامەواین‌ببند

سه‌شیرسرجامه‌کەنطاک

بیغاذازاسابراندبیدیار

ابونجون‌بنبیازبرکشید

بریدەسراییج‌امدهنراد

8 *Faridun Goes to Iraj's Palace and Mourns*

From a copy of the *Shahnama* of Abu'l-Qasim Firdawsi known as the Demotte *Shahnama*
Iran, ca. 1335–40
Opaque watercolor, ink, and gold on paper
Text and illustration: 40.8 x 29.4 cm
s86.0100

After Iraj's death, Faridun took his son's decapitated head to Iraj's garden. Tearing his hair in anguish, the old king wept by the side of a small pool. Iraj had built a large palace in the garden; Faridun ordered the palace and garden burned to the ground because they reminded him too strongly of his beloved son. Focusing on Faridun as he cradles his son's head, the painting depicts the palace and garden as they are about to be destroyed: servants in the lower right-hand corner of the scene are already cutting down the flowers and trees by the side of the pool.

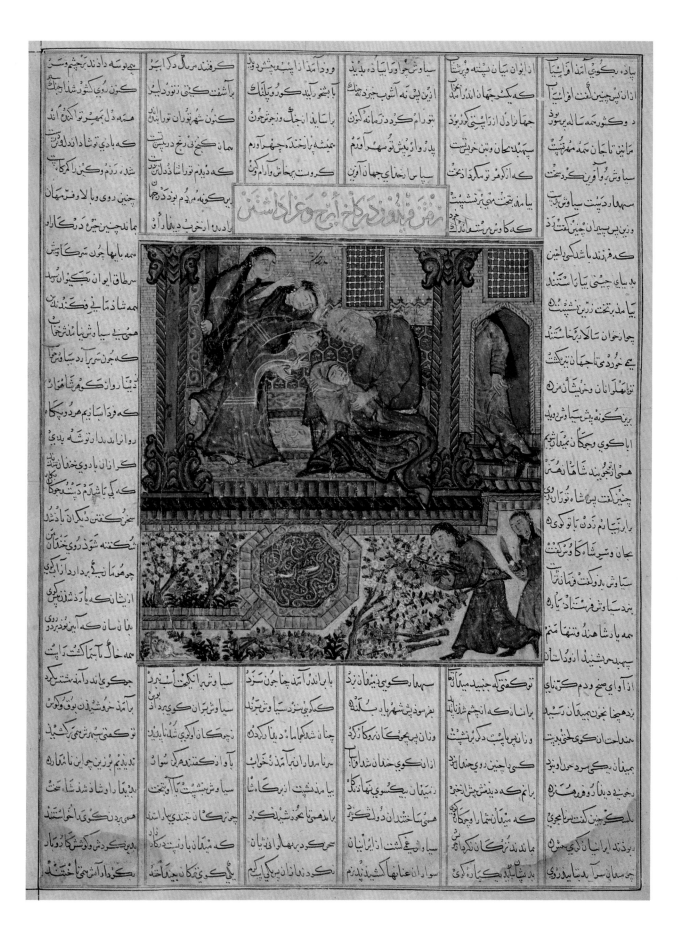

9 *Sindukht Becomes Aware of Rudaba's Actions*

From a copy of the *Shahnama* of Abu'l-Qasim Firdawsi known as the Demotte *Shahnama*
Iran, ca. 1335–40
Opaque watercolor, ink, and gold on paper
Text and illustration: 40.5 x 29.4 cm
s86.0102

Zal fell in love with Rudaba, the daughter of the infidel king of Kabul, whose blood was tainted by descent from the evil Zahhak. After consulting his sages, Zal's father, Sam, granted Zal permission to marry. When Zal learned of his father's approval, he sent a messenger to Rudaba to inform her of the good news. Rudaba bestowed on the messenger a beautiful headdress, new clothes, and a gold ring and sent her back to Zal. Rudaba's mother, Sindukht, however, intercepted the messenger on her way out of the castle and demanded to know what she was doing. The maid began to lie about her activities, but Sindukht searched her and found the gifts that Rudaba had given her. Angered by her daughter's secretiveness, Sindukht threw the maid to the ground and shut herself in the castle to confront Rudaba.

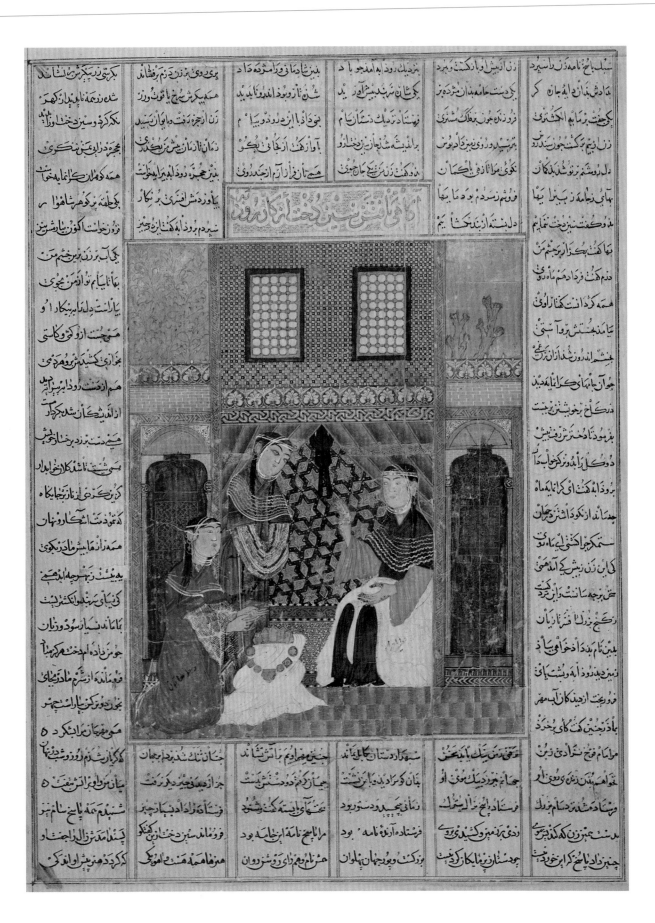

10 *Shah Zav, Son of Tahmasp, Enthroned*

From a copy of the *Shahnama* of Abu'l-Qasim Firdawsi known as the Demotte *Shahnama*
Iran, ca. 1335–40
Opaque watercolor, ink, and gold on paper
Text and illustration: 40.4 x 29.3 cm
s86.0107

Shah Nawdar, who ruled Iran oppressively for many years, was finally taken prisoner and executed by Afrasiyab, the ruler of Turan, a country east of Iran. Shah Nawdar's two sons were not deemed fit to govern, and his throne remained vacant until Zal suggested that Zav, a descendant of the great ruler Faridun, should be crowned. Zav, an old man at the time of his coronation, ruled Iran for only five years before his death. In the painting, which closely follows the text, the enthroned Zav is surrounded by his courtiers, including the albino Zal.

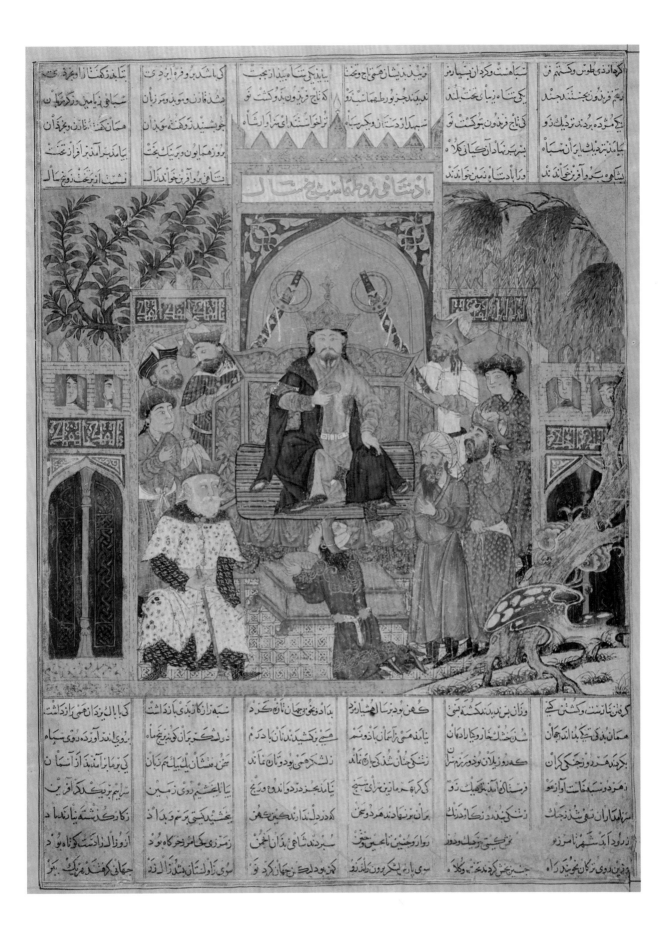

11 *Taynush before Iskandar and the Visit to the Brahmans*

From a copy of the *Shahnama* of Abu'l-Qasim Firdawsi known as the Demotte *Shahnama*
Iran, ca. 1335–40
Opaque watercolor, ink, and gold on paper
Text and illustration: 40.5 x 29.5 cm
s86.0105

This painting consists of two interrelated scenes. On the right is Iskandar—Alexander the Great, who was believed to have had an Iranian mother and was thus considered to be a legitimate ruler of Iran—shown conversing with Taynush, son of Qaydafa, queen of Andalus. In one of his adventures Iskandar killed Taynush's father-in-law and Taynush wished to avenge his death. Qaydafa interceded, imploring Iskandar not to harm her son. Although Iskandar and the queen made a pact, Iskandar lured Taynush into an ambush. Having trapped Taynush, Iskandar forced him to acknowledge his mother's peaceful desires and establish a truce with him. Iskandar then marched to India, the country of the Brahmans, to question them about the meaning of life and death. Iskandar's meeting with the sages, who advised the great warrior that any attempt to conquer the world was doomed to failure, is depicted on the left.

detail

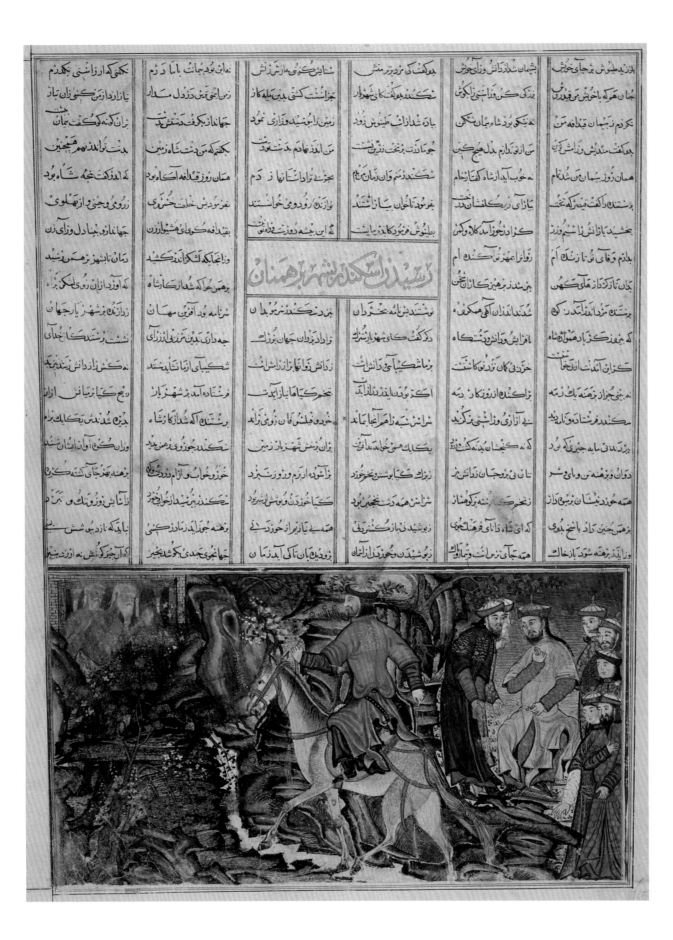

12 *Iskandar Builds the Iron Rampart*

From a copy of the *Shahnama* of Abu'l-Qasim Firdawsi known as the Demotte *Shahnama*
Iran, ca. 1335–40
Opaque watercolor, ink, and gold on paper
Text and illustration: 40.2 x 28.2 cm
s86.0104

After traveling extensively, Iskandar came to the end of the civilized world, beyond which were the lands of the people of Gog and Magog, strange creatures with black tongues and boarlike teeth. The local inhabitants sought Iskandar's protection from these savages, so he constructed two huge walls of iron and copper for their shelter. According to Firdawsi, workers from all over the world were brought together for this project. The different hats and costumes worn by the laborers in the painting reflect their diverse origin, while the shaggy creatures peering out from behind the rocks in the upper left represent the grotesque inhabitants of Gog and Magog.

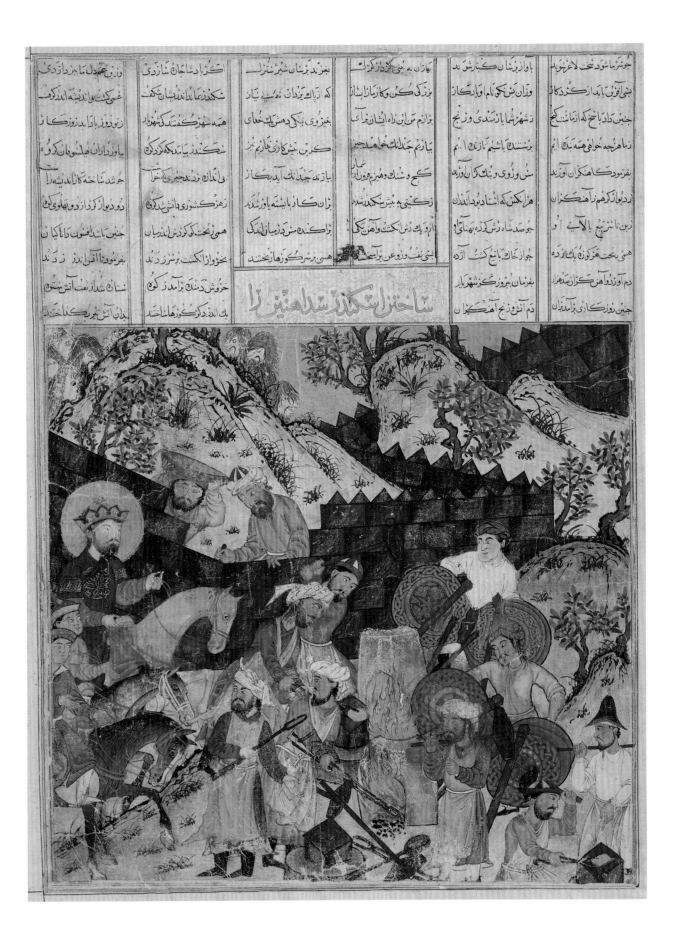

13 Ardawan Captured by Ardashir

From a copy of the *Shahnama* of Abu'l-Qasim Firdawsi known as the Demotte *Shahnama*
Iran, ca. 1335–40
Opaque watercolor, ink, and gold on paper
Text and illustration: 40.5 x 29.2 cm
s86.0103

Ardashir, an attendant at the court of the Iranian ruler Ardawan, engaged the ruler's son Bahman in battle and defeated him. When Ardawan learned of the news, he marched on Ardashir. The two fought for many days until Ardawan was taken prisoner by one of Ardashir's soldiers. The old king, exhausted and wounded, was brought before the youthful Ardashir, who ordered the executioner to cut him in half. The painting depicts the pivotal moment when the captive Ardawan is presented to Ardashir and learns of his impending death.

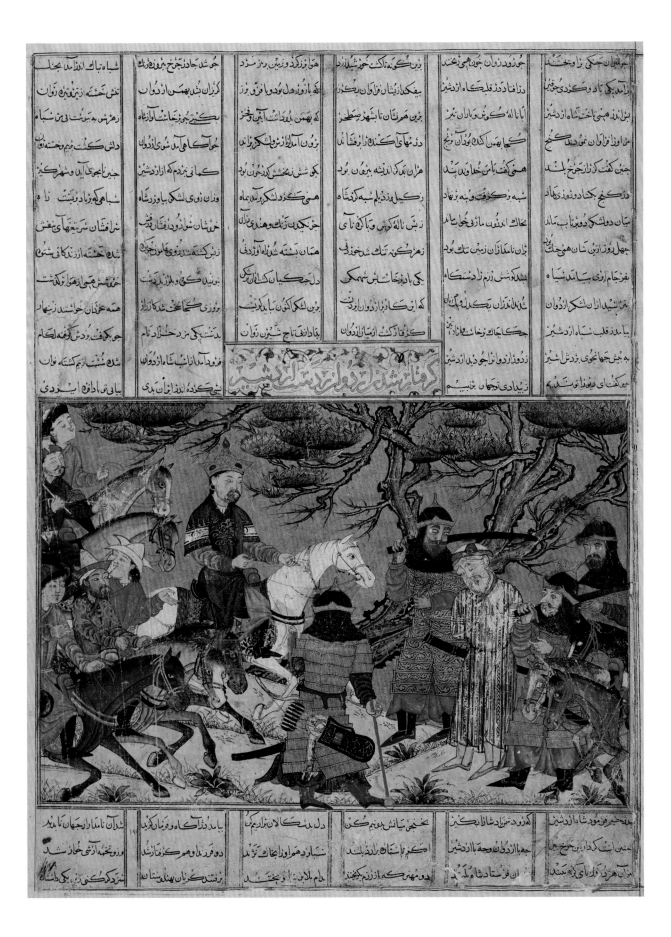

14 *Ardashir with His Wife, Who Throws Down the Cup of Poison*

From a copy of the *Shahnama* of Abu'l-Qasim Firdawsi known as the Demotte *Shahnama*
Iran, ca. 1335–40
Opaque watercolor, ink, and gold on paper
Text and illustration: 40.5 x 29.3 cm
s86.0106

One of Ardashir's first acts after defeating Ardawan was to marry Ardawan's daughter. Bahman, the dead king's son, entreated his sister to poison Ardashir in revenge for their father's brutal murder. One day while Ardashir was hunting, his wife mixed poison with sugar and water. When he returned from the hunt, his wife offered him the deadly potion but trembled so much that he became suspicious. He immediately ordered that four domestic fowls be tested with the mixture, and to everyone's surprise the birds died instantly. Ardashir then ordered his wife to be killed, but the priest entrusted with the task learned that she was pregnant with the ruler's child and secretly hid her. The artist of the painting chose to set this scene in front of an elaborate building; in the foreground are birds nibbling the poison.

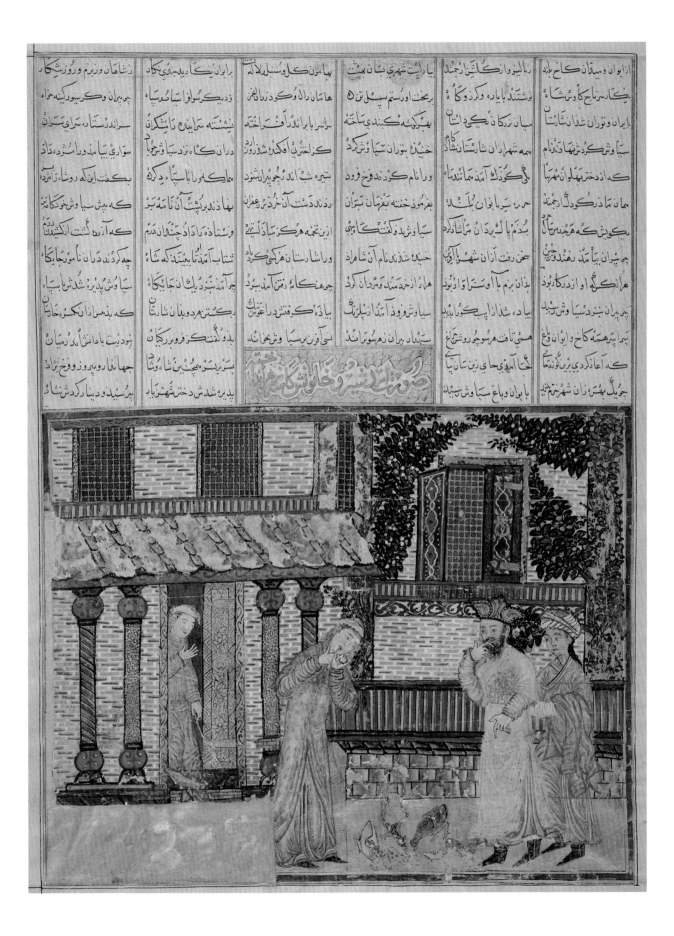

15 Rustam Encamped

From a copy of the *Shahnama* of Abu'l-Qasim Firdawsi
India(?), ca. 1425–50
Opaque watercolor and gold on paper mounted on board
Page and illustration: 18.2 x 18.0 cm
s86.0144

Several episodes in the *Shahnama* describe Rustam (identifiable by his clothes) encamped. The most likely incidents that this painting might depict are Rustam surrounded by his troops preparing to march with Kay Kaus on the king of Mazandaran; Suhrab observing the Iranian encampment; or Rustam encamped with his men on Mount Hamawaran. Since the painting has been removed from its original context, however, it is impossible to be sure which episode is represented here.

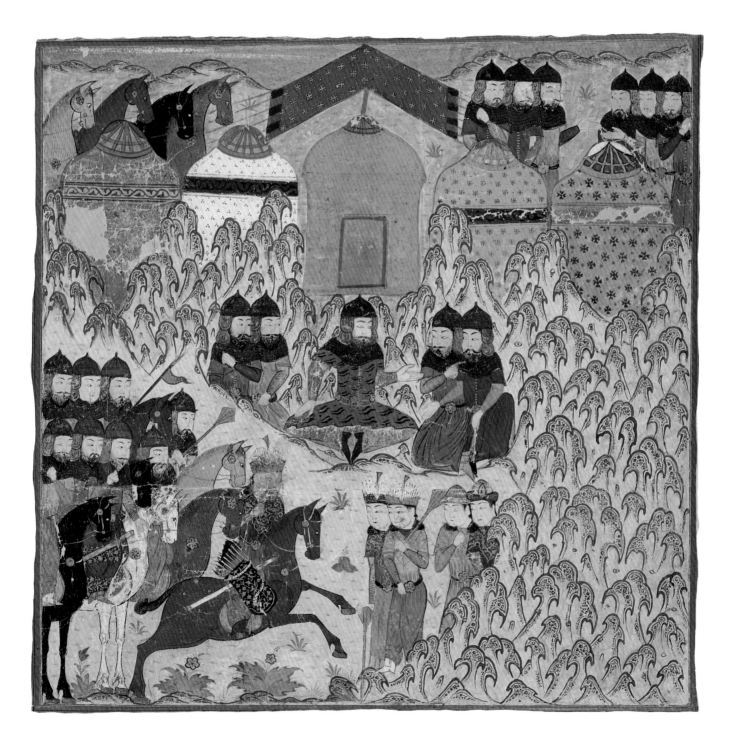

16 *Khusraw Parwez Seated on the Takht-i Taqdis*

From a copy of the *Shahnama* of Abu'l-Qasim Firdawsi
India(?), ca. 1425–50
Opaque watercolor and gold on paper mounted on board
Page and illustration: 15.3 x 17.9 cm
s86.0145

Thrones appear throughout the *Shahnama* to symbolize power and authority and, most important, legitimacy. The usurper Zahhak is credited with commissioning the first jewel-studded throne, the Takht-i Taqdis. When Faridun gave his kingdom to Iraj, he gave him the Takht-i Taqdis as well as his ox-faced mace and other royal trappings. From then on every Iranian king left his legacy on the throne. Kay Khusraw, for example, increased its height; Gushtasp embellished it with painting. Iskandar in his ignorance, however, had the throne broken apart, and it remained forgotten until Khusraw Parwez decided to reconstruct it. He ordered craftsmen from all over the world to work on the throne, which took two years for them to complete. Made of gold studded with turquoise and inset with precious gems, the throne was taller than it was wide. It stood in a garden and was turned in each season to take advantage of the sun's changing position. The throne was flanked by three tiers, each clearly depicted in the painting. The first, or lowest, tier was allocated to the *dihqans* and individuals with complaints, the middle to the viziers, and the highest to men of arms.

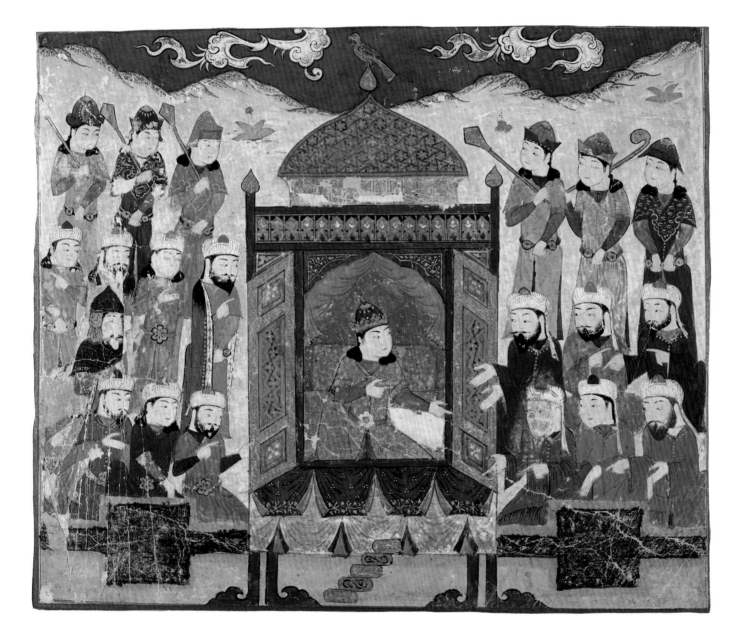

17 *Giv Brings Gurgin before Kay Khusraw*

From a copy of the *Shahnama* of Abu'l-Qasim Firdawsi made for Sultan-Ali Mirza
Iran, Gilan, A.H. 899 (A.D. 1493–94)
Opaque watercolor, ink, and gold on paper
Text and illustration: 23.0 x 14.9 cm
s86.0160

When the people of Armenia requested Kay Khusraw's aid in clearing their land of the wild boars that were ravaging the countryside, the ruler dispatched his warriors Bizhan and Gurgin to help them. Bizhan fell in love with Afrasiyab's daughter Manizha and failed to return to Iran with Gurgin. Bizhan's father, Giv, was unable to obtain an honest answer from Gurgin about what happened to his son. Distraught, Giv went to Kay Khusraw, who immediately perceived his warrior's grief. When Gurgin was brought before Kay Khusraw for questioning, he again refused to comment on Bizhan's whereabouts. With the arrival of the New Year's festival, the ruler looked into his magical truth-telling cup and discovered that Bizhan was alive but had been imprisoned for having fallen in love with Afrasiyab's daughter.

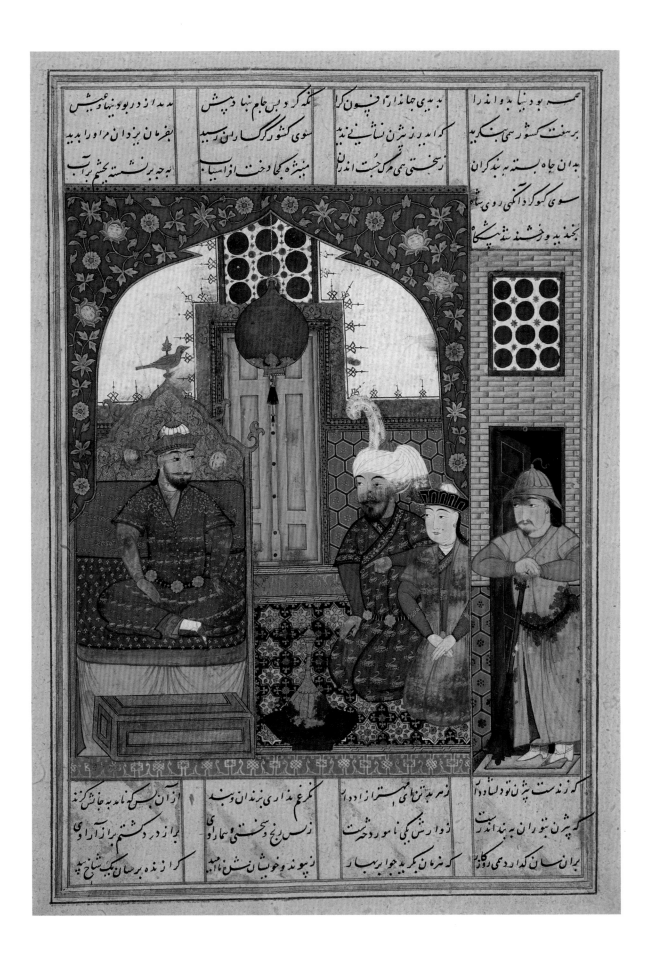

18 Rustam before Kay Khusraw under the Jeweled Tree

From a copy of the *Shahnama* of Abu'l-Qasim Firdawsi made for Sultan-Ali Mirza
Iran, Gilan, A.H. 899 (A.D. 1493–94)
Opaque watercolor, ink, and gold on paper
Text and illustration: 23.0 x 15.4 cm
s86.0159

To secure Bizhan's release from Afrasiyab's prison Kay Khusraw sent for the mighty warrior Rustam. When Rustam arrived at Kay Khusraw's court he was warmly greeted by the Iranian monarch and his men. Kay Khusraw then ordered his chamberlain to place his throne under a flowering tree in the garden. The tree had a silver trunk and leaves of gold and precious gems and bore fruit of quince and orange. The hollow tree was filled with musk and wine. Seated on the throne with Kay Khusraw, Rustam is seen assuring the ruler of his support and desire to obey his orders.

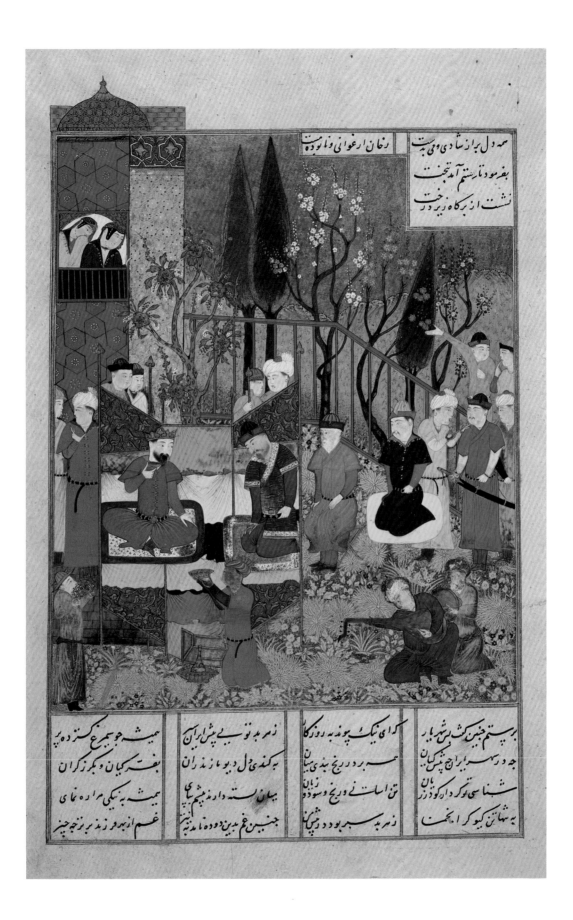

19 Battle between Zanga and Awkhast

From a copy of the *Shahnama* of Abu'l-Qasim Firdawsi made for Sultan-Ali Mirza
Iran, Gilan, A.H. 899 (A.D. 1493–94)
Opaque watercolor, ink, and gold on paper
Illustration: 32.9 x 20.6 cm
s86.0176

Afrasiyab and Kay Khusraw became engaged in a prolonged war that neither could win. As the conflict deteriorated they decided to settle their score by letting eleven of their champions fight each other in a series of duels. In one battle the Iranian Zanga fought the Turanian Awkhast. Although both fought furiously, neither could gain the advantage and they agreed at sundown to rest. Refreshed, they then continued their battle until Zanga wounded Awkhast with a spear. Awkhast, exhausted and dying, fell from his horse, whereon Zanga dismounted and threw his rival back on his steed. Zanga then took Awkhast's flag and rode victoriously back to his own troops. The painting depicts the final moments of the combat with the vanquished Awkhast slumped over his horse. The artist departed slightly from the text in two ways: Awkhast is seen wounded by an arrow rather than a spear and Zanga is holding the Turanian's belt to prevent him from falling from his horse.

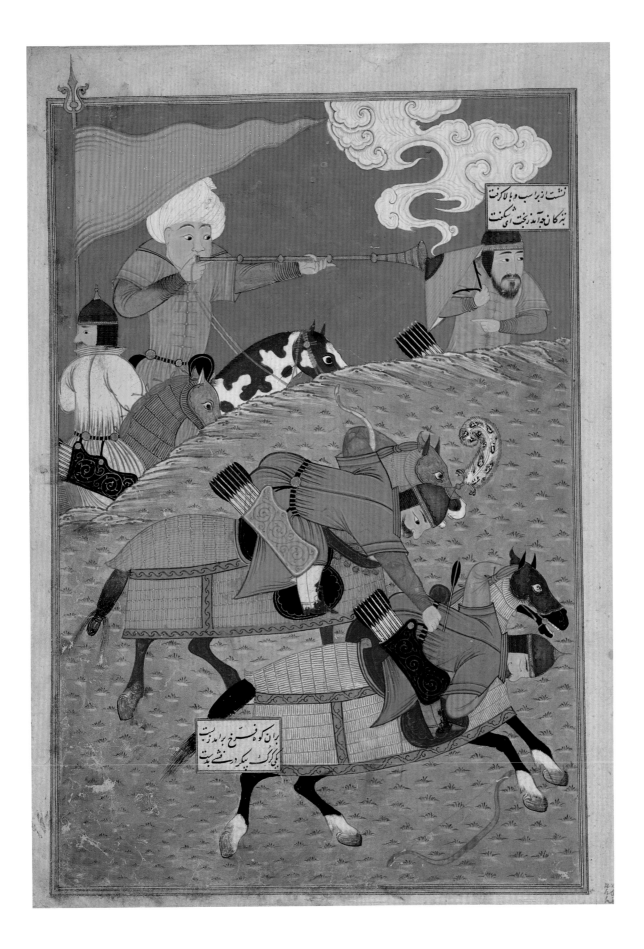

20 *Battle between Kay Khusraw and Afrasiyab*

From a copy of the *Shahnama* of Abu'l-Qasim Firdawsi made for Sultan-Ali Mirza
Iran, Gilan, A.H. 899 (A.D. 1493–94)
Opaque watercolor, ink, and gold on paper
Page: 34.5 x 24.2 cm
s86.0175

In the confrontation depicted here Kay Khusraw, having just slain the warrior Shida, is attacked by three more of Afrasiyab's men. The Iranian king quickly dispatches the first of the Turanians, then turns toward the second but is unable to wound him with his spear. Impressed by his strength and courage, Kay Khusraw draws his sword and cuts him in half. This so frightens the third of Afrasiyab's warriors that he flees the field of battle, causing the rest of the Turanian forces to retreat.

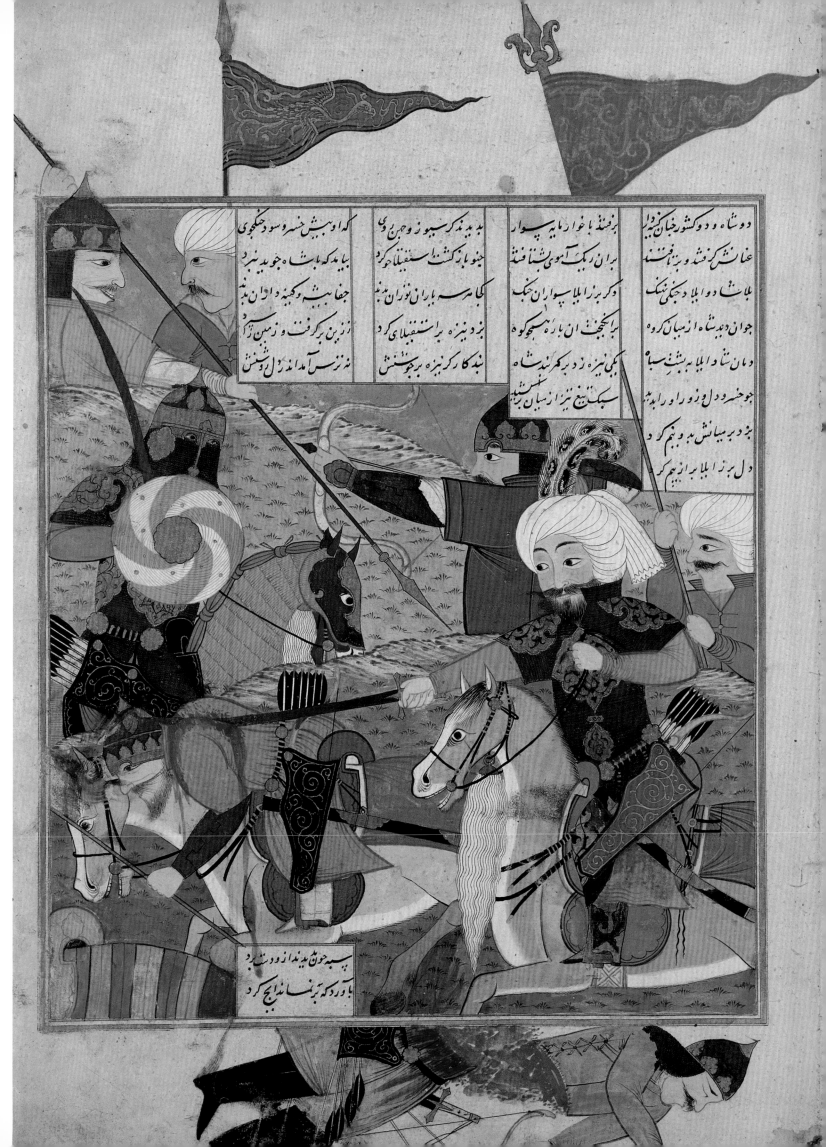

دو شاه و دو کشور جهان کشید بدو راه با خوار مایه سوار بدید ندکر سبوز و جهن وی که او بیش خشم و سود جنگوی

غمانش کرفتند و به نهفتند بر ان ره یک آموی شتافتند چو بازگشت استقبلا نحو کرد بیا مدکه باش جو بدینبرد

بلاش دو و ابلاک جنگی نهنگ وکر بر زا ابلک سپواران جنگ کجا هر سه با بران نوران بنند جفا نبش و کینه و ادوان بنند

جوان دیدشاه از مبال نحو ه برنجج ان باره سوی کوه بزد نیزه بر استنقلای کرد از بن برکرفت و زمین نژژد

و مان شا و ابلاک به بش نشسب یکی نیزه زد بر کمرکند شاه نشسب نبذ کارکه رکینیه بر چوتنش

جوخسرو دل و زور و را ابدید سبک تیج نیز از میان برکشید نه نسر آمد اندرل و دشنش

بزد بر میانش به و نیم کرد دل بر زا ابلک بر ار نیم کرد

پسبه جون بدانداز و دست برد باور دکه تر نساندل چ کرد

21 *Kay Khusraw with Afrasiyab's Women*

From a copy of the *Shahnama* of Abu'l-Qasim Firdawsi made for Sultan-Ali Mirza
Iran, Gilan, A.H. 899 (A.D. 1493–94)
Opaque watercolor, ink, and gold on paper
Text and illustration: 23.5 x 19.9 cm
s86.0174

After a long struggle Kay Khusraw forced Afrasiyab to flee his palace but could not capture him. Frustrated, Kay Khusraw's troops wanted to seek revenge by attacking Afrasiyab's family, but Kay Khusraw ordered them not to harm the ruler's relatives. He then called forth Afrasiyab's women, who appeared adorned in jewels and carrying cups of wine and ambergris. As they approached Kay Khusraw they began to cry. Afrasiyab's principal wife told Kay Khusraw of their sad state and how little the women's advice was heeded by the departed ruler. Remembering their own mothers and sisters, Kay Khusraw and his chieftains were greatly moved and sent the women home unharmed.

22 *Kay Khusraw and Kay Kaus*

From a copy of the *Shahnama* of Abu'l-Qasim Firdawsi made for Sultan-Ali Mirza
Iran, Gilan, A.H. 899 (A.D. 1493–94)
Opaque watercolor, ink, and gold on paper
Text and illustration: 25.9 x 19.6 cm
s86.0172

When Kay Khusraw returned from his adventures, his grandfather Kay Kaus greeted him warmly. The old ruler had the town lavishly decorated for his grandson's arrival, and the citizenry was ordered onto the roofs to pour musk and gems on the passersby. Kay Kaus went outside the city to welcome Kay Khusraw and praise him for his deeds. Kay Khusraw in return showered his grandfather with rubies, emeralds, and gold. Kay Kaus then ordered those in attendance to retreat to his palace, where Kay Khusraw told him of his adventures at sea and in Gang Dizh. The entertainment continued for a week until, on the eighth day, Kay Kaus dispensed gifts and robes of honor to the men who had fought valiantly with his grandson. The painting portrays Kay Khusraw and Kay Kaus seated together surrounded by attendants and courtiers, presumably discussing the young warrior's adventures.

23 *Kay Khusraw Installs Luhrasp as King*

From a copy of the *Shahnama* of Abu'l-Qasim Firdawsi made for Sultan-Ali Mirza
Iran, Gilan, A.H. 899 (A.D. 1493–94)
Opaque watercolor, ink, and gold on paper
Text and illustration: 23.5 x 19.4 cm
s86.0173

When Kay Kaus died, his grandson Kay Khusraw gathered his men together outside the city. Zal and Rustam pitched their tents close to the king's. Tus, Gudarz, Bizhan, Giv, and other warriors were also present. Kay Khusraw was seated on his throne holding the imperial ox-faced mace. Although his chieftains thought he was going to tell them about plans for his army, he chose instead to discuss the transitory nature of life and his desire to reward his men for their efforts. For a week the troops enjoyed themselves, and on the eighth day Kay Khusraw again called his men before him. To Rustam he gave his wardrobe, to Tus his steeds, to Giv his palaces, pavilions, tents, and stables. The elders began to grieve and asked Kay Khusraw to whom was he going to present his crown. Zal reminded the king of Rustam's deeds; Kay Khusraw gave Rustam the country of Nimroze. Gudarz spoke of Giv's chivalry and loyalty, and the king awarded him with the cities of Qum and Isfahan. Then Tus mentioned his valor, and the king bestowed on him Khurasan. Luhrasp remained the only person not recognized, so Kay Khusraw asked Bizhan to bring him forward, whereon he gave him his crown and the kingdom of Iran, the most prized of all his possessions.

جہان گشت با فر و آیین و آب

بتابید از آسمان زبرج

گیتی جوان گشت ازو یکسره

چو آمد بہ برج حمل آفتاب

نشست و نخست اندرون کوه کرد

تختی بکوه اندرون ساختند

پلنگینه پوشید خود با گروه

کیومرث شد بر جہان کدخدای

سر تخت و بختش درآمد ز کوه

ازو اندر آمد همی پرورش

که پوشیدنی نو بد و نو خورش

بیابان و که جای او بود

که نخستین جہان را ببد پادشا

همه دام و دد جانور گشت رام

جہان ماه و دیو و دد و مردمی

بر سم غار آمد نشست بکوه

سیہ بند را نام فرخ نهاد

چنینش جہان را دل آراسته

بنزدیک او آمد آن روز خوب

کیومرث را زان پس آید به یاد

نگویی جز از نام خورشید بر

زکیتی بر او یک دل آرام

از آنجا که برگشت کی برگشت کی

کیومرث را دل پر از جنگ بود

24 *The Court of Gayumarth*

Folio 21a from a copy of the *Shahnama* of Abu'l-Qasim Firdawsi
Iran (Shiraz), A.H. Muharram 924 (January 1518)
Opaque watercolor, ink, and gold on paper
Page: 29.0 x 19.4 cm
s86.0058.001

Gayumarth, who ascended the throne when the sun had entered the sign of Aries, was the first great ruler of Iran. For thirty years he lovingly governed his kingdom from a mountaintop. It is said that during his reign people wore leopard-skin garments and learned to prepare food. In his benevolent presence even the wild animals became tame. Gayumarth's only enemy was the evil demon Ahriman, who wished his own son to rule. Although the king was informed by the angel Surush of Ahriman's scheming, he was unable to prevent his son Siamak from being murdered by Ahriman's son. After mourning Siamak's death for a year, Gayumarth set out to avenge his son's murder, thus initiating a series of confrontations between the forces of good and evil that was to last generations.

25 *Rustam Astonished by the Witch He Cut in Half*

Folio 96b from a copy of the *Shahnama* of Abu'l-Qasim Firdawsi
Iran (Shiraz), A.H. Muharram 924 (January 1518)
Opaque watercolor, ink, and gold on paper
Text and illustration: 17.0 x 11.0 cm
s86.0058.001

One day Rustam came on a beautiful spring near which lay a bowl of wine and a roasted mountain goat. After dismounting from his horse he filled his cup with wine and began to play a lute that he found nearby. He sang of his misfortunes and the constant battles he was compelled to fight. Hearing Rustam's song, a hideous witch disguised herself as a beautiful maiden and approached the great warrior. Unaware that she was a witch, Rustam gave her a cup of wine and spoke to her of God's munificence. The witch could not endure his praise of God, and her face turned black. Rustam immediately caught her in his lariat and demanded to know who she was. Before his eyes she turned into a frightening hag, and drawing his knife, Rustam cut the witch in two.

26 Rustam and the White Demon

Folio 99b from a copy of the *Shahnama* of Abu'l-Qasim Firdawsi
Iran (Shiraz), A.H. Muharram 924 (January 1518)
Opaque watercolor, ink, and gold on paper
Text and illustration: 17.0 x 11.2 cm
s86.0058.001

When the aged ruler Kay Kaus lost his eyesight, the king's physicians told Rustam that they needed the blood of the White Demon to restore his vision. With Awlad (who had been taken prisoner by Rustam in an earlier adventure) as his guide, Rustam set out in search of the demons, whom they found in the seven mountains. Continuing his search for the White Demon, Rustam entered a cave as dark as hell. As his eyes grew accustomed to the darkness, he made out the mountainlike shape of a demon whose face was black but whose fur was as white as milk. The demon approached Rustam, who drew his sword and slashed at the demon's leg. Grappling with each other, they wrestled fiercely until the ground became red with their blood. With all his strength, Rustam threw down the demon and cut out the monster's heart and liver with his dagger. Emerging from the cave, Rustam gave Awlad the White Demon's liver, and the two then set out for Kay Kaus's palace.

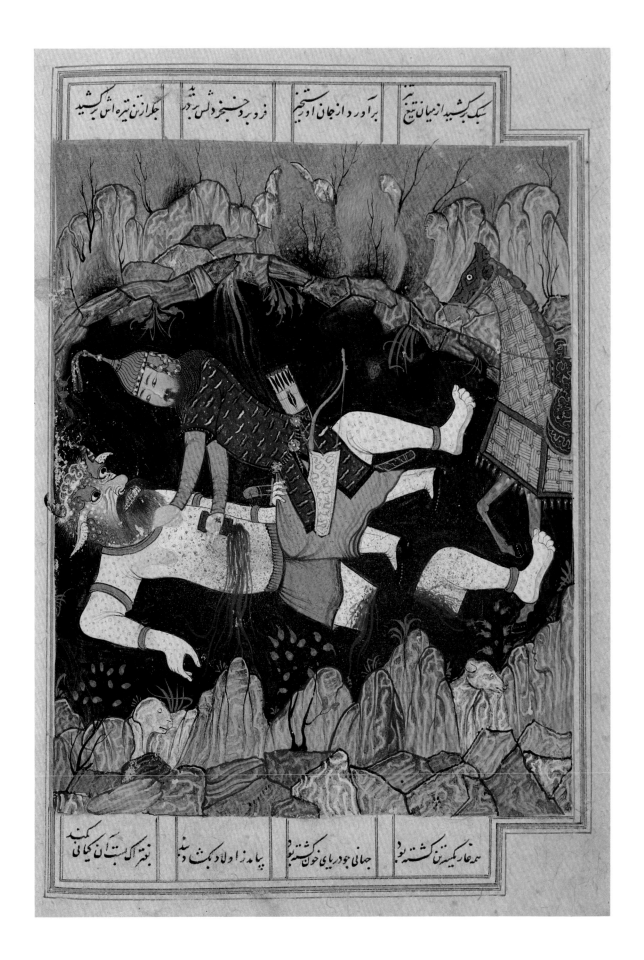

27 Sultan-Mahmud of Ghazna in Discussion with a Dervish

Folio 26a from a copy of the *Makhzan al-asrar* of Mawlana Haydar
Iran (Khurasan), A.H. 985(?) (A.D. 1577–78?)
Opaque watercolor, ink, and gold on paper
Text and illustration: 17.5 x 9.2 cm
s86.0054

One winter day Sultan-Mahmud of Ghazna (r. A.D. 997–1030) went for a ride with some of his companions. They came on a ruin where lived an old man with disheveled hair, wearing rags and no shoes. The king greeted the old man, but the sage ignored him. When Mahmud greeted him again, the ascetic asked him who he was and why had he come to visit. The king responded that he was famous in Ghazna and asked in turn why the old man had chosen to live in such a place and make his life so difficult. Furious, the ascetic answered by asking why the king had wasted his life by constantly looking for conquest and riches. He then asked Mahmud if he had no thought for the afterlife. The king responded by asking him what he would do if he too were faced with the moment of death. Smiling, the old man fell into an agitated state and gave up the ghost: "His parrot flew away and the cage was left empty."

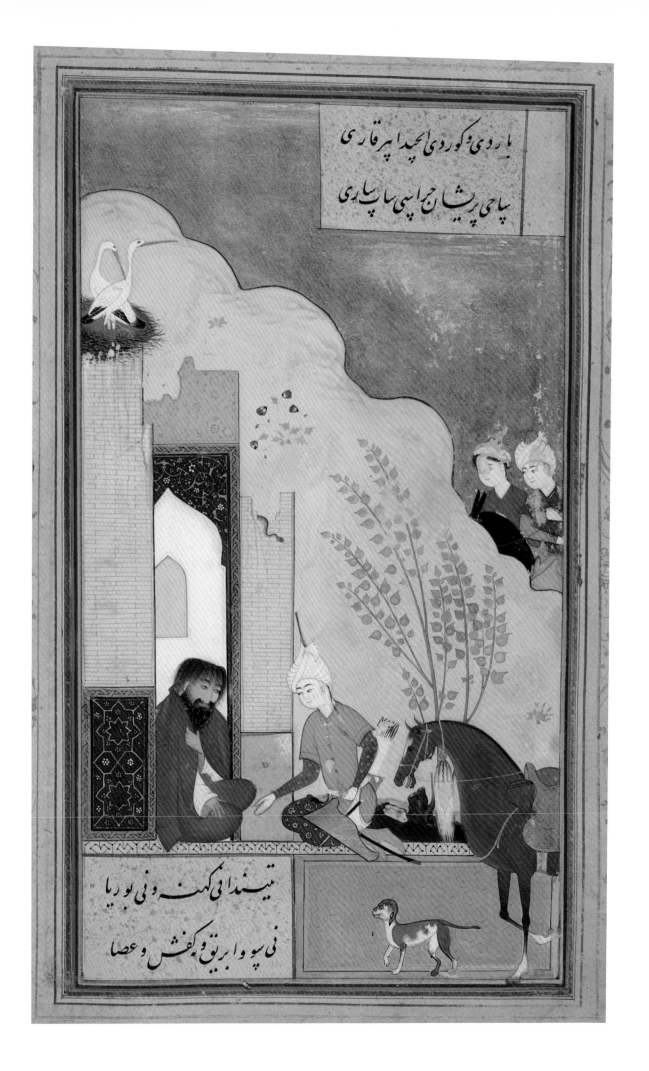

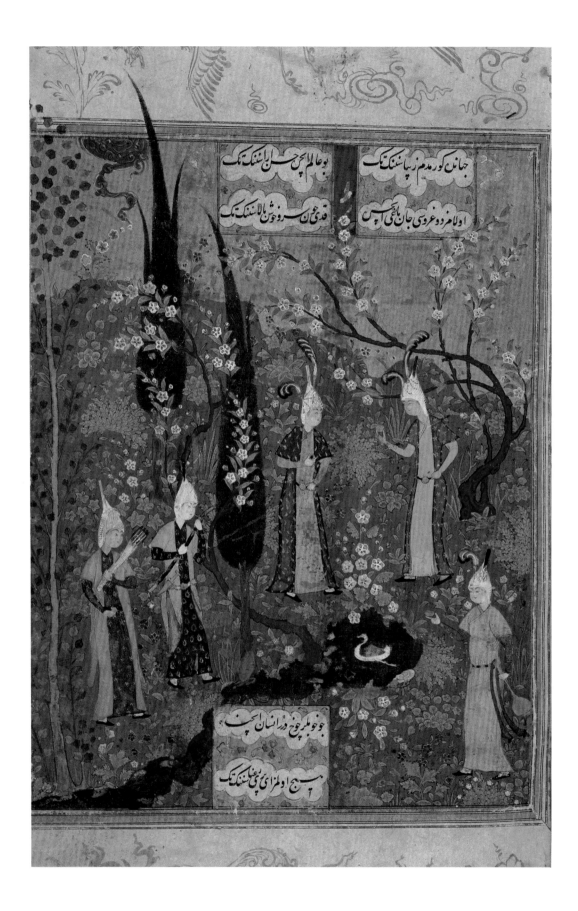

28 *Five Youths in a Landscape*

Folio 2a from a copy of the *Diwan* of Shah Isma'il (Khata'i)
made for Shah Isma'il
Iran (Tabriz), ca. 1520
Opaque watercolor, ink, and gold on paper
Text and illustration: 15.2 x 12.1 cm
s86.0060

Shah Isma'il I (r. 1501–24), founder of the Safavid dynasty (1501–1732), wrote a number of poems in a Turkish dialect using the nom de plume Khata'i. Although numerous copies of the shah's *Diwan* (Collected Poems) are extant, this appears to be the earliest to have survived. The painting of youths in a garden, although generic in form, establishes a visual parallel to the poetry written on the page:

> I have never seen anyone so beautiful as you on the earth, never in this world anyone so
> gorgeous as you.
> Truly, within the garden of the soul there can be no stature so elegant as your tall, erect
> cypress.
> Although there are many beauties among humanity, there is none, O beauty, so radiant as
> you.

29 Joseph Enthroned

From a copy of the *Falnama* ascribed to Ja'far al-Sadiq
Iran (Tabriz or Qazwin), ca. 1550
Opaque watercolor and gold on paper
Page and illustration: 59.4 x 44.5 cm
s86.0255

Ascribed to Shia Imam Ja'far al-Sadiq, the *Falnama* is a book of divination used for consultations and the offering of omens. The text combines folktales and popular stories with more orthodox hagiographical accounts.

The story of Joseph is incorporated into many Islamic texts, including the Koran. This painting appears to depict a scene from Joseph's life that occurred after his release from prison and appointment as the superintendent of the storerooms by the Egyptian pharaoh.

According to tradition, when Joseph's brothers arrived from Palestine in search of food, Joseph received them warmly in his palace but concealed his identity from them. He had his servants hide a gold cup in his brother Benjamin's baggage. As the brothers' caravan was about to leave town the brothers were accused of being thieves and their goods were searched. When the cup was found in Benjamin's saddlebags, Joseph told his brothers that Benjamin must remain in Egypt. Reuben implored Joseph to let him stay instead of his brother. This is the moment that may be portrayed in the painting. Both Reuben and Benjamin stayed behind with Joseph, while their brothers returned to Palestine. When their father learned what had happened, he told his sons to return to Egypt. On their return to Egypt the brothers told Joseph that their father had lost his eyesight. Hearing this, Joseph revealed his true identity. When the brothers were reunited with their father, they gave him Joseph's shirt, which, having touched it, caused Jacob to regain his eyesight.

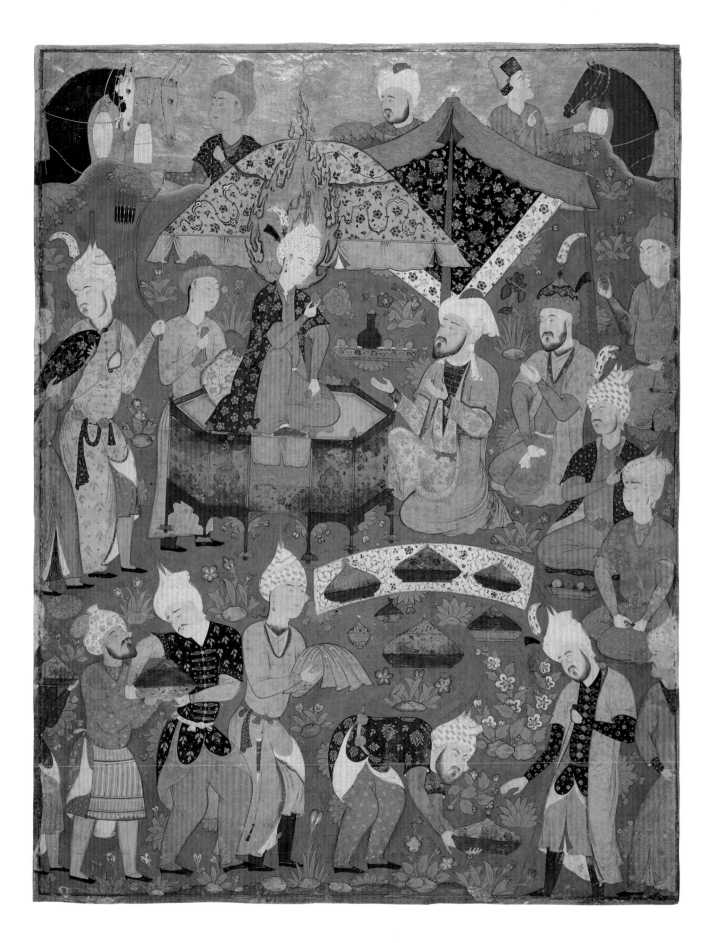

30 *A Demon Descends upon a Horseman*

From a copy of the *Falnama* ascribed to Ja'far al-Sadiq
Iran (Tabriz or Qazwin), ca. 1550
Opaque watercolor and gold on paper
Page and illustration: 59.3 x 44.8 cm
s86.0252

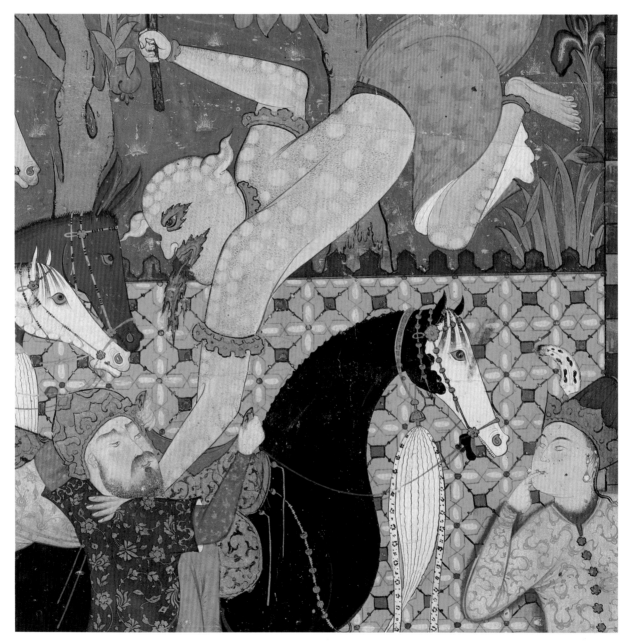

detail

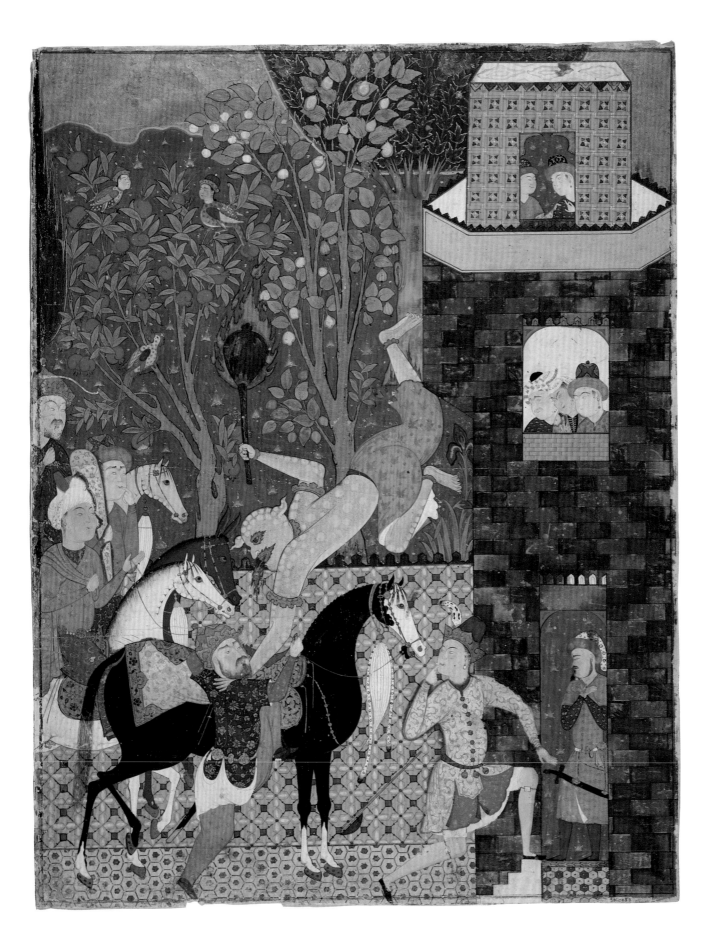

31 *Ascent of the Prophet to Heaven*

From a copy of the *Falnama* ascribed to Ja'far al-Sadiq
Iran (Tabriz or Qazwin), ca. 1550
Opaque watercolor and gold on paper
Page and illustration: 58.9 x 44.9 cm
s86.0253

The *Ascent of the Prophet to Heaven* is often conflated in Persian painting with a similar scene, *The Miraculous Night Journey of the Prophet*. Although separate events, both depict Muhammad riding the fabled Buraq, a steed described as having a tail and feet like a camel's, a rump like a horse's, and an emerald saddle, pearl reins, and turquoise stirrups. The presence of the lion in the upper left corner of this painting, however, distinguishes the image from other portrayals of either the ascent to heaven or the night journey. The animal is a symbolic representation of Ali, the prophet's son-in-law, whom Shi'ites call the "lion of God."

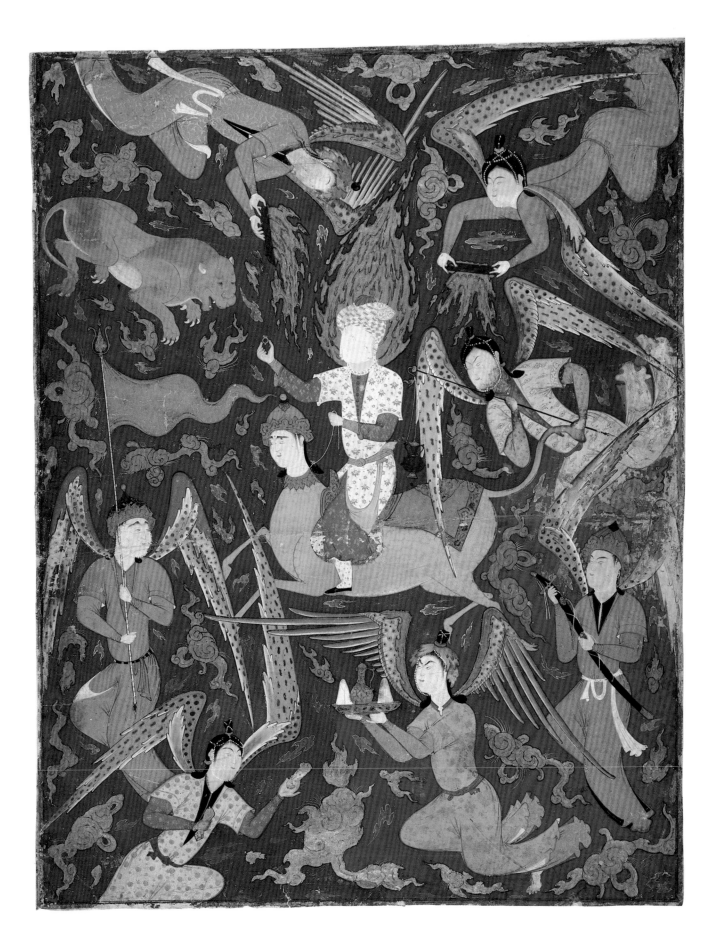

32 *Angels Bow before Adam and Eve in Paradise*

From a copy of the *Falnama* ascribed to Ja'far al-Sadiq
Iran (Tabriz or Qazwin), ca. 1550
Opaque watercolor and gold on paper; split and mounted on brown paper
Page and illustration: 59.3 x 44.5 cm
s86.0254

This large, boldly executed painting depicts the adoration of Adam and Eve by the angels. The story of Adam and Eve is cited in numerous Islamic texts and is recorded in the Koran (Sura VII: 11–13):

> And We created you, then fashioned you, then told the angels: Fall ye prostrate before Adam!
> And they fell prostrate, all save Iblis, who was not of those who make prostration.
> He said: What hindered thee that thou didst not fall prostrate when I bade thee? (Iblis) said:
> I am better than him. Thou createdst me of fire while him Thou didst create of mud.
> He said: Then go down hence! It is not for thee to show pride here, so go forth! Lo! thou art
> of those degraded.

According to Islamic tradition, God then placed Adam in paradise and while he was asleep created Eve, his companion.

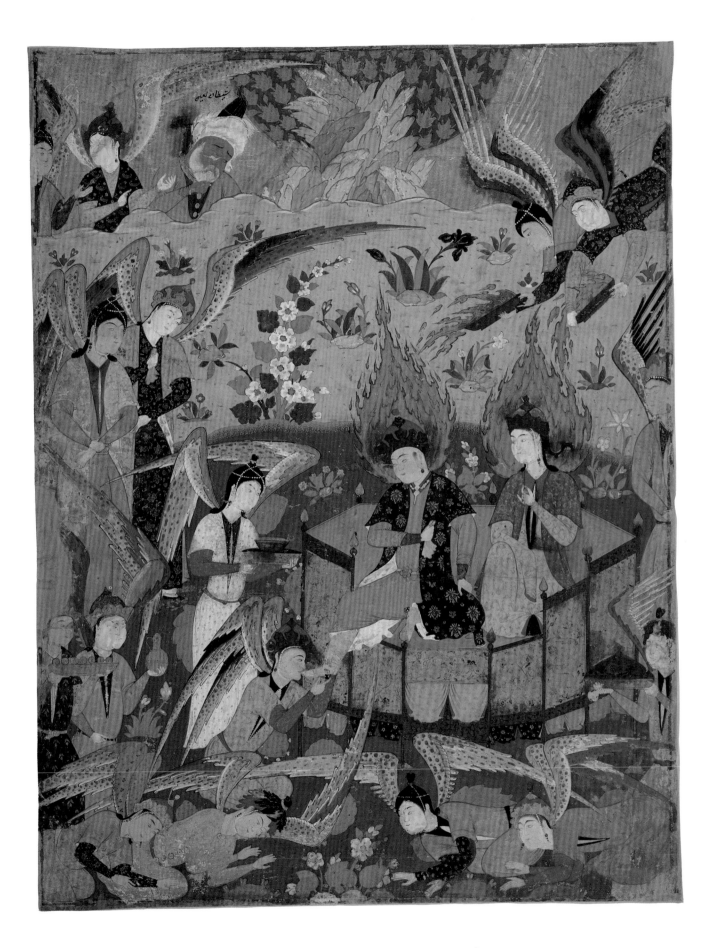

33 Adam and Eve

From a copy of the *Falnama* ascribed to Ja'far al-Sadiq
Iran (Tabriz or Qazwin), ca. 1550
Opaque watercolor, ink, and gold on paper
Page and illustration: 59.7 x 44.9 cm
s86.0251

In this painting Adam, whom Muslims consider the father of humanity and the first prophet, is depicted riding a serpent; Eve rides a peacock. According to tradition, Iblis, the Islamic counterpart to Satan, was intent on entering the Garden of Eden to foil Adam and Eve. By appealing to its vanity, Iblis enticed the peacock, the gatekeeper of paradise, to allow the serpent, then the most beautiful of all creatures, to enter Eden. Seated between the serpent's fangs, Iblis entered the garden and seduced Eve into eating the fruit of the forbidden tree.

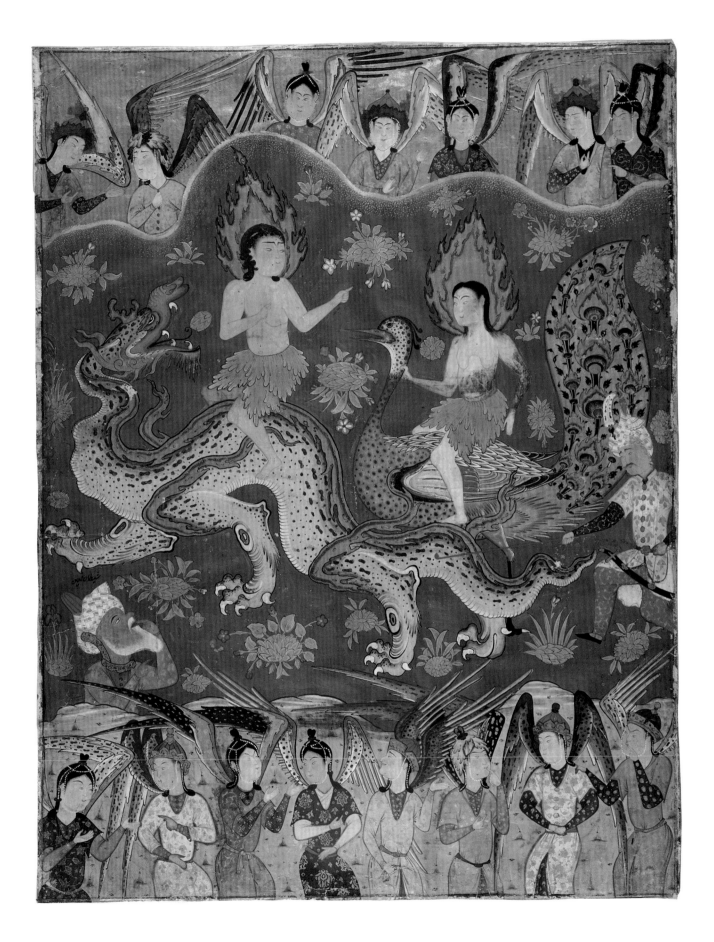

34 *Imam Zaynul-Abidin Visits the Ka'ba*

Folio 66a from a copy of the *Silsilat al-dhahab* of Mawlana Nuruddin Abdul-Rahman Jami
Iran (Tabriz?), A.H. 956 (A.D. 1549–50)
Opaque watercolor, ink, and gold on paper
Text and illustration: 17.8 x 13.5 cm
s86.0044

Among the many stories recounted by the Timurid poet Jami in the *Silsilat al-dhahab* (Chain of Gold) is the tale of Hisham, the Abbasid (A.D. 749–1258) caliph who vainly attempted to touch the Ka'ba during the hajj, or pilgrimage to Mecca. While the caliph was making his way to the stone, the crowd parted for Imam Zaynul-Abidin, allowing the imam to touch and kiss the Ka'ba. A nobleman from Damascus asked the caliph if he knew who the man was, but Hisham did not recognize him. Another man from Damascus, the poet Farazdaq, identified him as the favorite of Imam Husayn, the "Lord of Martyrs." In his honor the poet began to recite a *qasida* (eulogistic poem), which infuriated Hisham, who had him imprisoned. When Zaynul-Abidin learned of the poem and Farazdaq's imprisonment, he sent him twelve thousand silver coins as a gift.

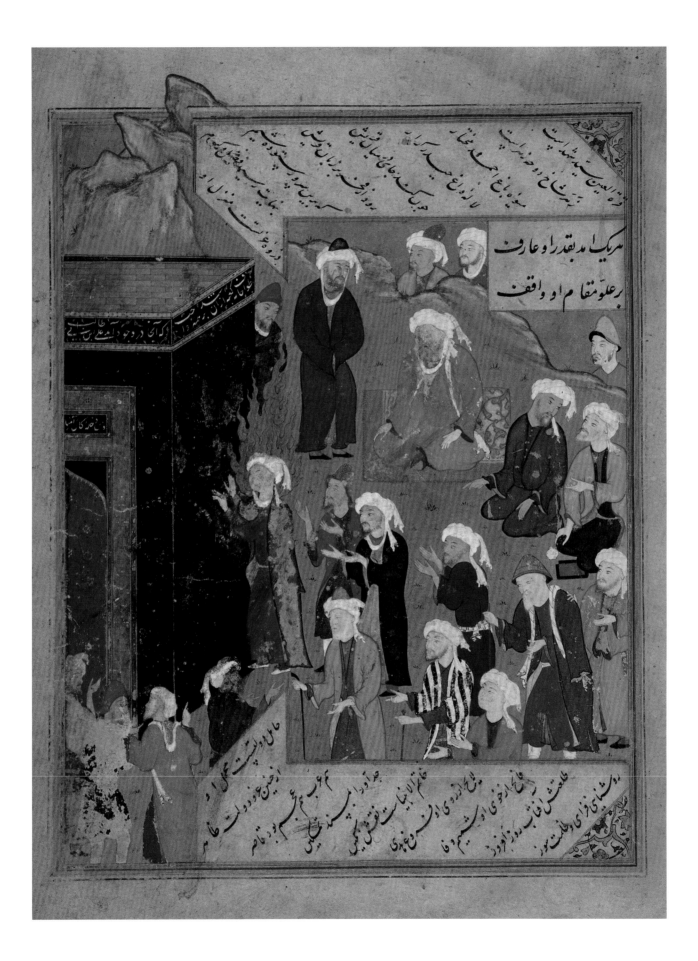

35 *A Prince and a Princess Seated on a Carpet in a Golden Landscape*

Folios 1b-2a from a copy of the *Tuhfat al-ahrar* of Mawlana Nuruddin Abdul-Rahman Jami
Iran (Bukhara), end of A.H. Muharram 966 (November 1558)
Opaque watercolor, ink, and gold on paper
Text and illustration per page: 13.3 x 6.7 cm
s86.0040

The *Tuhfat al-ahrar* (Gift of the Free) is the third of seven poems in Jami's *Haft awrang* (Seven Thrones). These folios, however, have been inserted into the manuscript and are from a *Diwan* of Hafiz.

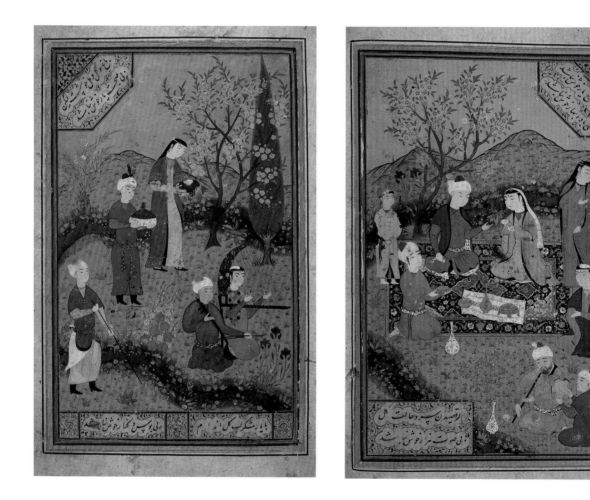

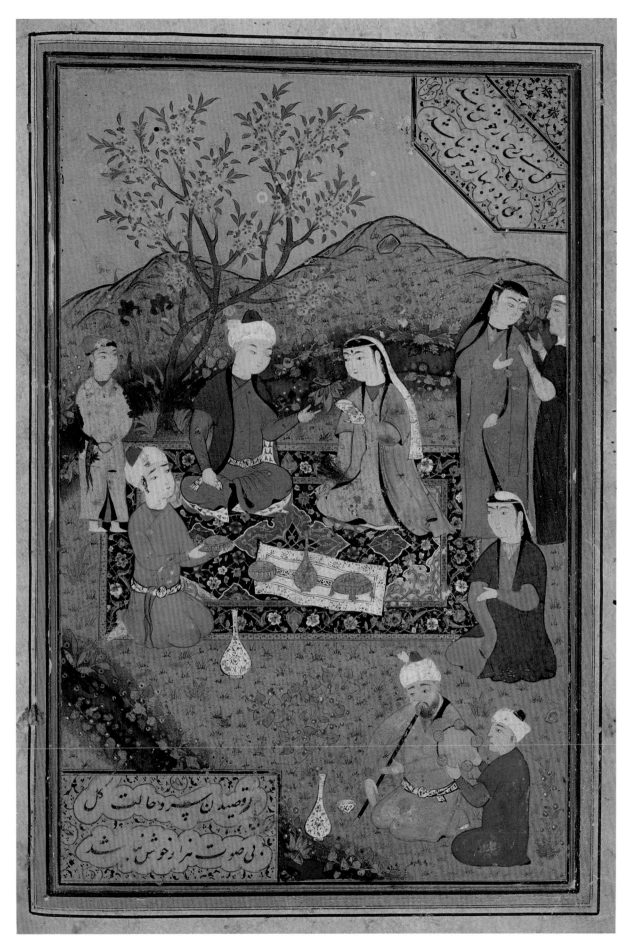

folio 1b

نیست پشیمان بیش ازز زردها | هم شود آن لحظه که مکند بد | ازدهیش نه بترزو کرد و | داد زز ماببثارزوی جو
برمه کس دست کشاد چو منع | بستن مشتت سکان و ستبغ | بجوا و نبود خورشید تم | مرد و بعض ارجه نیاب کم
چاشنی بجر جبکر خون کند | چشمه خورتشکی افرون کند | مرجه که شاه ازکف بارنده داد | جون کرم برکوار نده داد

بدلیش ازان پش کنجید سلیم | در امل به دخل و ذ من جحکیم | جون یعطا واد و سخی ورد ها | صامت و ناطی همه مکرد و
لاجرم مشن زال به حبسند | پیش شرف نام جوشعری بلند | تا ابدا زمانه اکرام خویش | باد فلک مرتبه جون نام خوش
همی برمان تو وکسل کرم | بدلک خر رشید مو زر کند | سنای شای ثانی مخاطبه خدایکان زمین | وزن زززبرده شما راز درم
لیکک قلذ از توجوکوه افکنی | وزمانی ایب رزاق وکلدار رزاق | دامک کبا ر پار پراز زرکن
بخ نهالی که تو آبش دهی | فتح الله خزایر السموان و الارض علی الاطلاق | میوه شاخش نبو و جز بی
ملک وران بر در تو ورد کی | قایمه تخت تو کرد و س شن | قاعده ملک تو بنیاد دین
ملک زنو تا فه پرور دکی

۵۸۵ ۰۷۱۵

36 Amir Khusraw Presents a Book of Poetry to Ala'uddin Khalji

From a copy of the *Khamsa* of Amir Abu'l-Hasan Yaminuddin Khusraw Dihlawi
Iran, Balkh, A.H. 909 (A.D. 1503–04)
Opaque watercolor, ink, and gold on paper
Text and illustration: 20.7 x 21.3 cm
s86.0213

The celebrated poet Amir Khusraw Dihlawi (1253–1325) was born in Patiyal in northern India. A man of remarkable talent, he was patronized from an early age by the sultans of the Mu'izzi (1206–90), Khalji (1290–1320), and Tughluq (1320–1414) dynasties. His *Khamsa* (Quintet) is a retelling of popular Persian romances and adventures.

Amir Khusraw dedicated his *Khamsa*, which closely follows the *Khamsa* of the poet Nizami (1141–1209), to the sultan Ala'uddin Khalji (r. 1296–1316). Although the scene depicted is not described in the *Khamsa*, the poet mentions in the text his hope of being well rewarded by Ala'uddin for his work. Unfortunately this did not happen, for Amir Khusraw later remarks that he felt he was not given enough money for his efforts.

37 Double-Page Illuminated Frontispiece

Folios 1b-2a from a copy of the *Khamsa* of Amir Abu'l-Hasan Yaminuddin Khusraw Dihlawi
made for Abu'l-Fath Bahram Mirza
Iran (Tabriz), ca. 1530–40
Opaque watercolor, ink, and gold on paper
Page: 30.2 x 18.3 cm
s86.0067, s86.0068

Inscribed with the titles of Abu'l-Fath Bahram Mirza, Shah Tahmasp's brother, this double-page frontispiece is among the few works that can be associated with this important patron. Born in 1517, Bahram Mirza spent his childhood in Tabriz, the capital of the Safavid empire. In 1530, Shah Tahmasp (r. 1524–76) appointed him to the governorship of Herat, where he remained for four years. He died in 1549 at the age of thirty-two. Among the other works of art commissioned by Bahram Mirza is a celebrated album of paintings, drawings, and calligraphy now in the Topkapı Sarayı Müzesi Kütüphanesi, Istanbul.

Overleaf: color plate 37

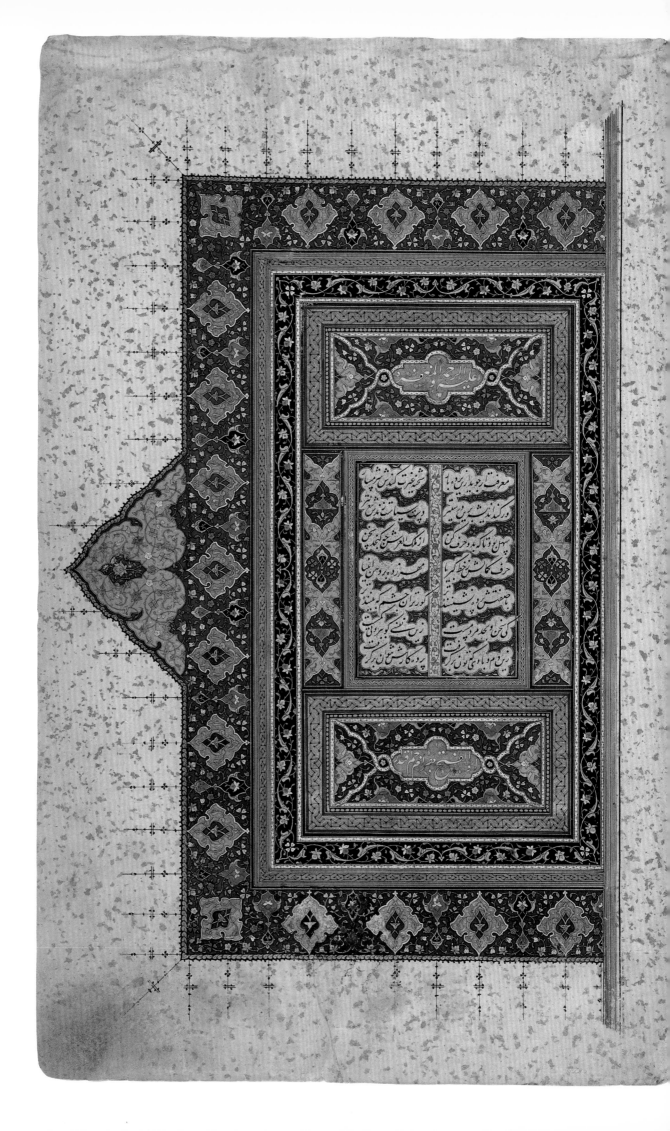

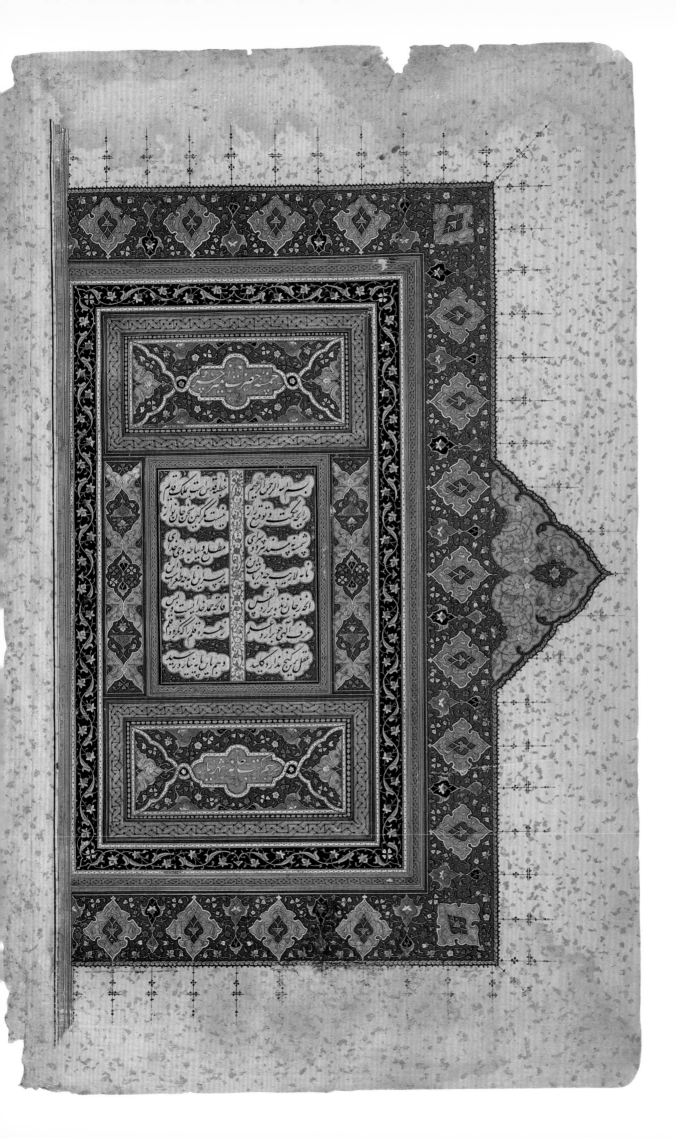

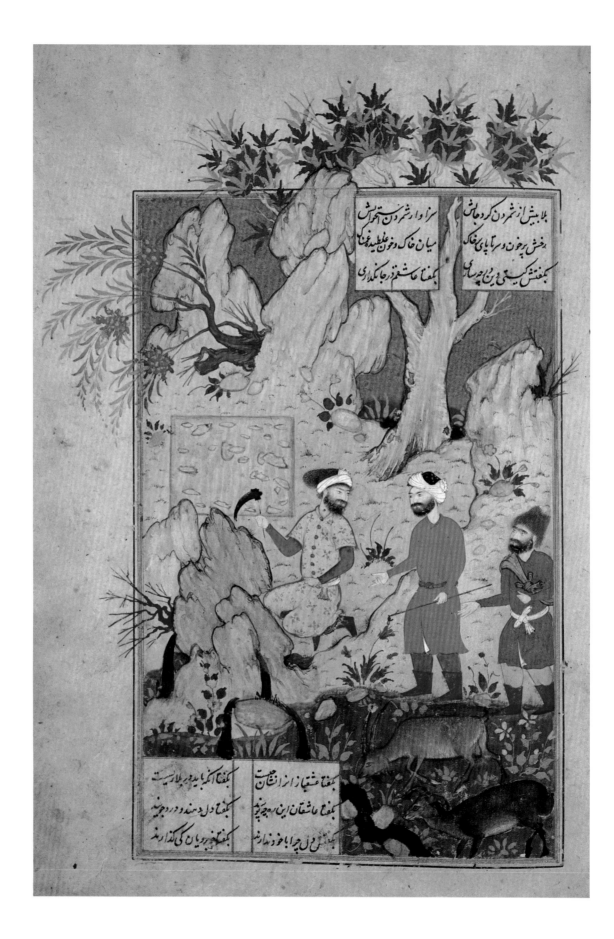

38 Khusraw, Dressed as a Shepherd, Visits Farhad

Folio 55a from a copy of the *Khamsa* of Amir Abu'l-Hasan Yaminuddin Khusraw Dihlawi
Iran (Qazwin), A.H. Rabi' II 972 (November 1564)
Opaque watercolor, ink, and gold on paper
Text and illustration: 15.3 x 9.7 cm
s86.0051

One night the Sasanian king Khusraw, who was in love with the Armenian princess Shirin, dreamed of a beautiful woman who held a vessel in each hand. One vessel contained milk, the other nectar. The woman offered the nectar to Khusraw and presented the milk to a youth. The vessel containing milk fell out of the young man's hand and shattered. On awakening, Khusraw asked that his dream be interpreted. He was told that through perseverance he would win his beloved's hand, while his rival, the stonecutter Farhad, would be disappointed. Encouraged, Khusraw disguised himself as a shepherd and went in search of Farhad, whom he soon found. The once-robust Farhad had become gaunt, and Khusraw questioned him about his health. Farhad answered that his poor condition was the result of love. The two then talked for many hours about the subject.

39 *Timur Feasts at the Occasion of the Marriage of His Grandsons*

Folio 153a from a copy of the *Habib al-siyar, Volume 3*
of Ghiyathuddin b. Humamuddin Muhammad Khwandamir
made for Mirza Abu-Talib b. Mirza Ala'uddawla
Iran (Qazwin), A.H. 987 (A.D. 1579–80)
Opaque watercolor, ink, and gold on paper
Text and illustration: 25.4 x 15.2 cm
s86.0047

Ghiyathuddin b. Humamuddin Muhammad Khwandamir, born around 1475, was a late Timurid-period (1370–1506) historian. Khwandamir's chronicle of pre-Islamic and Islamic history through the founding of the Safavid empire by Shah Isma'il contains a lengthy section on the life of the great ruler Timur (r. 1370–1405), or Tamerlane as he is better known in the West.

In 1404, shortly before his death, Timur decided to hold a *quriltay* (festive gathering) on the plain of Kanikul outside Samarqand to celebrate the marriage of several royal princes. Massive tents were pitched, and princes, princesses, and tribespeople from throughout his empire came to court. Embassies from Europe and the Muslim world were also present, bringing with them lavish gifts for Timur. When Timur's grandsons Khalil Sultan and Pir Muhammad b. Jahangir arrived, he could not stop his tears because he was reminded of his favorite grandson Muhammad Sultan b. Jahangir, who had died prematurely. This moment is represented in the painting.

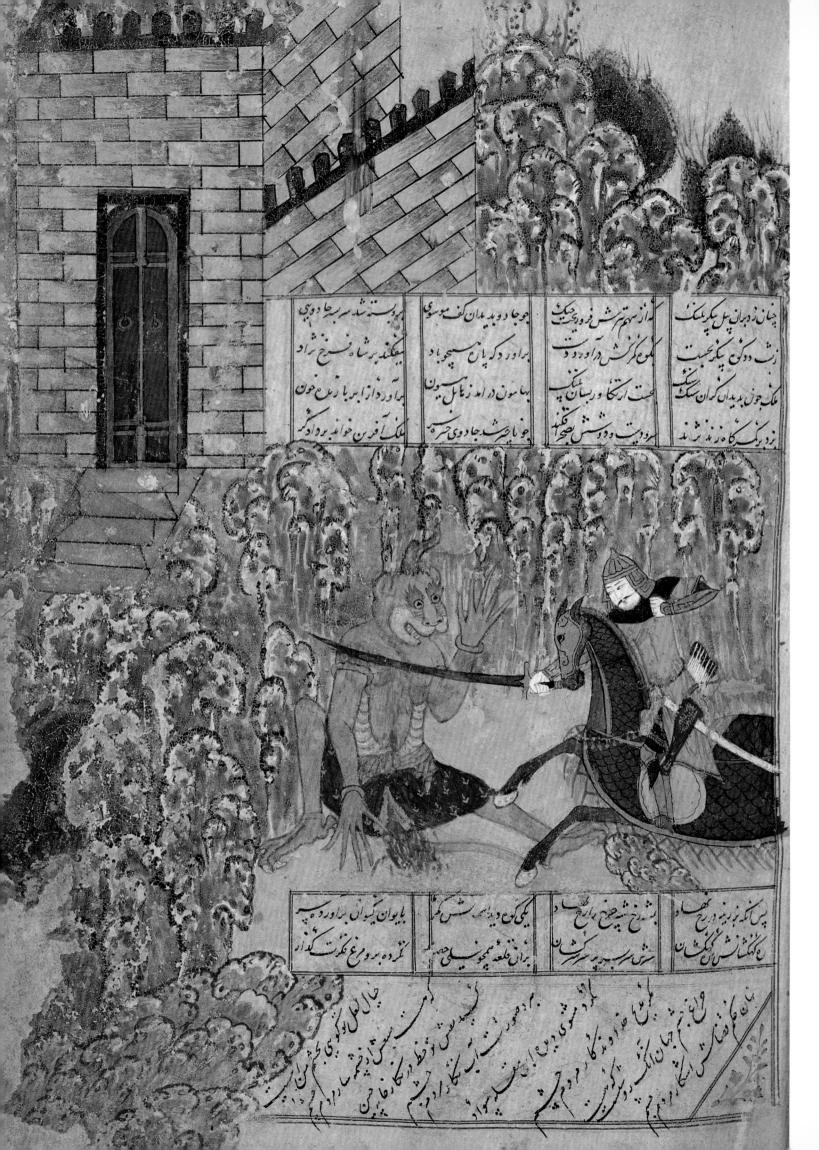

چنان زد بیان پیل پیکر پلنگ
کز آن سهم برجش فروریخت سنگ
جهان از دو بیدان کف موسوی
ربودکنی پیکر نحبت
بکوفت کرکش درآورد دست
براورد که پاک هیچجهاد
سربسته شد سر به جا دوی
یکفکند برشاه فرخ نژاد
تخت ارنگا وربسیان پلنگ
بهامون درامد زبال سپون
براور دراز ابر با زمن خون
ملک جون بدیدار ایشان سون
برد برکس کاسه بردبد احد
چوماجرش جادوی جسره
ملک آفرین خواهد بردادکر

پس آنکه نوربزه دارخ بها
لکن کن دنیایش شش کرا
بایوان کهیوان براور پس
بستنج شنه نج ارج یاد
ان کگنش شش نگنش شن
سربر سربه بره سربر شن
بران قلعه سجحویایی حر
کرده بره بره مرغ نکگت کذار

جان ظا فشار ب ایاک نخ خابی ملل
بسی دردی زیر ه یکاوی یم
چون درب کلوی هو اروی کا
یکاک انکاوم درابی دا نکاوم ابش

40 *Humay Slays the Demon before the Walls of Zarina Dizh*

Folio 56a from a copy of the *Khamsa* of Kamaluddin Abu'l-Ata
Mahmud Murshidi Kirmani (Khwaju)
Iran (Shiraz), A.H. Rajab 1, 841 (December 27, 1437)
Opaque watercolor, ink, and gold on paper
Page and illustration: 22.0 x 14.8 cm
s86.0034

Kamaluddin Abu'l-Ata Mahmud Murshidi of Kirman was commonly known as Khwaju Kirmani. Born in 1281, he became, during the reign of the Ilkhanid (1256–1353) sultan Abu-Sa'id (r. 1317–35), one of the court's most noted panegyrists. His *Khamsa*, or quintet of poems, is loosely based on the *Khamsa* of the great thirteenth-century poet Nizami. The story depicted here is from the romance *Humay u Humayun*, one of the five poems of Khwaju Kirmani's *Khamsa*.

When the legendary king Humay set out for Zarina, the mountaintop fort inhabited by a sorcerer, he was unaware of the dangers that he was to encounter. On his way there he had to cross a sea of fire. Imploring God's help, he was able to pass through the fire like the great Iranian hero Siyawush. When Humay arrived at the base of the mountain, a demon charged toward him. Again by seeking God's help, he was able to shoot the monster with an arrow. Seeing Humay, the sorcerer began to hurl rocks at him. Scared but still believing in God, Humay drew his sword and hacked his assailant to pieces. This moment, set against the backdrop of the fort and surrounding hills, is vividly depicted in the painting. Humay's triumph over the sorcerer becomes in this context a metaphor for faith in God.

41 *A Prince Prostrates Himself before a Holy Man*

Folio 101b from a copy of the *Khamsa* of Ilyas b. Yusuf Nizami
Iran, ca. 1470(?)
Opaque watercolor, ink, and gold on paper
Text and illustration: 25.1 x 16.4 cm
s86.0061

Ilyas b. Yusuf Nizami (1141–1209) is considered one of the greatest poets of the romantic epic in the history of Iranian literature. His *Khamsa* (Quintet) is composed of the *Makhzan al-asrar* (Treasure Chamber of Mysteries), *Khusraw u Shirin, Layla u Majnun,* the *Haft paykar* (Seven Portraits), and the Iskandar cycle, which is usually divided into two parts: the *Sharafnama* (Book of Honor) and the *Iqbalnama* (Book of Happiness). Completed in 1188, *Layla u Majnun* was composed in less than four months.

The story of Layla and Majnun, two love-struck children from rival clans, is set in Arabia. When Layla's father heard of Majnun's love for his daughter, he withdrew her from the school where she had met Majnun. Driven insane by her absence, Majnun (whose name means "demented") fled to the wilderness, where he lived among the beasts, reciting Layla's name and composing love songs for her.

One day Majnun's uncle, Salim Amiri, visited him in the wilderness, bringing him gifts of clothing and food. Majnun gave the food to his animal companions. Nizami then tells the story of a hermit who dwelled in a cave: A king, having heard of the hermit's asceticism, wanted to know what nourished him. One day the ruler and one of his courtiers rode toward the hermit's cave. The servant approached the ascetic and asked him how he lived and was shown the food that the old man ate. Trying to entice the hermit, the courtier said that if he joined the king's court he would have substantial nourishment. Rejecting this proposal, the hermit suggested to the courtier that if he would taste the food he ate, he would forsake his worldly life. The emotional king, recognizing the hermit's sincerity and love of God, fell to his feet and kissed the ground on which the hermit tread.

گرنو پراین کیا سپانیه | از خدمت شه خلاص یابی | فنجون سخی شنید ازین دست | شد کرم روز بارکی خورجیت

درپای رضا وزآمد افتاد	می کرد دعا و بوسه می داد	خرسند یبهشه نازنین است	خرسندی راد لایت این است
مجنون زیبا طان افسانه	برخاست ودست شاد مانه	دل داده بدو دستان نازی	رسید زمهرکسی نشانی
وانگاه گرفت کریه زپیش	رسید زحان ازرخ ویش	کان فرع شکسته بال چوب	کارش جوز سید وحال جو
با این کراز و سیاه روم	هم هند دک سیاه او یم	رنجورنیت با بنومند	چشم نجالش ازرومند
جون دیده سلام کان والس	دارد پیر مهر ما درخویش	نی کاردکراشت کوهترل	اورد زخانه ما درشد
ما درک زدوور دربسپرید	احوال بگونه دگر دنبد	دبدان گل رخ زرگشته	وان آینه رنگ ربگ خورد
اندام شش سکینه شدخود	ازانده ان بدست وباهرد	کرشت باب دیده رو	کرد بشانه کلک مویست
پیرتا قدش بمهربا لید	برجهد درتی بدر نالید	می سود بدرگار دست	که ابله سود که ورمیت
آ کردو پیر سری ازعبارشی	کزنده زبارخسته خارش	جون کرد زروی مهربانی	باوز تلطف انج دانی
گفت ایب براین جه ترکتارت	بازست جه جای عش بارت	تیغ اجل این این ودوستی	دانک توکنی هنوز سیتی
یکدشت بدرشکایت الود	من نیرگدشته که هم زرود	جون شب نشانه خردایید	مرغ خانه خودا یید
ازخلق نهفته جندماشی	نایه ده دخمنه جنده باشی	روزی دوکه هیت عزبکار	با به سرورو و بردم ما ر
جانت به سنک ریزنین	ای جان مکن این مترومیش	جان و دوت ای سرمنجان	هم سک دل وتواهنین جان
نتجنون زنجیرهای ما در	افر وخت جوشعلها واز	نالنده داننه توشنتم	خاک درتته در بهشتم
کرزرانک مرا بقل رنیت	دانک که مرادرین گنه ثبت	گر کار من این این برابود	این کار فتا و وبودنی بود

42 *Majnun Throws Himself at His Mother's Feet*

Folio 102a from a copy of the *Khamsa* of Ilyas b. Yusuf Nizami
Iran, ca. 1470(?)
Opaque watercolor, ink, and gold on paper
Text and illustration: 25.1 x 16.4 cm
s86.0061

The story of the hermit and the king made Majnun happy, and he began to ask about his friends and relatives. With tearful eyes, he inquired of his mother's health. Realizing Majnun's concern, Salim Amiri brought Majnun's mother to him. At the sight of her son, Majnun's mother could not contain her tears. She washed his hair, which had been matted with dust, and removed the thorns from his feet. Softly she asked him why he chose to live this way, pleading with him to return to a normal life. Majnun answered that the choice was no longer his and implored her to return home. The painting depicts the moment when Majnun's mother agrees to leave; Majnun, falling to his knees, kisses his mother's feet. Not long after returning home, Majnun's mother died.

43 Layla and Majnun in the Palm Grove

Folio 106b from a copy of the *Khamsa* of Ilyas b. Yusuf Nizami
Iran, ca. 1470(?)
Opaque watercolor, ink, and gold on paper
Text and illustration: 25.1 x 16.4 cm
s86.0061

One night Layla left her palace hoping to meet someone with news of Majnun. When she questioned a learned man who was passing by, he told her of her beloved's life in the wilderness. Layla began to cry and pleaded with him to arrange a meeting for them. Taking a piece of cloth that Layla had given him, the sage set out in search of Majnun. He found Majnun and convinced him to see Layla, arranging their meeting in a palm grove. At the arranged time of their meeting, Layla hid in the palm grove about ten paces away from her beloved. Majnun sensed Layla's presence and began to recite a love poem for her.

44 *Illuminated Heading and the First Fifteen Lines of Text from the Haft paykar*

From a copy of the *Khamsa* of Ilyas b. Yusuf Nizami
Iran, A.H. Rabi' II 15, 803 (December 11, 1497)
Opaque watercolor, ink, and gold on paper
Text and illumination: 18.0 x 10.0 cm
s86.0354

The *Haft paykar* (Seven Princesses) is the fourth poem in Nizami's quintet. Composed in 1197, the poem is dedicated to the Seljuq prince of Maragha, Ala'uddin Kurp Arsalan. Using the imagery of the Sasanian monarch Bahram Gur, the *Haft paykar* describes the education and behavior of an ideal ruler. The poem culminates in the story of the seven princesses with whom Bahram Gur is in love. Each princess is associated with a different planet, color, and day of the week, and represents a different aspect of love. Nizami employs Bahram Gur's passion for the princesses as a means of demonstrating that physical attraction is most enjoyed when set in the context of princely virtue, simplicity, and kindness.

45 *Nushirwan Listens to the Owls*

From a copy of the *Khamsa* of Ilyas b. Yusuf Nizami
Iran (Tabriz), ca. 1525
Opaque watercolor, ink, and gold on paper
Text and illustration: 19.3 x 12.1 cm
s86.0214

One day the Sasanian king Nushirwan and his vizier came on a ruined and deserted village. Disturbed by the sound of two owls hooting from a ruined building, Nushirwan asked his vizier what secrets the birds were telling each other. The vizier answered that one of the owls was giving his daughter in marriage to the other and was asking that in return she be granted one or two ruined villages as her nuptial settlement. The second owl, continued the vizier, replied, "If our worthy sovereign persists in his present courses and leaves his people to perish in misery and neglect, I will gladly give not two, not three, but a hundred thousand ruined villages." Nushirwan then realized the importance of preserving his good name and so reversed his oppressive policies.

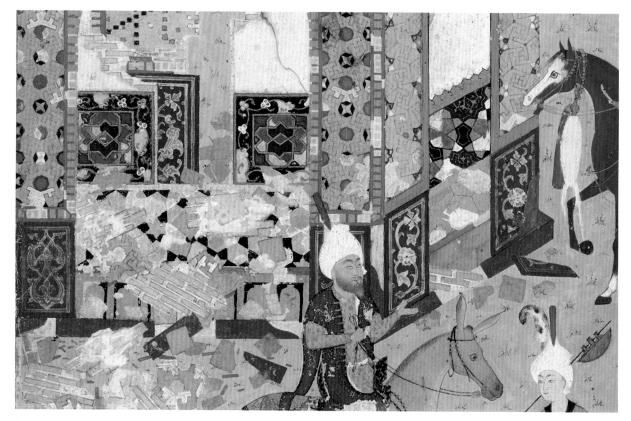

detail

46 *A Prince Enthroned Surrounded by Attendants*

From an unidentified text
Iran (Herat), ca. 1425–30
Opaque watercolor, ink, and gold on paper
Page: 21.7 x 13.4 cm
s86.0142, s86.0143

With its intense colors, carefully controlled lines, and elegant details, this image resonates with subtle rhythms and patterns. Although the manuscript from which the painting was removed has yet to be identified, the seated prince, with his round face and thin moustache, appears to be an idealized portrait of the Timurid prince Baysunghur (1399–1433). Devoid of any outward signs of emotion, the figures present a glacial facade typical of images found in paintings associated with Baysunghur's patronage.

detail

For full image, see pages 156–57.

47 *A Prince Enthroned*

Folios 1b-2a from a copy of the *Mathnawi* (Fifth Book) of Jalaluddin Rumi
Iran (Herat), A.H. 863 (A.D. 1458–59)
Opaque watercolor, ink, and gold on paper
Page: 16.4 x 10.5 cm
s86.0035

The *Mathnawi* of Jalaluddin Rumi (1207–1273) is composed of twenty-seven thousand couplets in six books. Although it is not known when Rumi began writing the *Mathnawi,* the first book probably was started shortly before the Mongol sack of Baghdad in 1256. Rumi continued to work on the treatise until his death in 1273.

The double-page painting that forms the frontispiece to this copy of the manuscript was added to the book at the Safavid court of Shah Tahmasp (r. 1524–76) around 1530. Although the painting's imagery is in keeping with Rumi's many analogies between royal pastimes and mystical enlightenment, it does not portray a specific scene from the text.

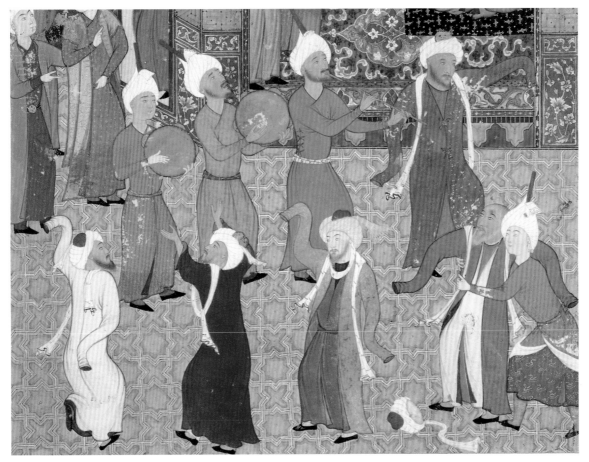

detail

For full image, see pages 158–59.

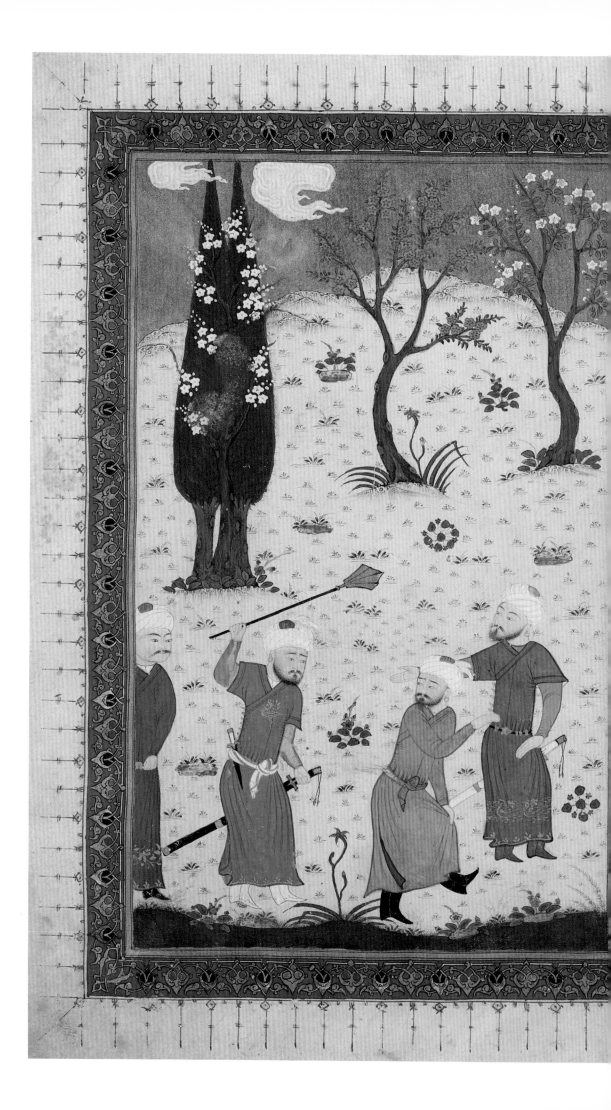

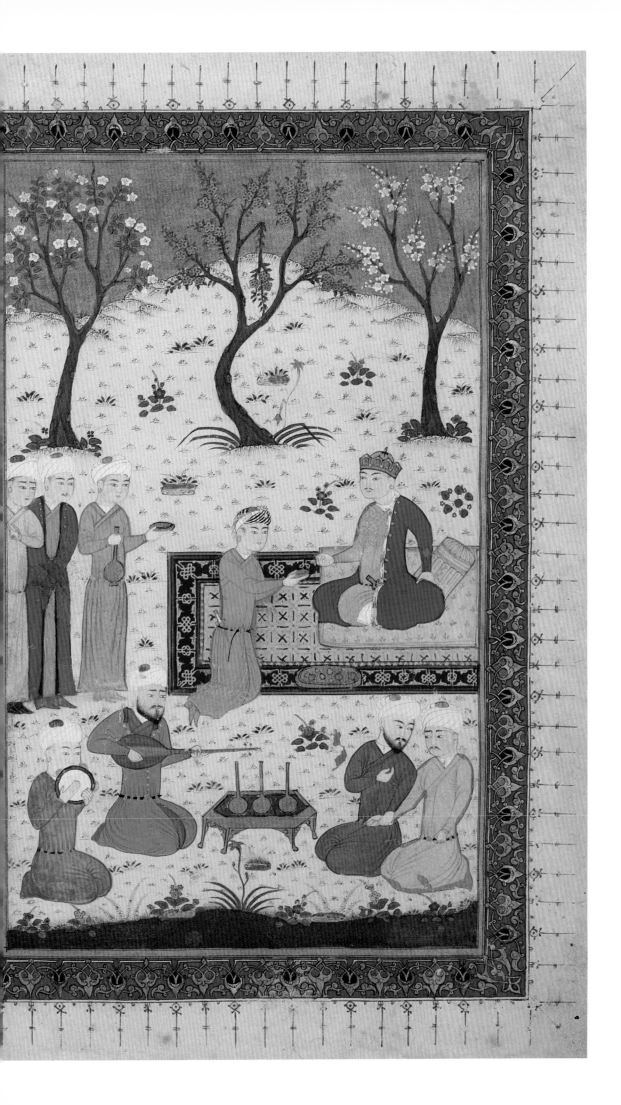

157

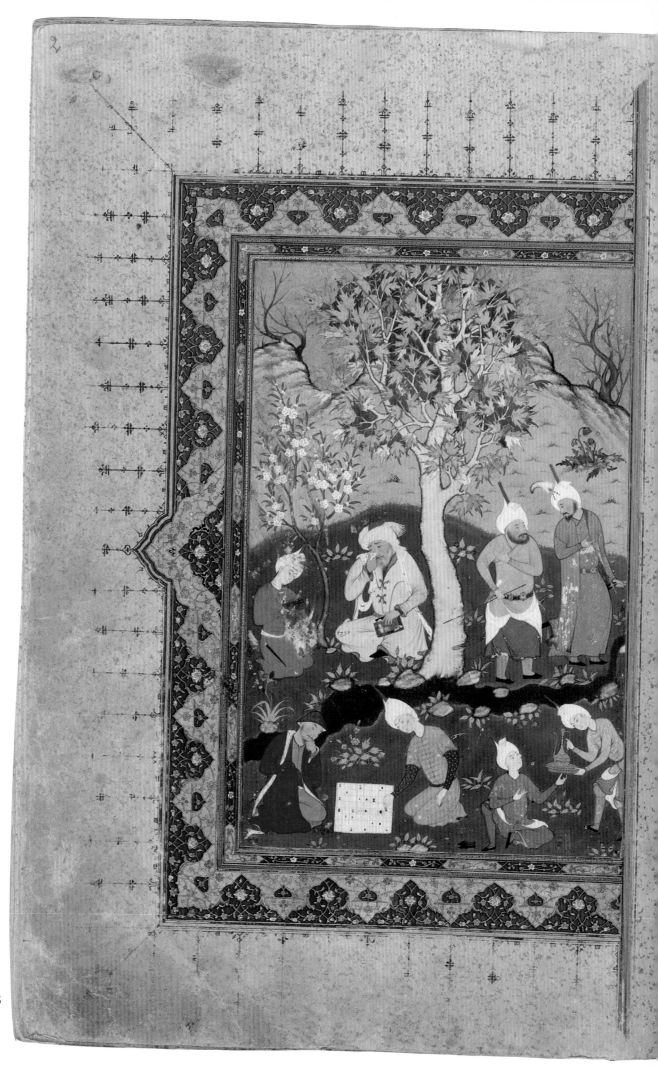

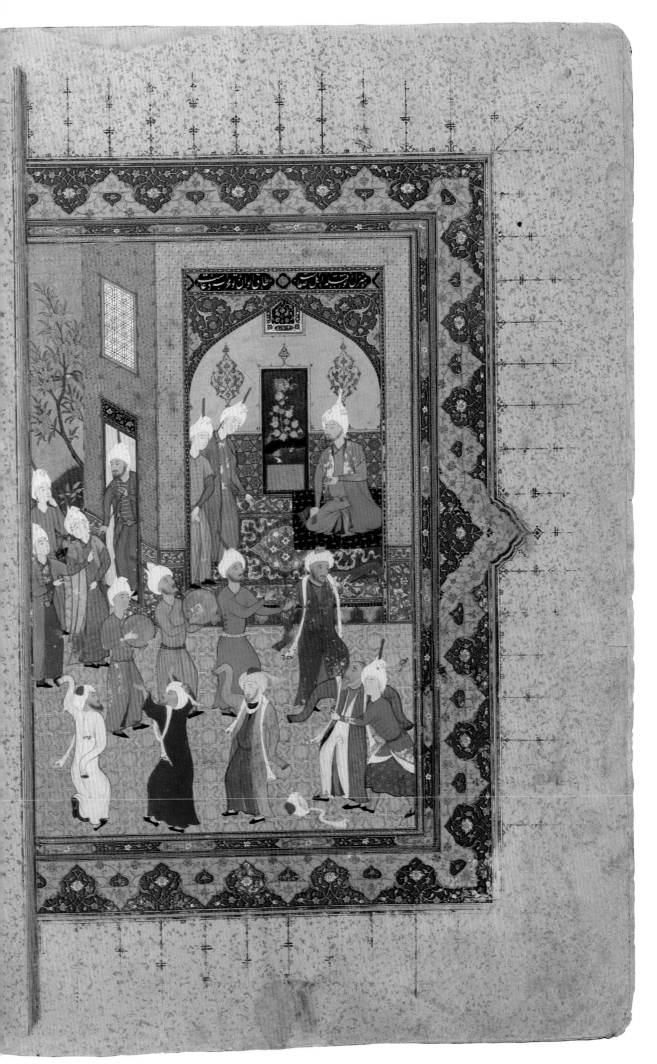

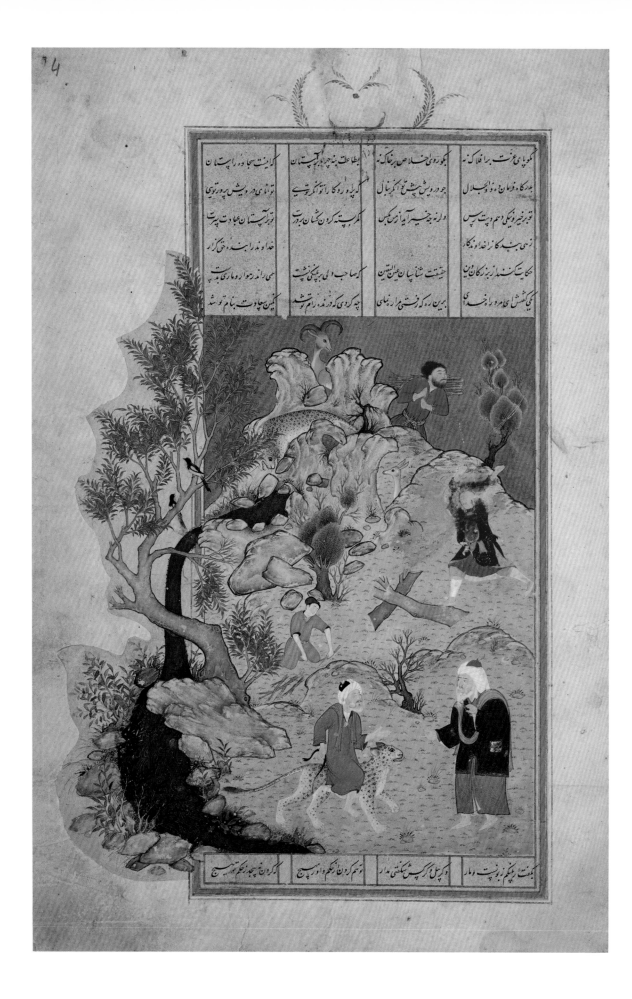

48 A Pious Man Rides a Leopard

Folio 4a from a copy of the *Bustan* of Abu-Abdullah Mushrifuddin b. Muslih Sa'di
Iran (Herat), A.H. Ramadan 931 (June–July 1525)
Opaque watercolor, ink, and gold on paper
Text and illustration: 20.6 x 13.7 cm
s86.0036

One of the stories in the great treatise on didactic and ethical questions by the Persian poet Sa'di (ca. 1200–1290/91), the *Bustan* (Orchard) concerns a pious man seen riding a leopard and holding a snake. Overcome with amazement, a nearby observer asked the man how he was able to tame such wild creatures. He responded that faith and belief in God dismiss the fear of wild animals and grant protection against enemies. The artist has constructed an elaborate scene with carefully rendered figures—woodsmen at work and animals peering out from the rocks—and a finely detailed landscape.

49 *Babur Receives a Courtier*

Attributed to Farrukh Beg
From a copy of the *Baburnama* of Zahiruddin Muhammad Babur
Pakistan (Lahore); Mughal, ca. 1589
Opaque watercolor and gold on paper
Illustration: 26.0 x 15.2 cm
s86.0230

Zahiruddin Muhammad Babur (r. 1526–30) was the first of the great Mughal emperors of India. Interested in poetry and literature, he wrote a remarkable memoir, the *Baburnama*, which was translated from the original Turki into Persian at the request of his grandson Akbar the Great (r. 1556–1605), to whom the finished work was presented in 1589. The new translation was illustrated with paintings by the greatest court artists; one of them, Farrukh Beg, had just arrived from Kabul at the Mughal court in Lahore.

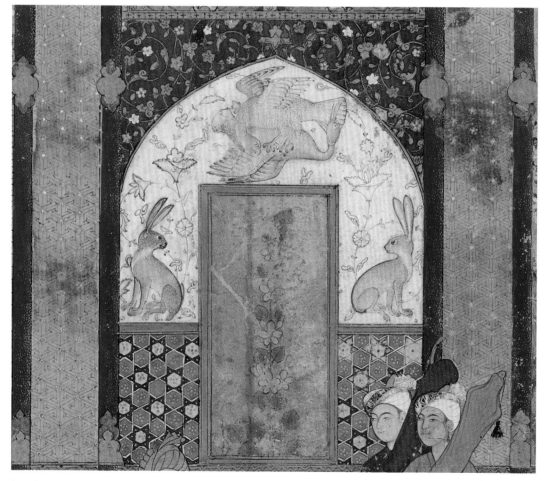

detail

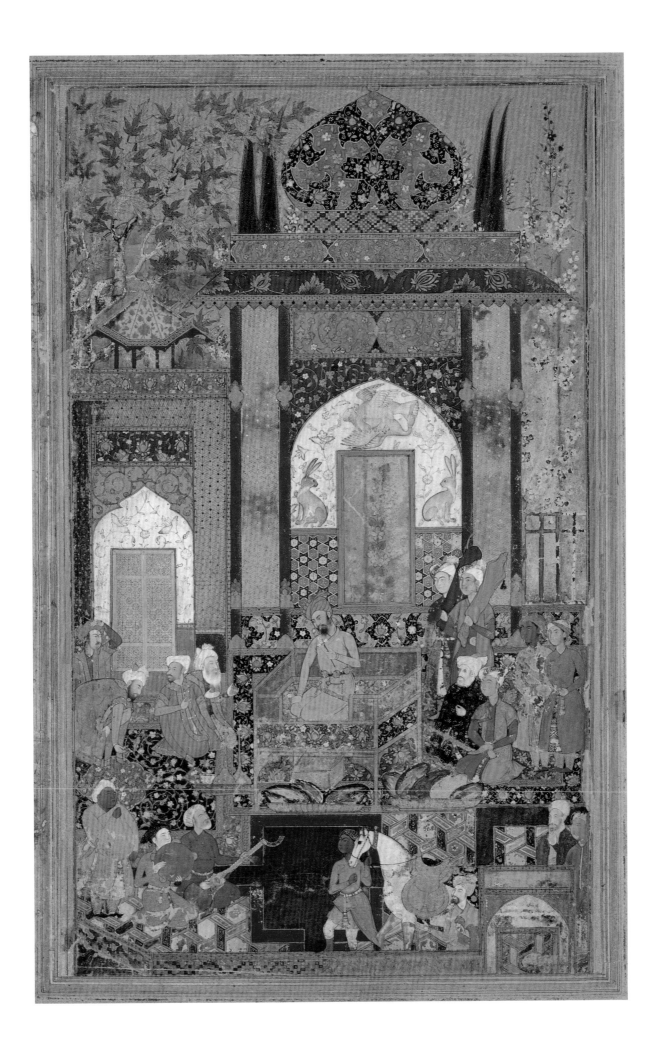

50 *A Drunken Babur Returns to Camp at Night*

Inscribed to Farrukh Beg
From a copy of the *Baburnama* of Zahiruddin Muhammad Babur
Pakistan (Lahore); Mughal, ca. 1589
Opaque watercolor, ink, and gold on paper
Text and illustration: 23.7 x 13.7 cm
s86.0231

The illustration is a precise evocation of an episode narrated with customary frankness by Babur in his autobiography:

> Having ridden out at the Mid-day Prayer for an excursion, we got on a boat and *'araq* was drunk. . . . We drank in the boat till the Bedtime Prayer; then getting off it, full of drink, we mounted, took torches in our hands, and went to camp from the river's bank, leaning over from our horses on this side, leaning over from that, at one loose-rein gallop! Very drunk I must have been for, when they told me the next day that we had galloped loose-rein into the camp, carrying torches, I could not recal [sic] it in the very least. After reaching my quarters, I vomited a good deal. (Annette Susannah Beveridge, trans., *The Baburnama in English* [Reprint, London: Luzac, 1969], pp. 287–88)

دوست بیک میرزا قلی احمدی کدایی محمد علی جنگ جنگ
پیس او عان پردی مغول اہل نغمہ روح دم بابا جان
قاسم علی یوسف علی تینکری قلی ابوالقاسم رمضان
لولی تا نماز خفتن درکشتی عرق خوردہ نماز خفتن ازکشتی
مست نافع برآمدہ سوار شدہ مشعل را در دست خود کرفتہ
ازکنار دریا تا دروازین طرف اسپ افتادہ وان طرف
اسپ افتادہ یک جیلا و تاختہ امدہ ام عرب منشی بودام

51 *Babur and Humayun with Courtiers*

From the Late Shahjahan Album
India; Mughal, ca. 1650
Opaque watercolor and gold on paper mounted on board
Page: 45.0 x 33.0 cm
Illustration: 21.0 x 12.6 cm
s86.0401

The emperor Babur is shown with his son and successor, Humayun (r. 1530–40; 1555–56), in a portrait made for an album of pictures and calligraphy commissioned by Shahjahan (r. 1628–58), Babur's great-great-grandson. Such images were family portraits as well as statements reasserting lines of imperial succession.

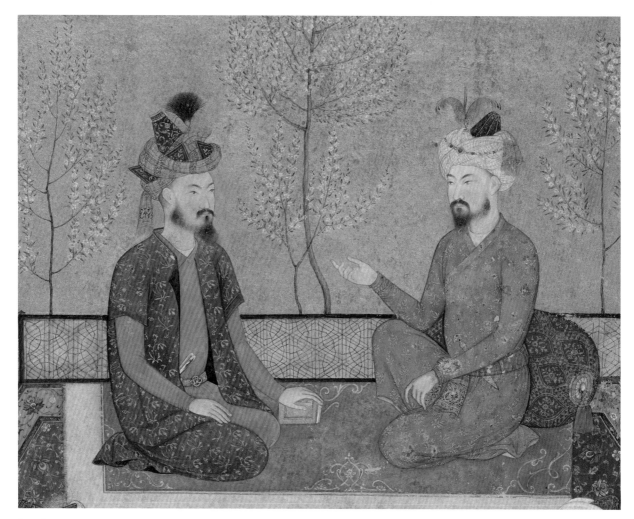

detail

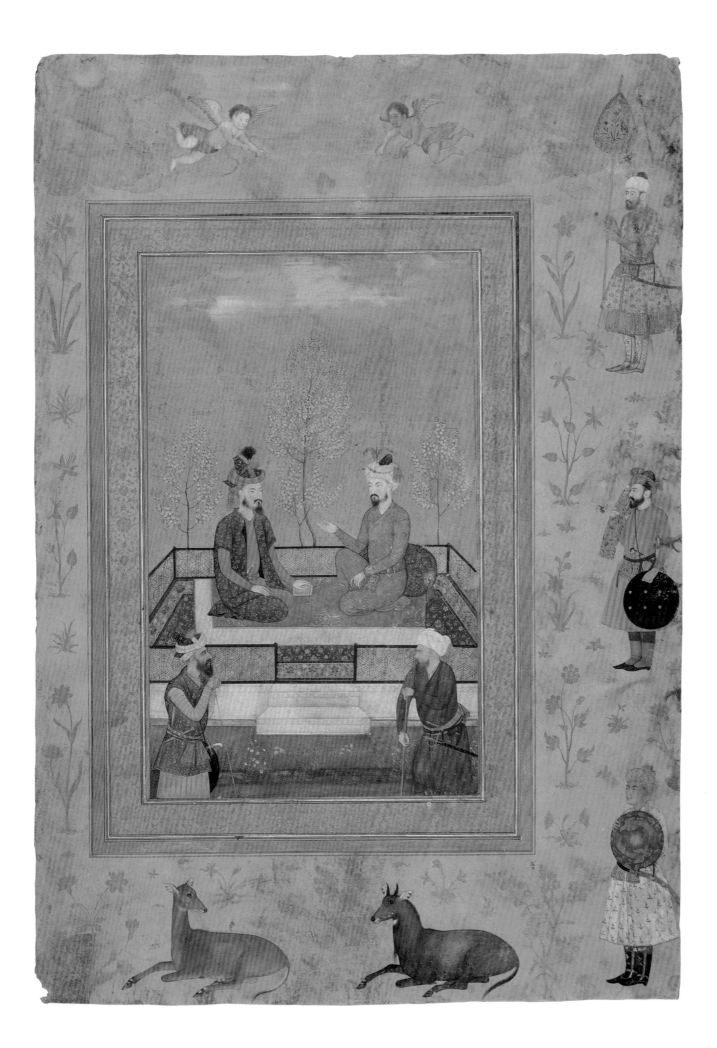

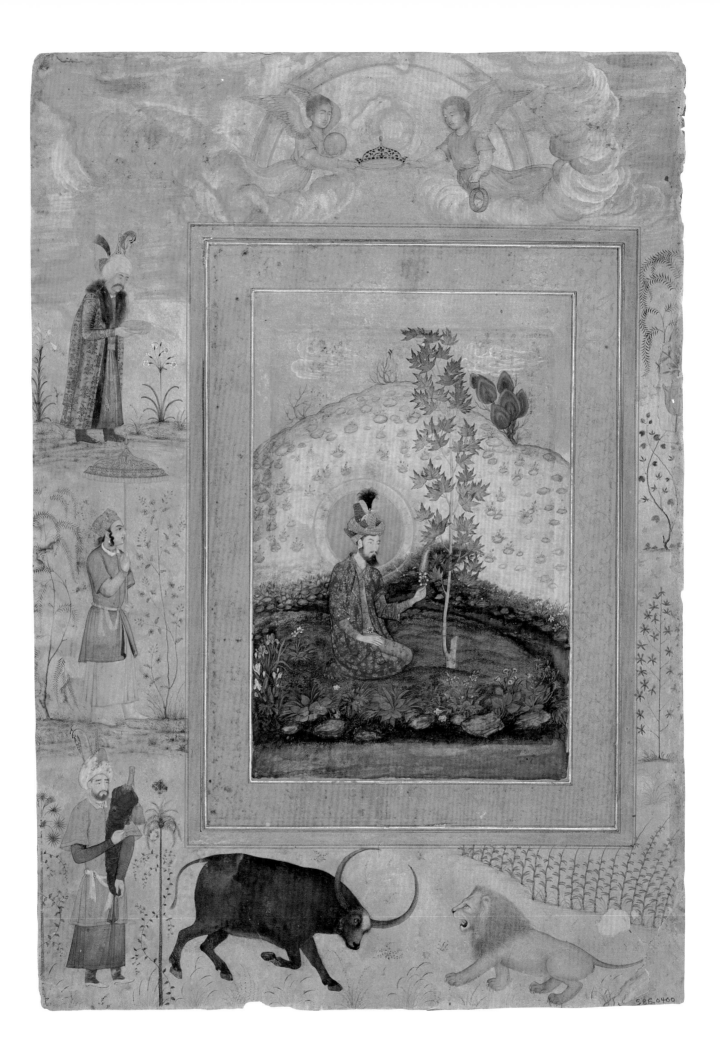

52 *Humayun Seated in a Landscape*

By Payag
From the Late Shahjahan Album
India; Mughal, ca. 1650
Opaque watercolor and gold on paper mounted on board
Page: 44.4 x 33.0 cm
Illustration: 18.8 x 12.3 cm
s86.0400

Seated in a tranquil landscape, the emperor Humayun examines a *sarpech*, a jeweled turban ornament in the shape of a feather. The image purposely associates the emperor with wealth and power, symbolized by the luxury and peacefulness of the scene. Made for the Late Shahjahan Album, it is an idealized view of Shahjahan's ancestry. Humayun's life, in fact, was anything but calm; for fifteen years he was exiled from India, homeless and virtually destitute.

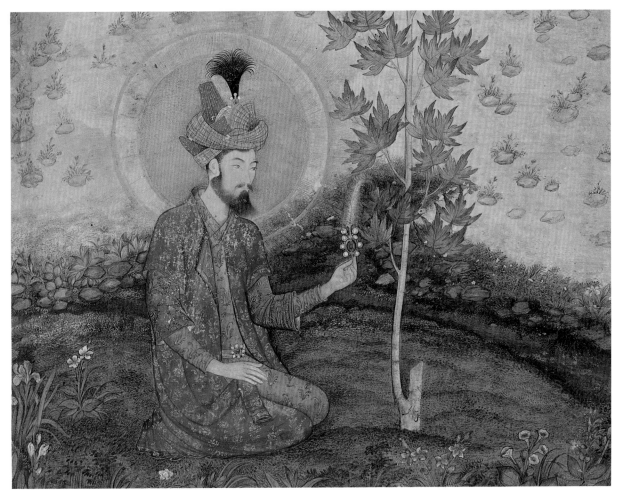

detail

53 *Jahangir with Courtiers*

From the Late Shahjahan Album
India; Mughal, ca. 1650
Opaque watercolor and gold on paper mounted on board
Page: 44.9 x 33.0 cm
Illustration: 25.5 x 20.1 cm
s86.0407

The emperor Jahangir is shown greeting his brother-in-law, Asaf Khan (d. 1641), one of the chief nobles at the Mughal court. When bound into the Late Shahjahan Album, the painting would have faced an almost identical image showing Shahjahan and Dara-Shikoh (1616–1659), his eldest and favorite son and intended successor. Dara was also Asaf Khan's grandson. The combined pages would thus provide a carefully calculated acknowledgment of Asaf Khan's importance.

54 *Shahjahan Enthroned with Mahabat Khan and a Shaykh*

Inscribed to Abid
From the Late Shahjahan Album
India; Mughal, A.H. Shahjahani II (A.D. 1629–30)
Opaque watercolor and gold on paper
Page: 36.9 x 25.1 cm
Illustration: 30.2 x 19.8 cm
s86.0406

On February 4, 1628, the first day of his accession celebrations, Shahjahan gave to Mahabat Khan (d. 1634) the title commander-in-chief and responsibility for the imperial armies. At the same time, he distributed coins, jewels, and other gifts to members of his family, the nobility, and men important within the Muslim religion. The episode shown here—Mahabat Khan is just left of the emperor—probably was originally intended for inclusion in the official contemporary history of Shahjahan's reign, the *Padishahnama*. That manuscript may never have been finished, however, and the illustration was placed instead in the Late Shahjahan Album.

detail

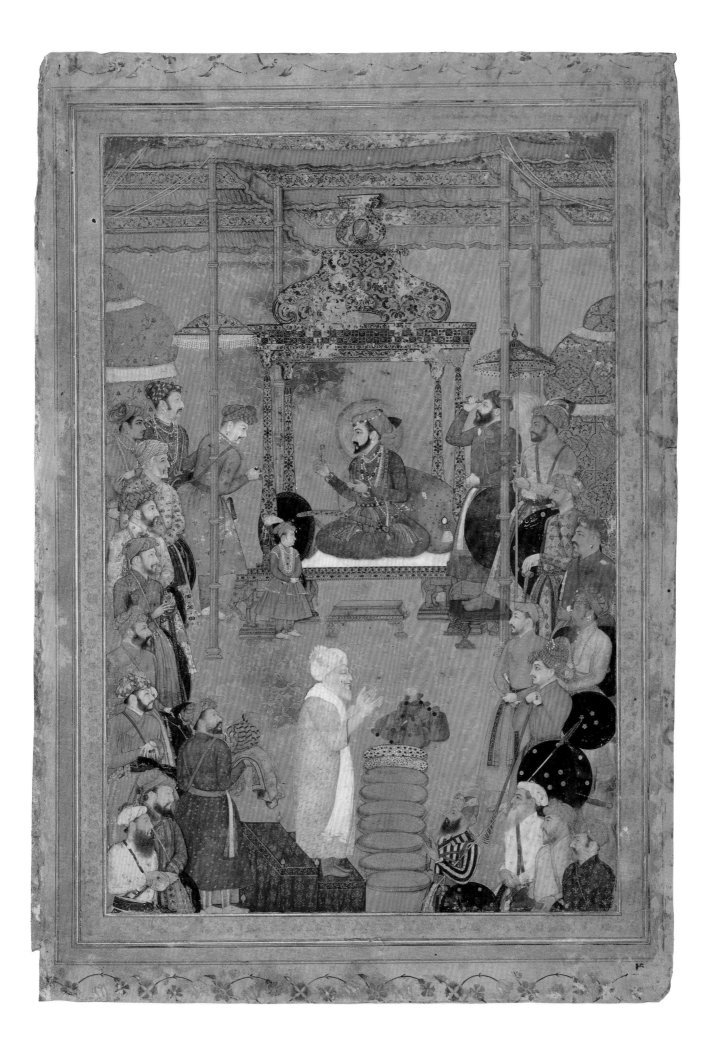

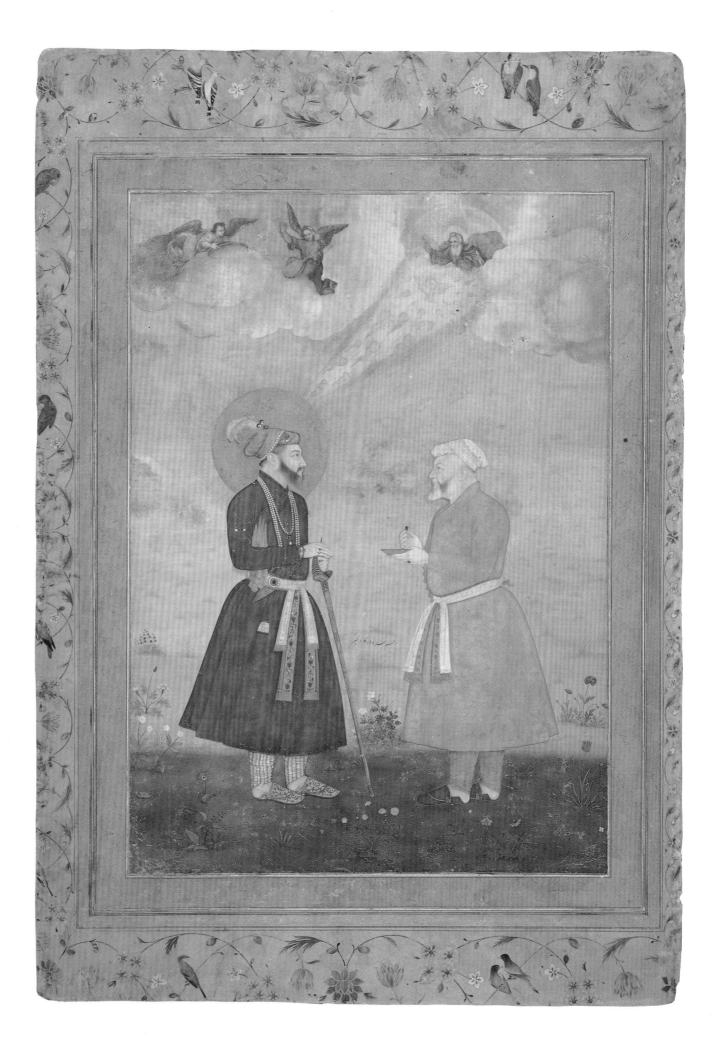

55 *Shahjahan with Asaf Khan*

Inscribed to Bichitr
From the Late Shahjahan Album
India; Mughal, ca. 1650
Opaque watercolor and gold on paper mounted on board
Page: 44.0 x 32.9 cm
Illustration: 26.3 x 18.7 cm
s86.0403

By his military and administrative abilities Asaf Khan established his power, but it was his family ties that made his position unchallenged. His sister Nur Jahan (d. 1645) was the favorite wife of Emperor Jahangir, while his daughter Mumtaz Mahal (1592–1631) married Shahjahan, who built the Taj Mahal as her tomb.

European prints and paintings brought by missionaries and traders suggested new symbols, which were readily adapted by Mughal artists. Depicted here, angels watch as God the Father casts the light that becomes Shahjahan's halo. The emperor saw himself as divine, and Asaf Khan served as intermediary between the godlike emperor and his subjects.

56 *A Poem by Amir Shahi*

From the Late Shahjahan Album
Calligraphy by Mir-Ali al-Sultani
Iran, sixteenth century
Opaque watercolor, ink, and gold on paper mounted on board
Page: 47.0 x 35.0 cm
Text: 22.6 x 13.0 cm
s86.0090

The poem can be translated as follows:

My heart is caught in your wavy hair.
My head bows only on your path.
Wash with ambergris the tablet of the gracious mind
That the condition of love be one heart and one lover.
Laugh at the fair since not one of a thousand roses of your springtime has yet bloomed.
Close your eyes like narcissus to the good and bad of the world
For in this garden the rose is one thing and the thorn another.
Shahi, do not be sad if your heart is upset
For the condition of the world is never stable.

detail

57 Calligraphy

From the Late Shahjahan Album
Iran, ca. 1640–50
Opaque watercolor, gold, and ink on paper mounted on board
Page: 36.9 x 25.3 cm
Text: 19.0 x 10.0 cm
s86.0094

The center poem can be translated as follows:

> In this ancient wayward inn
> How ignorant have human beings remained.
> Though they spend a lifetime in wealth and affluence,
> They do not appreciate it until they come to grief.

The calligraphy framing the poem reads:

> I am unable to express thanks for kindness.
> Tis better if I raise my hand in prayer.
> How great is the sea of liberality and the mine of generosity;
> Their existence is a manifestation of your being.
> It will not fit into this slim volume:
> A description of the king is beyond scope.
> If Sa'di is to compose all of that,
> It will take another volume.

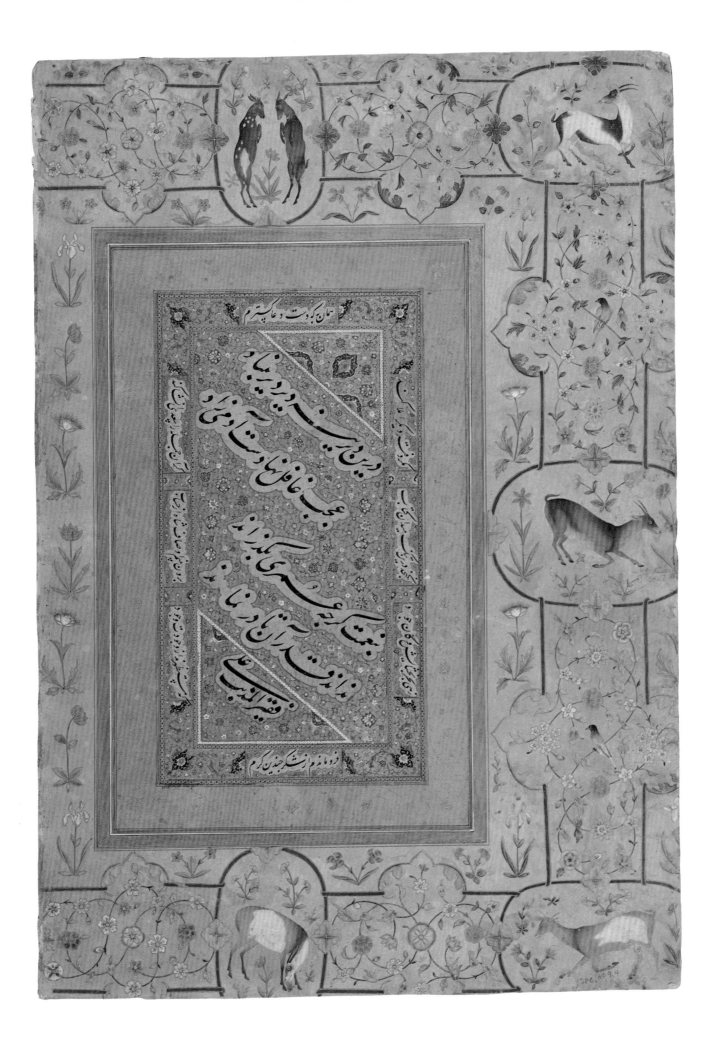

58 *An Old Woman and Two Sages in a Garden*

Iran (Bukhara), ca. 1520–30
Opaque watercolor, ink, and gold on paper mounted on an album page
Illustration: 22.1 x 14.2 cm
s86.0216

Set in a lush garden, the idealized scene in this painting depicts an elderly woman before two sages. The flat colors, conventional figures, and straightforward composition are typical of painting associated with the sixteenth-century Uzbek court at Bukhara. On the reverse of the painting is a panel of calligraphy inscribed with the words, "Ali is the sea of eternity. Ali is the successor of Muhammad."

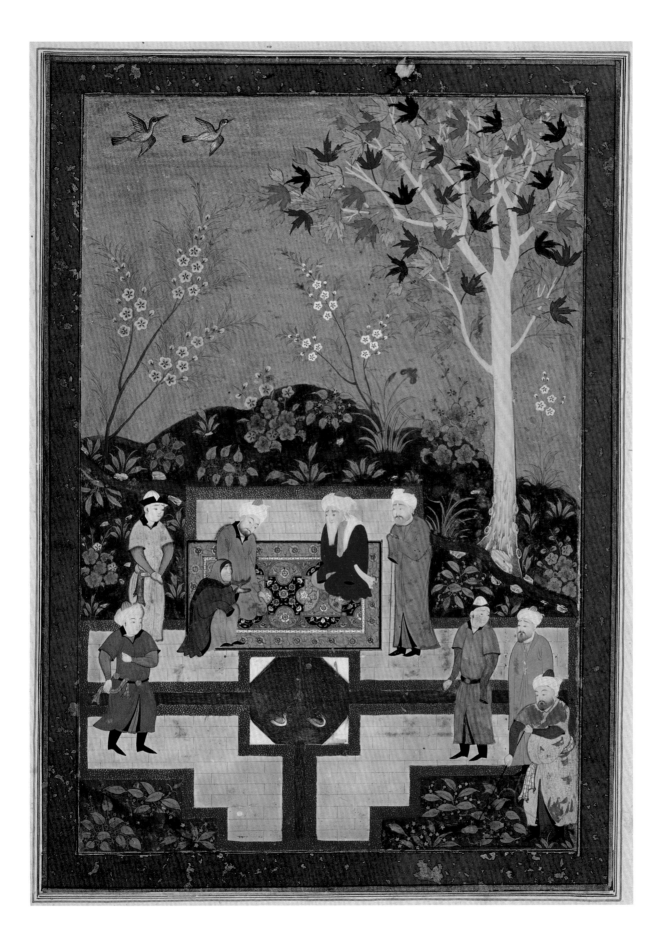

59 *A School Scene*

Attributable to Mir Sayyid-Ali
Iran (Tabriz), ca. 1540
Opaque watercolor, ink, and gold on paper mounted on board
Illustration: 27.0 x 15.1 cm
s86.0221

Composed of a series of interrelated scenes, this painting vividly depicts a master disciplining a youth, a group of students copying texts, craftsmen making paper, and several men cooking by an open fire. Although the lively vignettes create the impression of having been drawn from life, they are composed for the most part of stock images. For instance, the setting of the school, the man leaning on a staff, and the master beating a student are all based on details found in sixteenth-century Persian painting. The artist Mir Sayyid-Ali transformed the generic quality of the images into specific scenes by concentrating on the description of minute details, such as the shoes in the niches in front of the school or the colored paper drying in the foreground.

detail

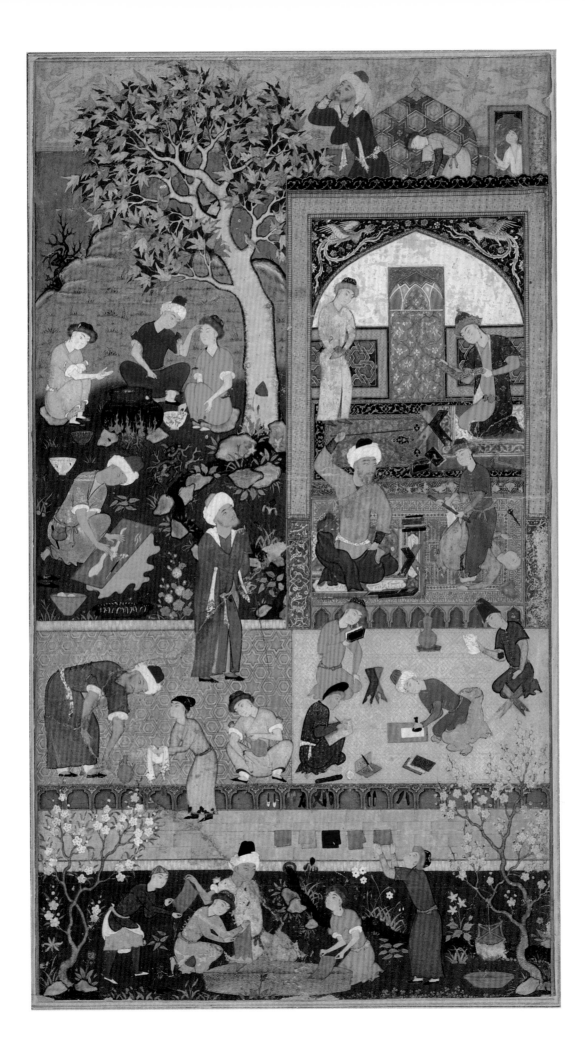

60 *Sulayman and Bilqis Enthroned*

Iran (Isfahan), ca. 1590–1600
Opaque watercolor, ink, and gold on paper mounted on board
Illustration: 24.9 x 18.0 cm
s86.0186

The great ruler Sulayman (Solomon) was endowed with the gift of communicating with the birds and the wind. Through the aid of a hoopoe he married Bilqis, the queen of Sheba, whose beauty was renowned. In this painting Sulayman and his queen are surrounded by their retinue of supernatural spirits, demons, men, and birds. Seated next to the king and queen is Asaf b. Barkhiya, Sulayman's prudent and wise grand vizier. There are many references to Sulayman in Islamic literature, including the following evocative passage from the Koran (Sura XXVII: 16–17):

> And Solomon was David's heir. And he said: O mankind! Lo! we have been taught the language of birds, and have been given (abundance) of all things. This surely is evident favour.
> And there were gathered together unto Solomon his armies of the jinn and humankind, and of the birds, and they were set in battle order.

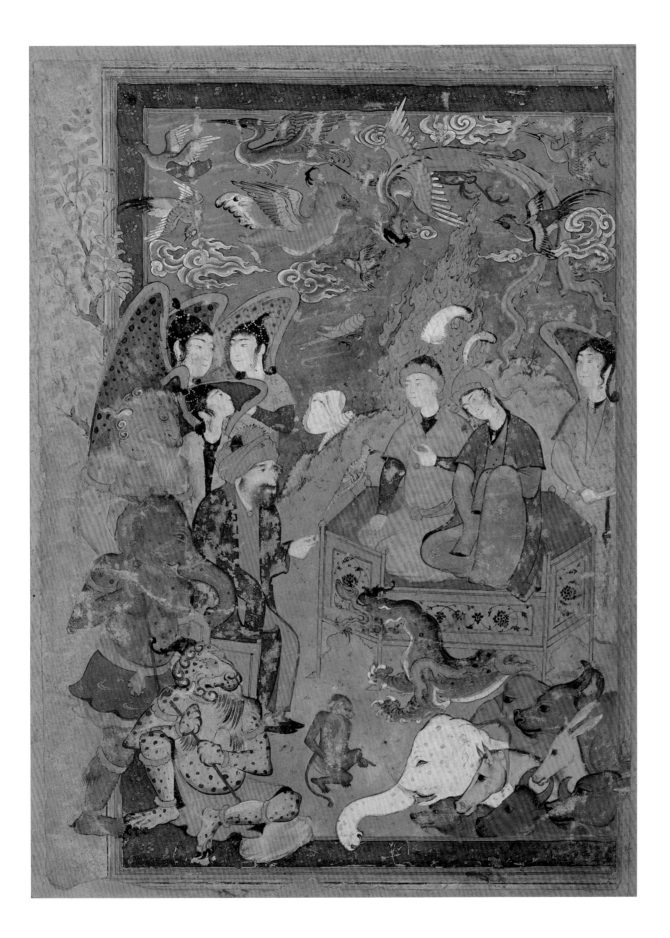

61 *A Hunt*

Iran (Tabriz), ca. 1530–40
Ink and color on paper mounted on an album page
Page: 26.5 x 20.5 cm
Illustration: 14.9 x 9.5 cm
s86.0290

"There were four things chosen for kings to do: Feasting, polo, war, and hunting." These words of Farrukhi of Sistan, a medieval Iranian poet, reflect hunting's importance as one of the princely activities par excellence. As a metaphor for bravery, skill, and valor, the royal hunt frequently was employed in Persian literature and painting. By the sixteenth century, when this drawing was executed, the imagery of the hunt had acquired a secondary series of associations. In mystical literature the hunt came to symbolize the quest for knowledge and release from the trappings of the material world.

62 *A Hunt*

Inscribed by Riza Abbasi
Iran (Isfahan), A.H. Shawwal 1, 1035 (June 26, 1626)
Ink and color on paper mounted on an album page
Illustration: 26.0 x 16.9 cm
s86.0314

This large, finely drawn hunting scene is typical of Riza Abbasi's work during the 1620s. The inscription in the center of the image was almost certainly written by the artist himself. It reads:

The first day of the month of auspicious Shawwal in the year [A.H.] 1035 [June 26, 1626]. This drawing was colored. The work of the humble Riza Abbasi.

63 *A Prince and a Princess Embrace*

Inscribed to Abdullah
Iran (Bukhara), ca. 1550
Opaque watercolor, ink, and gold on paper mounted on an album page
Text and illustration: 17.0 x 19.2 cm
s86.0301

This painting is typical of a number of portraits attributed to Abdullah, an artist who worked for the Shaybanid (1500–1598) ruler Abdul-Aziz (r. 1540–49) at Bukhara. The three couplets in Persian that surround the embracing couple echo the sentiment of the image:

> Your figure is like the delicate cypress,
> O my beloved, your stature is like the fir.
> Even if the cyprus reaches the height of the heavenly lote tree,
> When will it be equal to your stature?
> Without embracing the sapling of your stature,
> When shall I eat the fruit of the tree of hope?

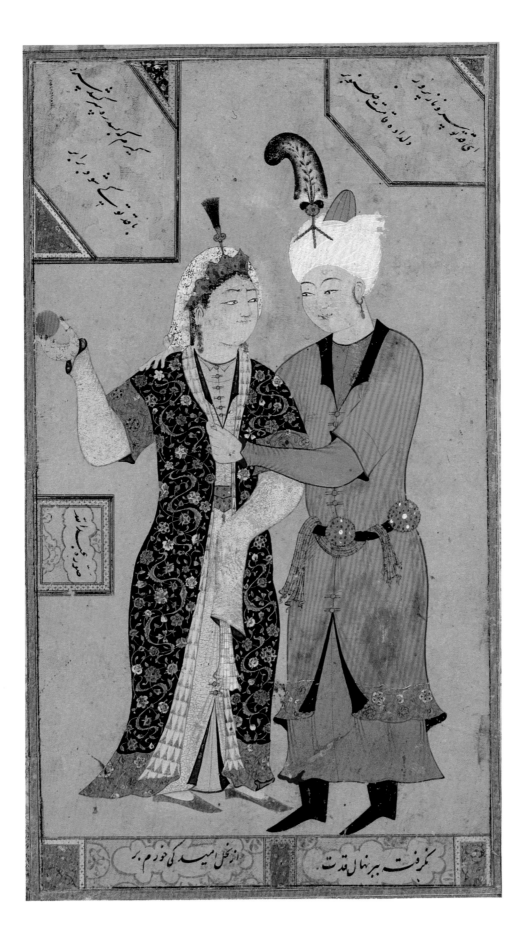

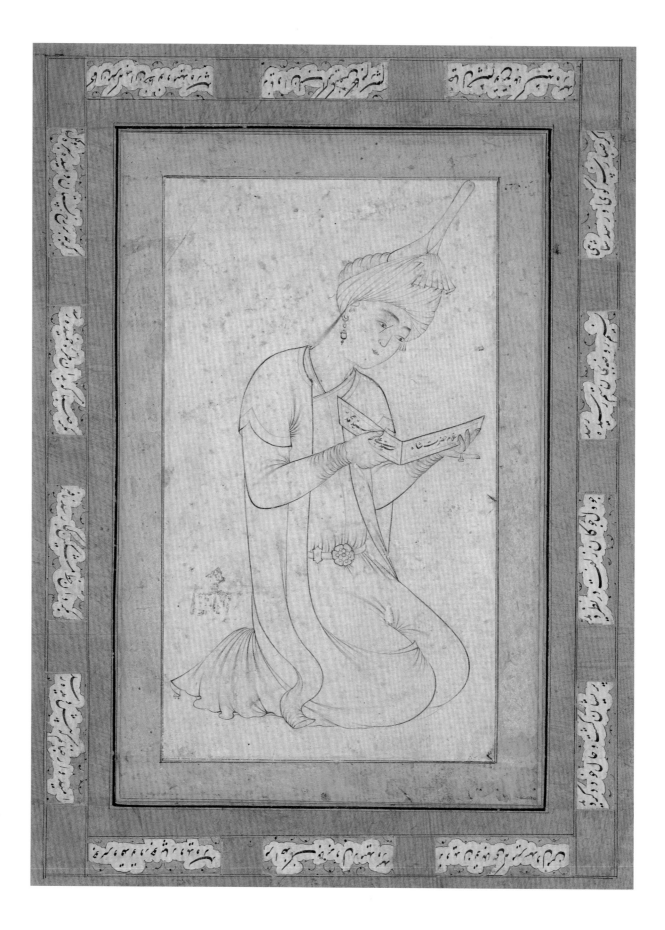

64 *A Seated Youth*

Attributable to Mir Sayyid-Ali
Inscribed to Sayyid-Ali b. Sayyid Muhammad
Iran (Tabriz), ca. 1540
Ink on paper mounted on an album page
Page: 40.1 x 25.2 cm
Illustration: 16.8 x 9.7 cm
s86.0291

The inscription on the tablet held by the youth reads, "The slave of his majesty the king, Sayyid-Ali b. Sayyid Muhammad." The inscription does not clearly indicate whether Sayyid-Ali was the author or subject of the drawing, or both. The strong lines, well-articulated form, and fine details are typical of Mir Sayyid-Ali's work. He may well have intended this to be a self-portrait.

65 *A Reclining Prince*

Attributable to Aqa Mirak
Iran (Tabriz), ca. 1530
Opaque watercolor and gold on paper mounted on an album page
Illustration: 15.6 x 12.6 cm
s86.0300

The sweeping lines and finely rendered features of the idealized figure are remarkably vital and lively. The verse inscribed on the tablet held by the prince establishes a literary parallel to the figure's elegance by alluding to the fabled beauty of the biblical Joseph:

Fate granted such beauty to the face of Yusuf.
Try to draw such [beauty] for your face, O slave.

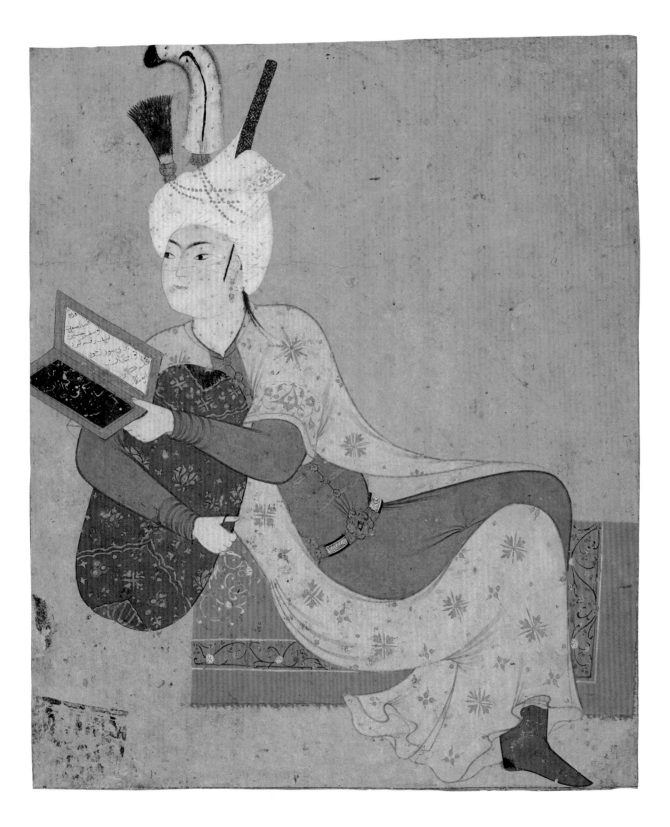

66 *A Youth and an Old Man*

Painting inscribed by Aqa Riza (also known as Riza Abbasi)
Calligraphy inscribed by Mir-Ali Katib
Iran (Isfahan), ca. 1605
Opaque watercolor and gold on paper mounted on an album page
Text and illustration: 32.6 x 21.4 cm
s86.0292

The subject of this colored drawing—an old man's attraction for a handsome young man—is a common metaphor in Persian art and poetry for the adoration of divine beauty. The sinuous lines of the drawing reinforce the subtle interplay between the alluring gesture of the youth and restrained anticipation of the old man. Above and below the image are couplets copied in 1530–31 by the renowned calligrapher Mir-Ali Katib. Encircling the page and providing an apt counterpoint to the drawing is a poem from the *Sharafnama* (Book of Honor), the fifth poem of Nizami's *Khamsa*, which describes the dispute between the people of Rum and China concerning the art of drawing. It reads:

> One said, "The painting [drawing] of Rum was liked in all countries."
> Another said, "Have you not heard that the art of painting in China is noted in the world?"
> A difference arose of the excelling glory in the judgment of [the art of painting] of the Rumi and the Chinese.
> Each made according to his statement an example of drawing from his pen.
> It was finally decided that they should build an arched [vaulted] building
> Between the two brows of the high vault [arch] to set forth a curtain for painting:
> One side for the Rumi to do his work, and the other side for the Chinese to draw.
> [They were] not to see one another's design until the time the competition came to an end.

67 *A Seated Princess*

Painting attributable to Muhammad-Sharif Musawwir
Borders inscribed to Muhammad Murad Samarqandi
Iran (Bukhara?), ca. 1600
Opaque watercolor and gold on paper mounted on an album page
Page: 44.6 x 31.8 cm
Illustration: 19.4 x 11.2 cm
s86.0304

This painting is the right-hand half of a double-page composition that presumably was part of an album. The left-hand half of the page, in the Musée du Louvre in Paris, depicts a seated prince.

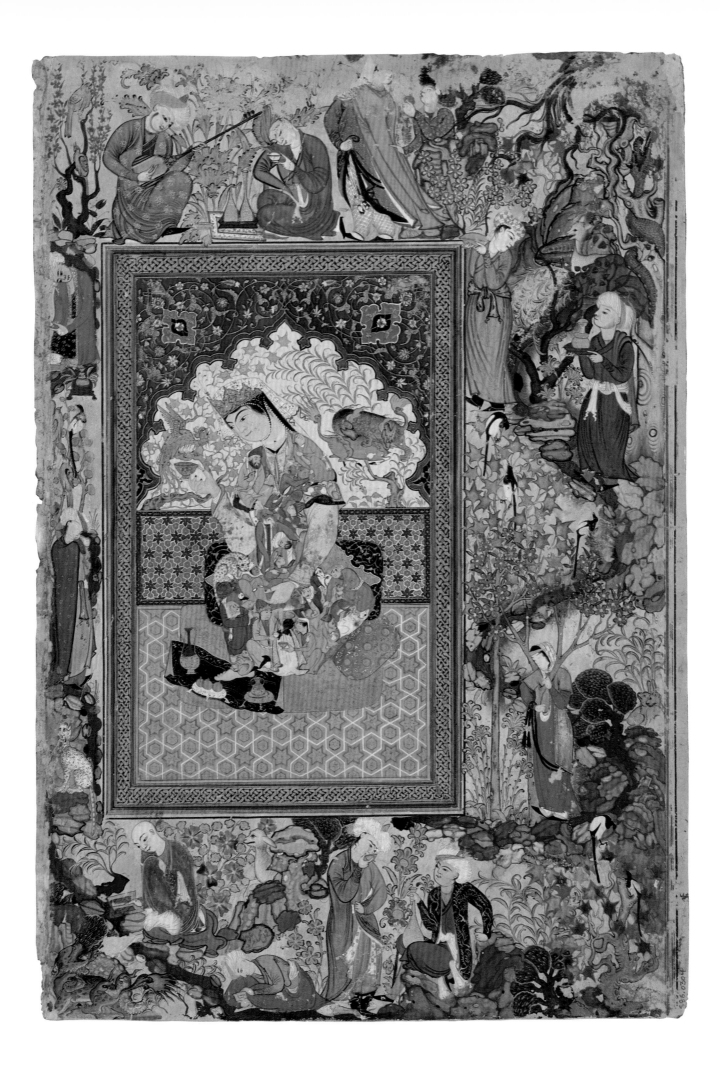

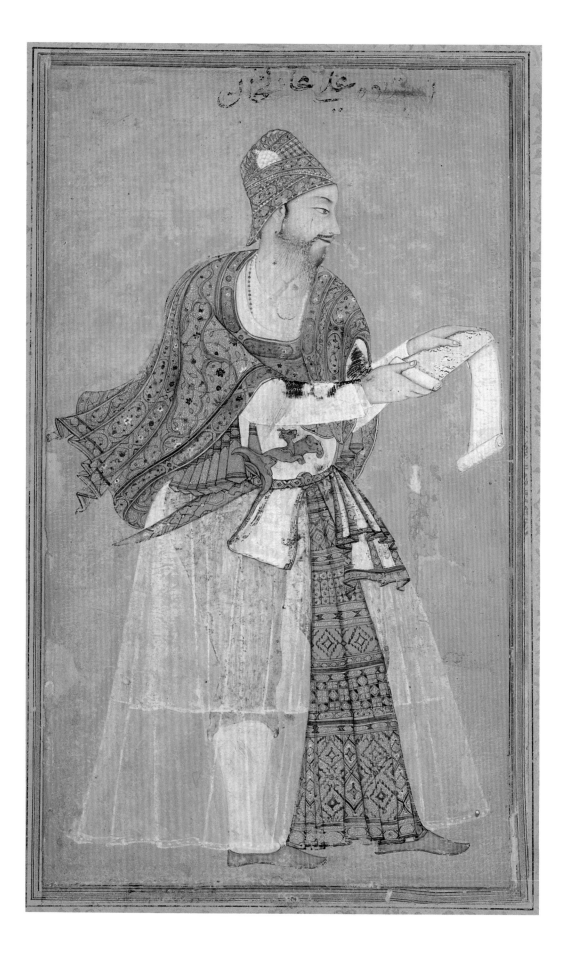

68 *Sultan Ali Adilshah 1 of Bijapur*

India, Deccan (Bijapur), ca. 1605
Opaque watercolor, ink, and gold on paper mounted on board
Illustration: 17.2 x 9.8 cm
s86.0446

Ali Adilshah 1 (r. 1557–79) had been kept imprisoned for several years by his father, Ibrahim Adilshah 1 (r. 1534–57), ostensibly because of religious differences. When the elder king died, Ali Adilshah blinded his brother, seized the throne, and began a campaign of religious persecution. He was murdered by a eunuch and succeeded by his nephew Ibrahim 11 (r. 1579–1627), then nine years old. Ibrahim became a brilliant patron of music and the visual arts. This portrait of his uncle can be dated to his reign.

69 *The Emperor Jahangir with Bow and Arrow*

India; Mughal, ca. 1605
Opaque watercolor, ink, and gold on paper mounted on board
Text and illustration: 14.8 x 7.5 cm
s86.0408

This is no idealized portrait of the emperor, for his physiognomy and character are specific and unique. Unlike contemporary works from other areas of India—the Deccan, for example—portraits made for the Mughal court provide the viewer with historically accurate information about the physical appearance of the people or objects depicted.

The inscription at the top of the page reads:

This is a portrait of Padishah Salim.
May God continue his kingdom forever.

پست تمثال پادشاه سلیم خلّد الله ملکه ابداً

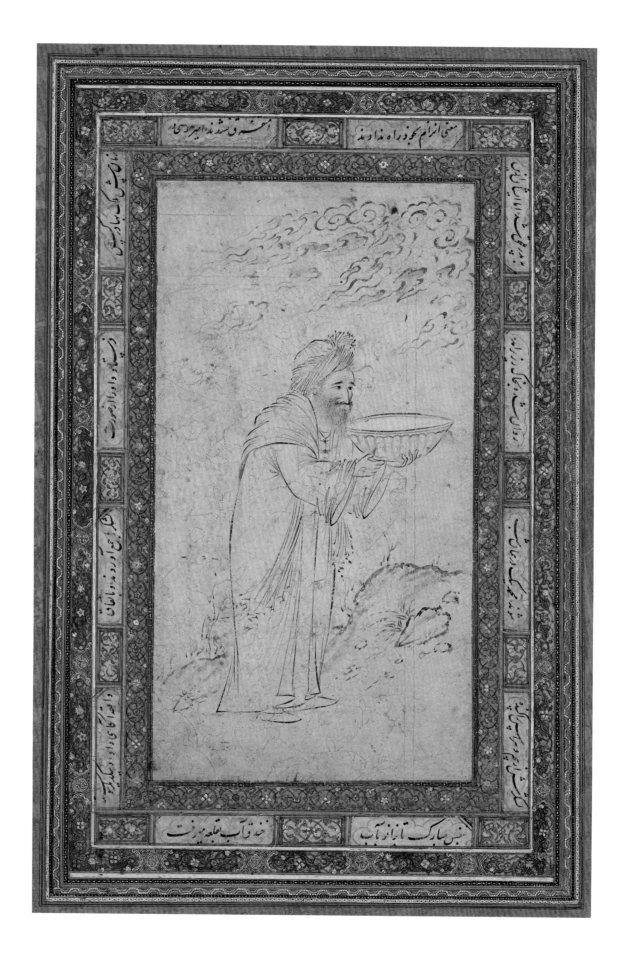

A Jeweler's Eye

70 *An Old Man Carries A Bowl*

Iran (Isfahan), ca. 1610–15
Ink and lead white on paper
Page: 37.4 x 24.5 cm
Illustration: 16.9 x 9.1 cm
s86.0303

Standing figures seen in three-quarter profile, leaning on a stick or carrying a bowl, are frequently depicted in Persian painting and drawing. Although these figures often appear to be drawn from life, they usually are based on standard compositions.

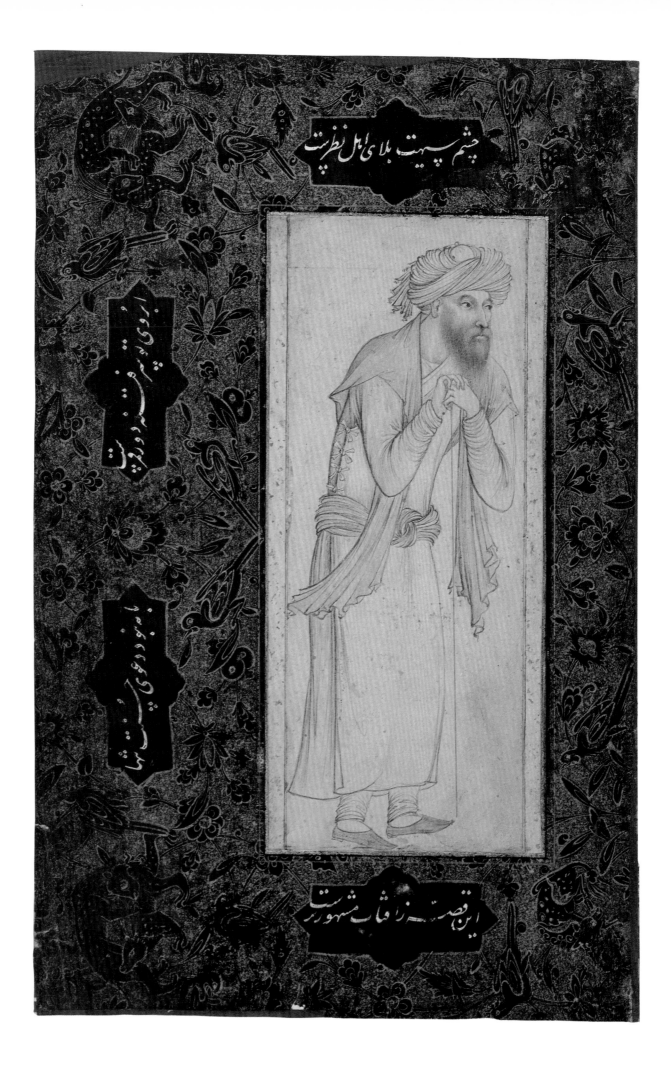

71 *A Bearded Man Leans on a Stick*

Iran (Isfahan), ca. 1630-40
Ink on paper mounted on an album page
Page: 33.7 x 22.8 cm
Illustration: 17.4 x 6.6 cm
s86.0312

The subject of this portrait, although based on a standard composition, is drawn with finely rendered features and a thoughtful expression. The poetry on the album page provides a kind of literary parallel to the drawing:

Your black eyes are the affliction of viewers,
Your brows are as mysteriously fascinating as the halo around the moon.
You shouldn't claim only the moon's beauty:
This tale is more well known than the sun.

72 Dara-Shikoh with Mian Mir and Mulla Shah

India; Mughal, ca. 1635
Opaque watercolor and gold on paper
Illustration: 17.0 x 10.4 cm
s86.0432

Dara-Shikoh and his sister Jahanara were followers of the religious teacher Mulla Shah (d. 1661). This sage, who continued the teachings of Mian Mir (d. 1636), the great Sufi mystic of Lahore (in present-day Pakistan), accepted Dara as a disciple in 1640.

While it was not unusual for a Mughal ruler or prince to establish the appearance of devotion to a great religious sage, Dara's link was profound and sincere. He had first met Mulla Shah in 1635, when he and his wife, Nadira Begum, had sought solace from Mian Mir at the death of their first child. This scene probably refers to that encounter.

73 *Doublure of a Bookbinding*

Iran, late fifteenth–early sixteenth century
Gold-painted leather filigree over multicolored paper
ground; backed with cloth
33.0 x 21.5 cm
s86.0012

The finely worked designs of this doublure, or interior cover, are typical of late fifteenth-century Timurid craftsmanship. The poetry above and below the central panel extol the manuscript's quality:

This copy is a paradisiac garden.
The calligraphy is comparable to hyacinth and herbs.

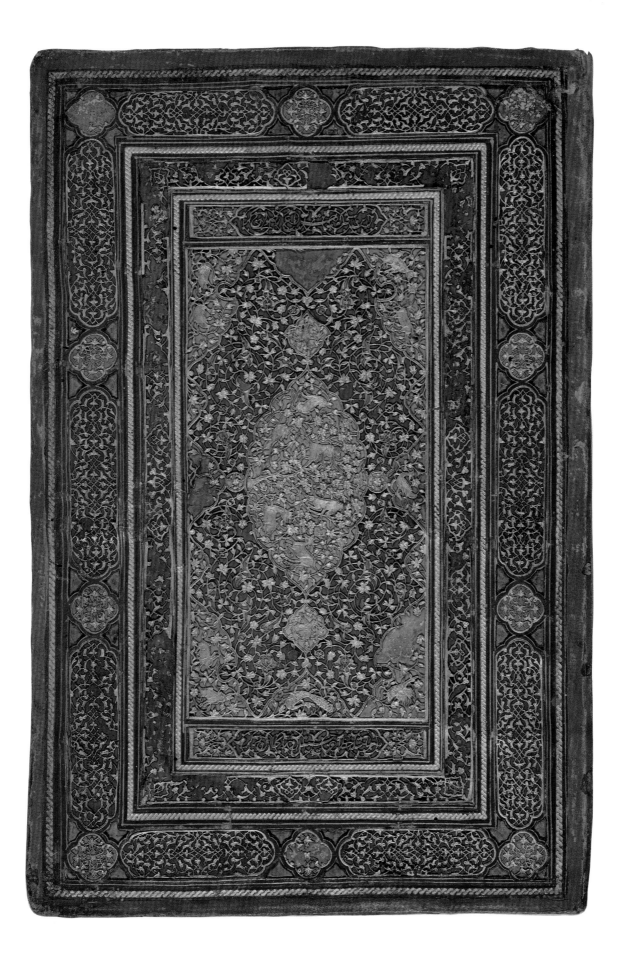

74 Bookbinding

From a copy of the *Khamsa* of Amir Abu'l-Hasan Yaminuddin Khusraw Dihlawi
Iran (Qazwin), ca. 1575–1600
Leather over paper pasteboards with gold block-stamping;
doublures of leather filigree over multicolored paper ground
36.3 x 24.2 cm
s86.0472

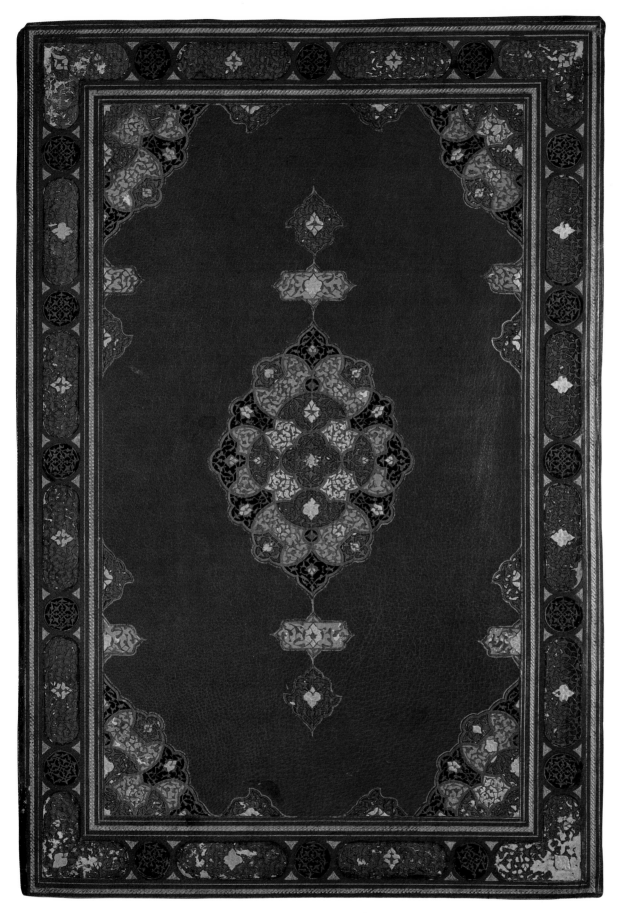

Doublure (interior cover). Overleaf: upper and lower covers.

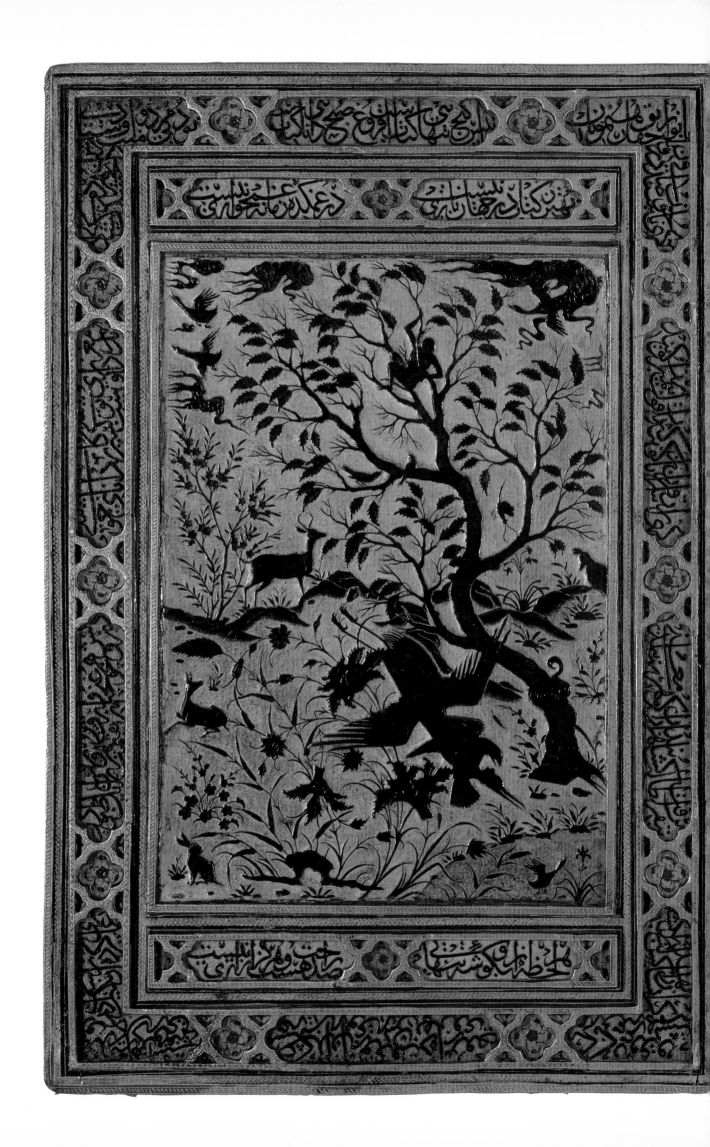

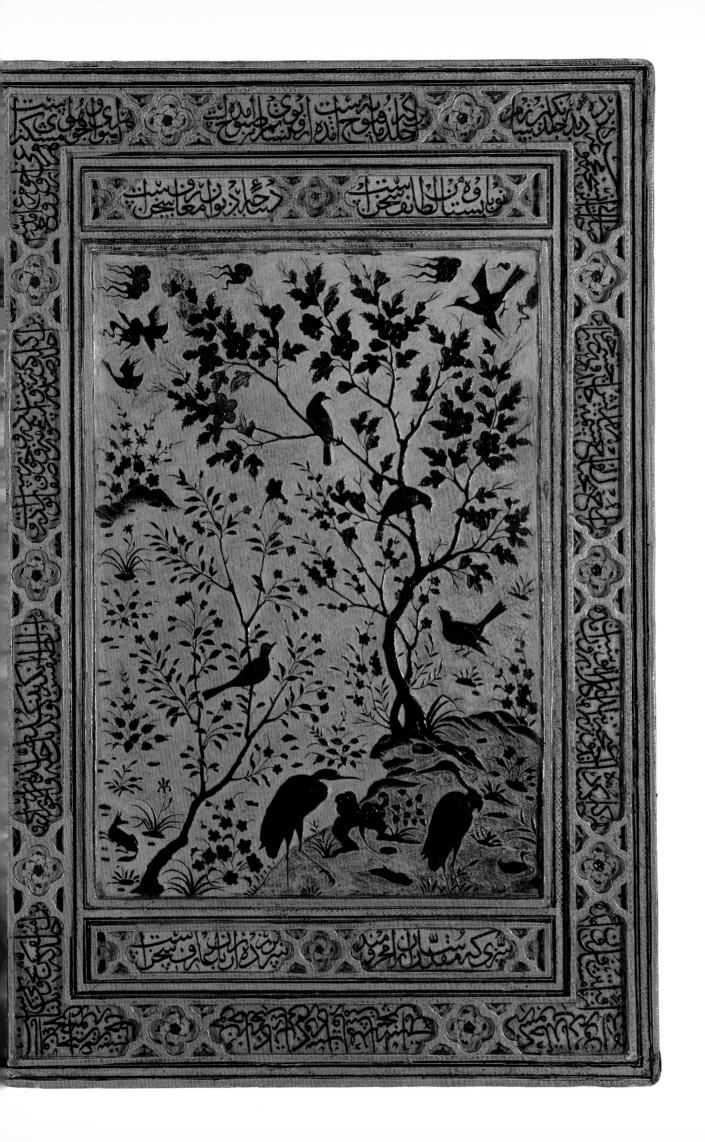

75 Doublure of a Bookbinding [?]

Iran, seventeenth century
Leather filigree over multicolored paper ground
25.8 x 16.6 cm
s86.0013

The six couplets around the edge of this intricately worked cover can be translated as follows:

Ink was brought from the soot of the night,
Paper from the luminous morning.
The seven globes of the universe turn at the foot of your calligraphy by divine grace.
O Lord, what can the pen of your might do?
Calligraphy worthy of sovereignty.

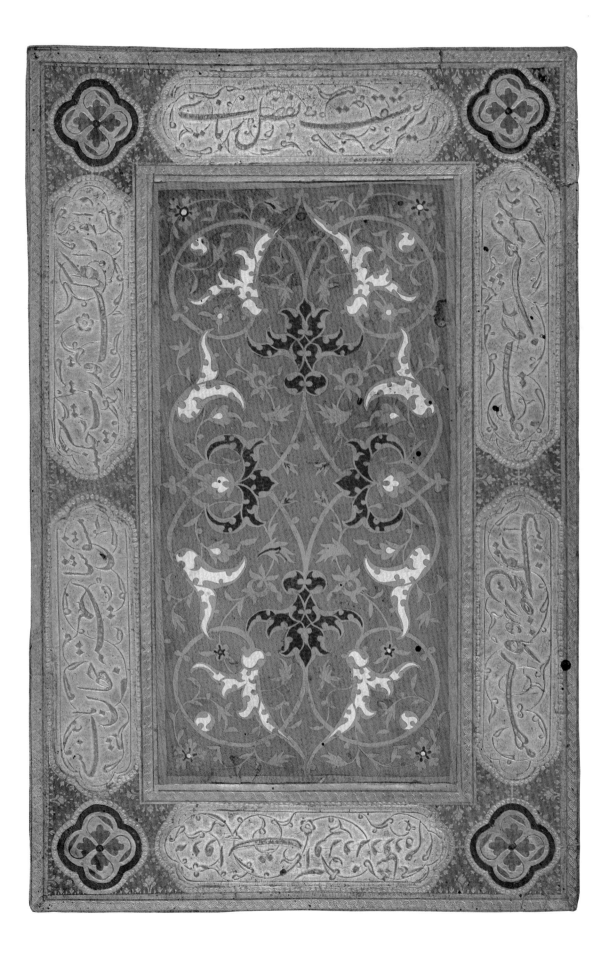

76 *Cover of a Bookbinding [?]*

Made by Ali Üsküdari
Turkey, A.H. 1160 (A.D. 1747–48)
Cloth with lacquer painting
26.2 x 13.4 cm
s86.0023

The elegant lines and sweeping forms of the illumination in the center of this panel, which recall the expressive designs of art nouveau jewelry, are typical of Ali Üsküdari's work. A well-known eighteenth-century Ottoman illuminator, Ali Üsküdari often employed elaborate floral and vegetal patterns in his compositions. It is not clear how this piece was used; it may have been part of a bookbinding, or perhaps a writing pad.

219

Henri Vever, 1931

Chronology

Henri Vever frequently lent and donated works of art to exhibitions and museums. Objects produced by the Maison Vever were also frequently shown in exhibitions. Events related to exhibitions are shown in indented paragraphs.

1794
Pierre-Paul Vever (PPV) is born.

1821
PPV enters the jewelry business in Metz.

1823
PPV marries; his elder son, Jean-Jacques Ernest (EV), is born.

1827
Joseph Félix, PPV's second son, is born; he later becomes a soldier.

1843
Having worked for two years in Germany and Austria, EV joins the family business.

1848
PPV retires; EV assumes control of the Maison Vever, which he begins to expand.

1851
EV's elder son, Paul (PV), is born.

1853
PPV dies.

1854
Henri (HV), EV's second son, is born.

1861
HV's future wife, Jeanne Louise Monthiers, is born.

1870
At the fall of Metz during the Franco-Prussian War, the Vever family flees to Luxembourg on foot. EV wins the Croix de la Légion d'Honneur.

1871
EV purchases Gustave Baugrand's jewelry studio in Paris. PV attends the Ecole Polytechnique, while HV apprentices at the firms Loguet and then Hallet. HV buys his first Rembrandt print and attends night classes at the Ecole des Arts Décoratifs in Paris.

1871–72
HV wins first prize in the category "Dessin-copie: Fleurs et Ornaments" at the Ecole des Arts Décoratifs.

1873
HV takes the admission examination for the Ecole des Beaux-Arts, is accepted, and enters the studios of M. A. Millet and J. L. Gérôme.

1874
EV is named a judge of the Tribunal de Commerce de la Seine. PV finishes his studies at the Polytechnique. Both Vever brothers help their father prepare for the 1878 *Exposition Universelle* in Paris.

1875
EV is named president of the Chambre Syndicale de la Bijouterie, Joaillerie, et Orfèvrerie. HV wins a third-class medal at the Ecole des Beaux-Arts.

1878
EV is named a jury member for the *Exposition Universelle*.

1881
EV retires; his sons assume control of the Maison Vever. HV marries Jeanne Monthiers.

1882
HV's only child, Marguerite, is born.

1883
The art dealer Siegfried Bing opens a gallery at 19, rue de la Paix, in the building occupied by the Maison Vever.

1885
From the art dealer Georges Durand-Ruel, HV buys his first painting by Camille Corot and begins to collect paintings of the school of 1830.

1888
HV buys Japanese prints from Bing.

1889
Through Durand-Ruel, HV starts to collect works by Edgar Degas, Claude Monet, Camille Pissarro, Auguste Renoir, and Alfred Sisley.

The Maison Vever exhibits jewelry at the *Exposition Universelle* in Paris and wins the Grand Prix de Joaillerie.

1890
HV lends seventy prints to an exhibition of Japanese art organized by Bing at the Ecole des Beaux-Arts.

1891
The Vever brothers visit Russia and Russian jewelers. HV and his wife travel down the Volga and visit Tiflis, Baku, Samarqand, Bukhara, and Istanbul.

In Moscow, the Maison Vever participates in its first international exhibition of jewelry.

1892
Bing organizes the *diners japonisants* with the regular participation of HV.

HV lends 227 Japanese prints to the *Exposition Internationale du Blanc et Noir* in Paris.

1893
The French government appoints HV commissioner for jewelry to the *World's Columbian Exposition* in Chicago, where the Maison Vever shows jewelry and enamels.

HV travels from Chicago to Saint Louis, California, and Canada and visits jewelry firms, such as Tiffany and Mermod & Jaccard.

HV lends thirty-five items, including ceramics, rugs, and textiles, to the *Exposition d'Art Musulman* organized by the Union Centrale des Arts Décoratifs and held at the Palais de l'Industrie in Paris.

1894
The Maison Vever participates in the *Exposition Universelle et Internationale* in Lyon. HV makes his first donation—of forty Japanese prints—to the Musée du Louvre.

1897
HV sells his collection of modern paintings—including works by Corot, Degas, Jean Meissonier, Monet, Pissarro, Pierre Puvis de Chavannes, Renoir, and Sisley—at the Galerie Georges Petit in Paris.

With Boucheron and other firms the Maison Vever receives a Grand Prix at the *Exposition Universelle* in Brussels.

1898
HV becomes a Chevalier de la Légion d'Honneur. The Maison Vever retains artist Eugène Grasset to create preparatory drawings for jewelry to be produced especially for the *Exposition Universelle* to be held in Paris in 1900.

HV donates Japanese prints to the Louvre.

1899
HV is appointed to the Conseil d'Administration de l'Union Centrale des Arts Décoratifs, a position he holds until 1919.

1900
HV joins the council of the Société Franco-Japonaise of Paris and is elected mayor of Noyers.

The Maison Vever wins its third Grand Prix, for participation in the *Exposition Universelle*. HV donates Japanese prints to the Louvre.

1901

Emperor Matsuhito of Japan confers on HV the Order of the Rising Sun.

1903

HV lends ten paintings and manuscripts to the *Exposition des Arts Musulmans* held at the Musée des Arts Décoratifs in Paris. HV donates Japanese prints to the Louvre.

1904

HV is named president of the Commission de la Bibliothèque, a position he holds until 1925.

1905

HV donates two works by Auguste Rodin and fourteen Japanese prints to the Musée des Arts Décoratifs.

1906–08

HV publishes his three-volume *Bijouterie française au XIXᵉ siècle*, which became the standard text on nineteenth-century jewelry.

1907

The Maison Vever moves from 19 to 14, rue de la Paix.

1908

The revolution in Persia brings a flood of high-quality objects to the European market.

The Maison Vever wins a Grand Prix at the *Exposition Franco-Britannique* in London and shows several pieces at the *Exposition de la Parure Précieuse Feminine* held at the Musée Galliera in Paris.

1909

The Musée des Arts Décoratifs organizes an exhibition cycle on the evolution of the Japanese print, with one exhibition scheduled per year. The first is on the *"primitives"*; HV lends 95 of the 328 works exhibited.

1910

The second Musée des Arts Décoratifs exhibition of Japanese prints focuses on eighteenth-century artists, such as Harunobu, Koryusai, and Shunsho; HV lends 116 of the 602 works exhibited. HV donates a page of a Persian Koran to the Musée des Arts Décoratifs.

1911

The third Musée des Arts Décoratifs exhibition of Japanese prints highlights the work of Bunsho, Kiyonaga, and Sharaku; HV lends 99 of the 335 works exhibited in addition to 20 illustrated books. HV donates Japanese prints to the Louvre.

1912

The fourth Musée des Arts Décoratifs exhibition of Japanese prints concentrates on Utamaro; HV lends 62 of the 306 works exhibited in addition to 25 illustrated books. HV lends 49 of the 227 entries (paintings, manuscripts, and bookbindings) in the *Exposition des Arts Musulmans* held at the Musée des Arts Décoratifs.

1913

HV and Georges Marteau write *Miniatures persanes*, the catalogue of the 1912 *Exposition des Arts Musulmans*.

The fifth Musée des Arts Décoratifs exhibition of Japanese prints includes such nineteenth-century artists as Choki, Eishi, Eisho, and Hokusai; HV lends 87 of the 405 works exhibited.

1914

The sixth and final Musée des Arts Décoratifs exhibition of Japanese prints shows the work of Toyokuni I and Hiroshige; HV lends 64 of the 404 works exhibited.

1915

PV dies.

1919

The Maison Vever wins the commission to make the sword of honor offered to Marshall Ferdinand Foch by the City of Paris on the occasion of the armistice celebrations.

1920s

Through the art dealer Yamanaka, HV sells several thousand Japanese prints to businessman Kojiro Matsukata.

1921

HV retires; PV's sons, André and Pierre, assume control of the Maison Vever.

1922
HV donates a large eight-part Japanese screen to the Musée du Louvre.

1924
HV donates three hundred pieces of nineteenth-century French jewelry and fifty pieces made by the Maison Vever to the Musée des Arts Décoratifs.

1925
HV is named vice-president of Group III of the *Exposition Internationale des Arts Décoratifs et Industriels Modernes* in Paris.

1927
HV lends 32 of the 51 entries (in the paintings and bookbindings section) in the *Tentoonstelling van Islamische Kunst* held at the Gemeentemuseum in the Hague. HV donates 150 bronze soldiers and pieces of artillery made by his father to the Musée de Metz.

1929
The nineteenth-century jewelry donated to the Musée des Arts Décoratifs by HV in 1924 forms the nucleus of the Musée Galliera's exhibition of jewelry made in 1829.

1931
HV lends fifty-five entries (paintings, manuscripts, bookbindings, and textiles) in the *Exhibition of Persian Art* held at Burlington House in London.

1934
HV lends eighteen prints to *L'Estampe japonaise moderne et ses origines* held at the Musée des Arts Décoratifs.

1937
HV is named Officier de la Légion d'Honneur.

1938
HV lends 14 of the 98 entries in the paintings, manuscripts, and bookbindings section in *Les arts de l'Iran, L'ancienne Perse, et Bagdad* held at the Bibliothèque Nationale.

1939
Marguerite Vever dies.

1942
HV dies.

1947–48
On the death of Mme Vever a small portion of HV's Japanese collection is sold in Paris.

1960
Jean Vever assumes control of Maison Vever.

1974–76
Sotheby's, London, sells Japanese prints from HV's collection.

1982
The Maison Vever closes.

1986
The Smithsonian Institution acquires the Vever Collection of Persian and Indian paintings, manuscripts, bookbindings, and textiles for the Arthur M. Sackler Gallery.

1988–89
More than 150 works from the Vever Collection are exhibited at the Arthur M. Sackler Gallery, Washington, D.C.

Appendix 1

Document of Sale by Galerie Georges Petit
of Vever's European Collection, 1897

—◆—

COLLECTION H. V.

Tableaux Modernes

PASTELS, AQUARELLES, DESSINS

Sculptures

GALERIE GEORGES PETIT, 8, RUE DE SÈZE

Les Lundi 1er et Mardi 2 Février 1897

A DEUX HEURES PRÉCISES

—

COMMISSAIRE-PRISEUR	EXPERT
Me PAUL CHEVALLIER	M. GEORGES PETIT
10, rue Grange-Batelière.	*12, rue Godot-de-Mauroi.*

RÉSUMÉ DU CATALOGUE

TABLEAUX

Prices in French francs as noted by Vever in his copy of the sale catalogue

220	1. BERTON (A.).—Cicilia.
1200	2. BOUDIN (E.).—Vaches dans la vallée de la Toucque.
530	3. BOUDIN (E.).—A Marée basse.
1220	4. BOUDIN (E.).—Port de Nice.
450	5. BOUDIN (E.).—Le Port de Fécamp.
8800	6. BONVIN (F.).—La Servante du Peintre.
2000	7. BONVIN (F.).—L'Aïeule.
500	8. BONVIN (F.).—Nature morte.
1000	9. BONVIN (F.).—La Bouillabaisse.
300	10. BONVIN (F.).—La Palette.
600	11. BROWN (J.-L).—Avant la course.
3800	12. CARRIÈRE (E.).—L'Enfant malade.
7400	13. CAZIN (J.-C.).—Lever de Lune au bord de la Mer.
11000	14. CAZIN (J.-C.).—Le Chemin perdu.
8650	15. CAZIN (J.-C.).—Village de pêcheurs.

2300	16. CHAPLIN (C.).—Innocence.
130	17. CLARY (E.).—Prairie.
285	18. CLARY (E.).—Près Champigny.
175	19. CLARY (E.).—Bords de Rivière.
26800	20. COROT.—Eurydice blessée.
32000	21. COROT.—L'Abreuvoir.
27800	22. COROT.—Le Chemin montant.
30000	23. COROT.—Nymphe couchée au bord de la mer.
16000	24. COROT.—Le Lac.
16000	25. COROT.—Matinée.
12000	26. COROT.—Route ensoleillée.
35000	27. COROT.—Ville-d'Avray.
8500	28. COROT.—Le Pêcheur.
6200	29. COROT.—Effet de Matin.
15800	30. COROT.—La jeune Mère.
3900	31. COROT.—Souvenir d'Italie (Effet du matin).

3800 32. COROT.—Souvenir d'Italie (Effet du soleil couchant).

5000 33. COROT.—Cascade de Terni.

78000 34. DAUBIGNY.—Les Bords de l'Oise.

13100 35. DIAZ DE LA PENA.—La Châtelaine.

780 36. FANTIN-LATOUR (H.).—Fleurs. Nature morte.

1350 37. FRANÇAIS (F.-L.).—La Moisson.

350 38. DE GROUX (H.).—Le Chambardement.

11500 39. HARPIGNIES (H.).—Le Crépuscule.

3000 40. HARPIGNIES (H.).—La Sarthe à Saint-Cénery.

820 41. HARPIGNIES (H.).—Les Ruines.

780 42. HARPIGNIES (H.).—Bords de Rivière.

750 43. HARPIGNIES (H.).—Saint-Rive.

1120 44. HARPIGNIES (H.).—LÉtang.

105 45. HEILBUTH (F.).—La Seine à Bougival.

1700 46. ISABEY (E.).—Le Sermon.

1800 47. JACQUE (C.).—Poules.

720 48. JONGKIND (J.-B.).—Le Fiacre.

520 49. JONGKIND (J.-B.).—Le Coup de l'étrier.

1950 50. LEBOURG (A.).—Soleil couchant sur un canal (Rotterdam).

550 51. LEBOURG (A.).—Le Village de la Frette (Effet de neige).

1400 52. LEBOURG (A.).—Le Port de Rouen.

1900 53. LEBOURG (A.).—Place de la Concorde.

750 54. LEBOURG (A.).—La Seine à Rouen.

440 55. LEBOURG (A.).—L'Ile Lacroix et la Côte Sainte-Catherine.

700 56. LEBOURG (A.).—Effet de Neige.

1650 57. LEBOURG (A.).—Rotterdam.

920 58. LEBOURG (A.).—Canal à Schidam (Hollande).

900 59. LEBOURG (A.).—Un Canal à Rotterdam (Automne, 1895).

3957 60. LEBOURG (A.).—Un Quai de déchargement à Rouen.

650 61. LEBOURG (A.).—La Seine à Rouen (Pont Boïeldieu).

530 62. LEBOURG (A.).—L'Ile Lacroix, à Rouen.

930 63. LEBOURG (A.).—La cathédrale de Dordrecht (Automne).

860 64. LEBOURG (A.).—Bords de canal (Environs de Rotterdam).

560 65. LEBOURG (A.).—Effet de neige.

1620 66. LEBOURG (A.).—Bas-Meudon, l'hiver.

900 67. LEBOURG (A.).—Elbeuf.

1300 68. LEBOURG (A.).—Notre-Dame.

1300 69. LEBOURG (A.).—Le Lac.

400 70. LEBOURG (A.).—Falaise de Dieppe.

2050 71. LEBOURG (A.).—Bords de la Schie (Rotterdam, 1895).

800 72. LEBOURG (A.).—La Seine à Rouen (Côte Ste-Catherine).

1400 73. LÉPINE—Montmartre, l'hiver.

450 74. LESSORE (E.).—Vue de Paris, Quai Henri IV

320 75. LÉVY (É.).—Jeune Baigneuse.

72000 76. MEISSONIER (E.).—Le Déjeuner.

94100 77. MEISSONIER (E.).—Officier d'état-major en observation.

21500 78. MONET (C.).—Le Pont d'Argenteuil.

9000 79. MONET (C.).—Sainte-Adresse.

12000 80. MONET (C.).—L'Église de Vernon.

10800 81. MONET (C.).—L'Église de Varangeville.

12600 82. MONET (C.).—Les Glaçons.

6000 83. MONET (C.).—La Berge, à Lavacourt.

6700 84. MONET (C.).—La Débâcle de la Seine.

5000 85. MONET (C.).—Paysage d'hiver.

7000 86. MONET (C.).—Faisans.

1420 87. DE NITTIS (J.).—Le vieux Jardin.

1250 88. DE NITTIS (J.).—La Charmille.

780 89. PETITJEAN (E.).—Joinville (Haute-Marne).

900 90. PISSARRO (C.).—Vue de Bazincourt (Eure).

950 91. PISSARRO (C.).—Ferme, près Pontoise.

22500 92. PUVIS DE CHAVANNES (P.).—Ludus pro Patria.

850 93. RAFFAELLI (J.-F.).—Le Balayeur.

1350 94. RENOIR (P.-A.).—Baigneuse.

1150 95. RENOIR (P.-A.).—Deux Baigneuses.

6000 96. RENOIR (P.-A.).—Femme nue au bord de la mer.

900 97. RENOIR (P.-A.).—Tête d'étude.

750 98. RIBOT (T.).—Deux têtes de femmes (Étude).

77500 99. ROUSSEAU (TH.).—La Vallée de Tiffauge.

3000 100. ROUSSEAU (TH.).—Coucher de Soleil.

3100 101. SISLEY (A.).—L'Inondation

1250 102. SISLEY (A.).—Le Pont de Moret.

4600 103. SISLEY (A.).—Route de Louveciennes (Effet de neige).

700 104. SISLEY (A.).—Sous bois.

1150 105. SISLEY (A.).—La première Neige.

1650 106. SISLEY (A.).—Entre Moret et Saint-Mammès.

1700 107. SISLEY (A.).—Pommiers en fleurs.

720 108. SISLEY (A.).—Le Bois en Avril.

1750 109. SISLEY (A.).—Noyer dans la prairie de Thomery (Août).

650 110. SISLEY (A.).—Le Champ.

1000 111. SISLEY (A.).—Environs de Paris.

2200 112. SISLEY (A.).—Effet de neige.

2500 113. SISLEY (A.).—L'Automne.

1400 114. SISLEY (A.).—Un Chantier, à Saint-Mammès.

1050 115. SISLEY (A.).—Après-midi d'Août (Village de Champagne).

116. SISLEY (A.).—Le Port de Moret.

1750 117. SISLEY (A.).—Le Pont de Moret.

700 118. SISLEY (A.).—Garage de bateaux, à Saint-Mammès.

PASTELS

4200	119. BESNARD (A.).—Le Réveil.	
850	120. BESNARD (A.).—Tête de Femme.	
45	121. BOUDIN (E.).—Marée basse.	
110	122. BOUDIN (E.).—Bateau en partance.	
50	123. BOUDIN (E.).—Soleil couchant.	
55	124. BOUDIN (E.).—Marine.	
40	125. BOUDIN (E.).—Marine.	
170	126. BOUDIN (E.).—Bateaux de pêche.	
570	127. CHÉRET (J.).—Folie et Gaîté (Panneau décoratif).	

465	128. CHÉRET (J.).—La Danse.
10500	129. DEGAS.—La Toilette.
1300	130. GILBERT (R.).—Le Vieux Grognard.
1550	131. L'HERMITTE (L.-A.)—La Moisson.
27000	132. MILLET (J.-F.).—La Femme au Puits.
16200	133. MILLET (J.-F.).—La Plaine.
20200	134. MILLET (J.-F.).—Les Puiseuses d'eau.
9200	135. MILLET (J.-F.).—La Méridienne.

AQUARELLES

125	136. BINET (A.).—Alcazar de Séville.
5200	137. DAUMIER (H.).—Le Défenseur.
1850	138. DAUMIER (H.).—Le Plaidoyer.
195	139. GRASSET (E.).—Le Comte de Maugrignon.
180	140. GRASSET (E.).—Damoiselle à atourner.
180	141. GRASSET (E.).—Orage imminent.
200	142. GRASSET (E.).—Ronde d'Anges.

180	143. GRASSET (E.).—Le Miroir de la Source.
1000	144. HARPIGNIES (H.).—Lever de Lune.
155	145. MILLET (J.-F.).—Vichy.
95	146. RIVIÈRE (H.).—Terres labourées (Automne).
70	147. RIVIÈRE (H.).—Les Arbres.
70	148. RIVIÈRE (H.).—L'Averse.
149	149. RIVIÈRE (H.).—Côtes de Bretagne.

DESSINS

165	150. BAUDRY (P.).—Étude pour la décoration de l'Opéra.
290	151. DEGAS.—Danseuse.
220	152. DEGAS.—Danseuse.
110	153. DUPRÉ (J.).—En plaine.
240	154. FORAIN (J.-L.).—V' là l' pantalon d'un lapin!
240	155. FORAIN (J.-L.).—C' qui me plait dans ta bande, etc.
210	156. FORAIN (J.-L.).—Dis donc, tu devrais dire à ta patronne, etc.
210	157. FORAIN (J.-L.).—Qui qu'a encore dit qu't'étais un'salope?
175	158. FORAIN (J.-L.).—Vous auriez aimé mieux ma mère?
140	159. FORAIN (J.-L.).—. . . Comme un homme a l'air moule! . . .
155	160. FORAIN (J.-L.).—L'boa de ta femme pour mes étrennes!
145	161. FORAIN (J.-L.).—Paul! mon enfant, il faut renvoyer, etc.
310	162. FORAIN (J.-L.).—Que j' vous fasse rigoler, etc.
220	163. FORAIN (J.-L.).—. . . Avez-vous fait attention, etc.

155	164. FORAIN (J.-L.).—Tu vois ce monsier là-bas, etc.
145	165. FORAIN (J.-L.).—"Dernier, jour de mansarde."
160	166. FORAIN (J.-L.).—De quoi te plains-tu, etc.
150	167. FORAIN (J.-L.).—Tu peux t' fouiller pour ta bague . . . , etc.
300	168. FORAIN (J.-L.).—Très importante page de croquis.
130	169. FORAIN (J.-L.).—Tiens, dis-donc, ta Rosa, etc.
255	170. FORAIN (J.-L.).—J'monte en voiture avec lui, etc.
125	171. HEIDBRINCK.—Au Mont-de-Piété.
40	172. JACQUE (C.).—Petite bergère.
300	173. JACQUE (C.).—Intérieur rustique.
105	174. RENOUARD (P.).—Dessin.
380	175. RENOUARD (P.).—Vive la Grève!
150	176. RENOUARD (P.).—A Saint-Pierre de Rome.
155	177. RENOUARD (P.).—Après la Leçon.

SCULPTURES

2000	178. BARYE.—Hercule et le Sanglier.
510	179. BARYE.—Le Lion à la patte levée.
1700	180. CARRIÈS (J.).—L'Homme à la grenouille.
250	181. CARRIÈS (J.).—Masque de face.
250	182. CARRIÈS (J.).—Pot de grès.
1800	183. DALOU (J.).—Nymphe et Faune.

450	184. GÉMITO.—Un Philosophe.
4900	185. RODIN.—Le Baiser.
7400	186. RODIN.—Ève.
620	187. RODIN.—La Fatigue.
700	188. RODIN.—Les Damnées.

1912

Juin 8 Ludwig Rosenthal, 14 Hildegardstrasse – Munich (du 29 mai)
 1 feuille xylographique Apocalypse (collect Amherst) 1250 1000 compt.
 Londres

 10 Blondeau. 50 Rue La Boëtie
 1 bol cloisonné ming. 600 400 compt

 14 Kevorkian
 1 miniature persane, jeune seigneur debout (encadrée) 3000 2500 payé le
 rouge et or 8 Juillet

 17 Sté du Livre d'Art
 1 tableau de Ménard, pour Théocrite (n° 6) 1125
 Suite à part des gravures et état (n° 5) 430
 d° d° d° d° (n° 7) 410
 ─────
 1965 comptant

 22 A. Aftandil. Banque d'Escompte de Perse à Tauris, Perse
 1 manuscrit persan: "Bostan" du poëte Sadi à deux
 miniatures; calligraphié par Mir Ali, daté 8000 3000 comptant

 1 miniature persane femme debout, mantille verte 000

 Sambon, place Vendôme
 1 lécythe athénien fond blanc crème, figures noires
 rehaussées de rouge – Dionysos buste, et une ménade
 dormant. (Sicile VI°/V° siècle av. J.C.) vente Jean
 Lambros d'Athènes pl. VII. H. 27 cent. ... 400 comptant

Appendix 2

Ledger of Acquisitions, 1894 and 1907–17

———————◆———————

Henri Vever kept a ledger for the years 1894 and 1907–17 in which he meticulously recorded all his art purchases in French francs. The ledger documents the entire range of Vever's art purchases, including European and Japanese prints, drawings, paintings, sculptures, books, and bookbindings; Japanese and Chinese ceramics, metalware, and lacquer ware; and Persian and Indian paintings, manuscripts, bookbindings, and textiles. The following transcription comprises all entries from the ledger that relate to the purchase of Persian and Indian material. The entries follow as closely as possible Vever's own notations in the original French.

An entry begins with the year, date, name of dealer or auction house from which the purchase was made, description of the purchase, asking price, and price paid. Arthur M. Sackler Gallery accession numbers (s86.0054, for example) have been added under "Acquisitions" when a work has been definitively identified. The original ledger continues to July 13, 1917, but contains no record of purchases of Persian and Indian objects after July 8, 1914, the last date in this transcription.

The Addendum is a transcription of a coded chart totaling Vever's art purchases through 1912, which Vever included in the ledger. Mathematical calculations have been left as they occur in the ledger, even when they are incorrect.

Date	Provenance	Acquisitions	Asking Price	Price Paid
1894 Février	Manzi	4 miniatures persanes		500
1908 Avril 9	Gal. Monif	1 vol., 9 miniatures persanes [s86.0054]	5000	2800
1908 Avril 15	Vignier	9? miniatures persanes (dont 6 ont été montées par paires) [s86.0197–98, .0277–80]		8000
1908 Novembre 24	Drouot, vente par G. Normand	1 vol., manuscrit persan, 16 miniatures, no. 18 [s86.0059]	850+10%[1]	935
1909 Février 26	Demotte	[1] miniature indo-persane, personnages		250
1909 Décembre 21	L. Rosenberg	5 miniatures persanes 1 [miniature] "Divan" avec grand encadrement couleur [s86.0229] 1 [miniature] très fraîche, encadrement, et dos, or: seigneur recevant une statue cavalier [s86.0201] 1 [miniature] indienne, petite: femme debout (2 fleurs) [s86.0447] 1 [miniature] persane, "femmes groupées" 1 [miniature] persane, défilé de femmes	3500 2500 350 1000 1500 <u>8850</u>- 20%	7000
1909 Décembre 21	Delteil, Vente (Rosenberg?)	1 [miniature] fauconnier avec cheval, no. 95		176

———————

1. This figure represents the auction house's commission.

Date	Provenance	Acquisitions	Asking Price	Price Paid
1910 Janvier	Demotte	7 miniatures indo-persanes [s86.0400–02, .0404–07] 7 revers à encadrements [indo-persanes]² } à 5000	35000	29000
1910 Février	Vignier	1 miniature persane: couple 1 [miniature persane]: ivresse [s86.0306] 1 [miniature persane]: page ornée 2 [miniature persane]: pages ornées		3000
1910 Juillet 21	Rosenberg	1 miniature persane, deux figures sur une même feuille—signé [s86.0305] 1 miniature indoue, portrait de prince (étui cuir) [s86.0408] 1 grisaille, derviche s'appuyant sur une cane [s86.0312]	3000 1500 1800	5000
1910 Juillet	Bacri	2 miniatures persanes avec encadrement (à réunir en une seule) (escarpolette) [s86.0187.001–.002]	1800	1600
1910 Juillet 29	Rosenberg	2 titres Corans égyptiens ? (ou turcs) xvɪᵉ S., pages simple, face et revers		2500
1910 Août 1	Demotte	3 titres doubles de Coran xvɪᵉ S., turc, et quelques pages (texte) de ce même Coran [s86.0073.001–.002,.0074.001–.002,.0077.001–.002] 1 lot pages séparées et petits encadrements	4000	3500 150
1910 Août 2	Monif	1 miniature persane, titre et encadrement bleu et or [s86.0196.003] 1 miniature persane, entrelacs blancs [s86.0190] 1 pages doubles [sic], 2 feuilles (danse des anges) (une avec revers) qui sont les 2 premières pages d'un livre dont il demandait RSPXX,³ commandé par le Shah Bayieskar daté 1438 (?) [s86.0196.001–.002]		4800
1910 Août 9	Monif	1 page double, 2 feuilles, milieu du même livre, avec encadrement; musiciens, etc. daté 816 H = 1438 (?) demandait 4000 !! [s86.0192.001–.002] 2 pages à personnages: chasse de seigneurs, une sur fond bleu, l'autre sur fond blanc (chevaux, faucons) [s86.0188.001–.002] 2 pages très petits personnages au centre et grande bordure 1 page simple, titre ornemental, venant du livre indiqué plus haut, et faisant pendant à celle que j'ai (revers d'une page à personnages)	3000 3000 2500 800	5500
1910 Août 10	Demotte	1 miniature à 2 personnages, vase ou bouteille à long col, blanc [s86.0294] 1 [miniature] femme au trait, sur parchemin [s86.0307] 1 [miniature] double feuille, titre d'ouvrage, encadrements fins, Perse xvɪᵉ S. 1 [miniature] double feuille, indo-persan	2500 2000 1000 500	3500
1910 Août 13	Oberlé	1 manuscrit persan xvɪɪᵉ S., daté 1039 H. 1 [manuscrit persan], daté 1021 H. (moins bon)	3500	1000
1910 Octobre 14	Monif	15 miniat. Pers. [sic] provenant du manuscrit Bayes Kaz [s86.0257–72]		7000
1910 Octobre 26	Rosenberg père	1 miniature bataille, fond d'or, no. 148 1 [miniature] Divan du Shah, no. 153 1 [miniature] combat, charge de cavalerie, no. 172⁴		6000

2. It is not clear whether Vever is referring to the versos of his seven Late Shahjahan Album paintings or to individual pages from another album.

3. Vever often used a code to indicate a purchase price; here RSPXX equals fifteen thousand.

4. Vever exchanged paintings 148 and 172 on June 18, 1914, for s86.0133.001 and s86.0133.002.

Date	Provenance	Acquisitions	Asking Price	Price Paid
1910 Novembre 9	Demotte (compte spéciale)	1 miniature, début xvii^e S., portrait présumé de Djehangir et d'un de ses grand vizirs, signée: "ouvrage de l'humble Natchestar"⁵ [s86.0403]	4000	
		1 manuscrit Arabe d'Egypte xv^e S. (Le poème du manteau) dedié à Kaït Bey [sic] (1440–1460) [s86.0030]	1500	
		1 manuscrit Arabe d'Egypte xv^e S., II^e div. du Coran, belle reliure [s86.0028]	1000	
		Reliure persane fin xv^e S., à l'extérieur décor d'oiseaux dans des rinceaux, à l'intérieur décor d'ornements en cuir doré et découpé sur fond bleu [s86.0015]	800	
		1 petite reliure persane [en] cuir découpé et doré sur fond bleu [s86.0479]	?300?	5000
		3 reliures art Arabe xv^e S., provenant de Samarcande		Soldé le 28 [Novembre] 1911
		1 grande étoile céramique fond bleu, Samarcande, xiv^e–xv^e S.	200	
		prix spécial	7800	
1910 Décembre 9	Indjoudjian	1 double page de titre de Coran, très fine	2500	
		1 étoffe persane à oiseaux, jaune [s86.0490]	500	
		1 étoffe, 2 personnages (peinture sur visage) [s86.0489]⁶	200	2800
1911 Mai 2	Kevorkian	1 miniature persane (Vente Rosenberg no. [?]) reproduite		700
1911 Mai 12	Vente Rouart	No. 67 — 1 miniature indo-persane [s86.0448]	50	
		No. 73 — 1 miniature persane avec encadrement de forme [s86.0206]	1100	1150
1911 Octobre 19	Claude Anet	1 reliure persane [s86.0472]		
		2 pages de titres, du livre renfermé dans cette reliure [s86.0072.001.–.002]		10000 payé le 30 oct.
		(1 miniature très effacée — 2 personnages avec sabres?) [s86.0424]	000	
1911 Novembre 7	Kevorkian	1 bol, no. 33, x^e S.	2500	2000
		1 bol bleu, Rages, x^e S.	1100	1000
		1 coupe, Rages, x^e S.	1500	1000
		1 miniature, chasse, xvi^e S., no. 209	1500	1000
		1 miniature, no. 147, venant de Shah Abbas — jeune prince et son précepteur, au trait d'or [s86.0292]	5000	4000
		1 miniature indienne, 4 portraits, no. 235 catal., xvii^e S., école Mughal [s86.0421]	1500	900
		1 cadre, 2 écritures, no. 108 et 14	500	100
			13600	10000 (versé 5000 le 14)
1911 Novembre 7	Monif	1 miniature, tonalité blanche [s86.0285]	600	
		1 miniature, maître d'école et enfants, revers arabesques [s86.0286]	600	
		1 miniature, princesse entourée de ses femmes, no. 618 [s86.0205]	400	
		1 miniature, roi sur un trône, avec anges, etc. [s86.0287]	600	
		1 miniature, apprêts d'un repas en plein air, bordure et revers titre	500	
		1 miniature, roi sur son trône, tête enflamée, animaux, bordure [s86.0195.001]		
		1 miniature anges, animaux, etc., bordure fin xvi^e S. — par ou attribué à Ibrahim Abbassi?? (cette attribution me parait très douteuse) [s86.0195.002]	1800	
			4500	4000 payé le 23 Nov.

5. The inscription was misread. It actually refers to Bichitr.
6. Although not catalogued in *An Annotated and Illustrated Checklist of the Vever Collection*, these textiles are part of the Vever Collection, now owned by the Arthur M. Sackler Gallery.

Date	Provenance	Acquisitions	Asking Price	Price Paid
1912 Janvier 23	Ludwig Rosenthal de Munich	1 miniature persane au trait, jeune homme tenant un faucon sur le poing [s86.0313]		200
1912 Juin 14	Kevorkian	1 miniature persane, jeune seigneur debout (encadrée), rouge et noir	3000	2500
1912 Juin 22	Arsène Aftandil	1 manuscrit persan: "Bostan" du poète Sadi à deux miniatures: calligraphié par Mir Ali, daté [s86.0036]	8000	3000
		1 miniature persane, femme debout, mantille verte [s86.0297]		000
1912 Juin 21	Mr. Hafiz Mahmud Khan Shairani, London	1 miniature indo-persane, souverain sur son trône, entouré de nombreux personnages, peint par Farrukh Beg (voir Ain Akbary [sic] by Abul-fazl where Farruk's name is mentioned) £35 [s86.0232]	875	750
1912 Juillet 4	Demotte	1 miniature persane, personnage debout à bonnet d'or, genre assyrien—début du XVIIᵉ S. [s86.0302]	1500	1000 payé en Sept.
1912 Juillet 5	Vente Aftandil	1 manuscrit persan—recueil de poésies de Hafez—6 miniatures et 1 sarloh (no. 27)[7]	220 + 10%	242
1912 Septembre	Demotte	1 miniature avec personnages à turban (art turc XVᵉ S.)	7000	3500
		1 [miniature] prince Mongol XVᵉ S. (bouffon); robe verte, manteau jaune, tient un oiseau dans la main [s86.0293]	3000	2500
		1 [miniature] scène d'amoureux, oeuvre de Abdullah, élève de Mirak [s86.0301]	4000	2500
		1 [miniature] seigneur et dame, avec marge (pendant de colle. de Marteau) bordure oiseaux, animaux et feuillage, XVIIᵉ S. [s86.0315]	4000	3500
		3 [miniatures] oiseaux, indo-persan [sic], par Mançour [s86.0410–12]	3000	2500
		1 [miniature] persan, jupe de gaze (genre Sassanide) art indo-persan XVIIᵉ S. [s86.0446]	1000	500 __ 15000
1912 Septembre 12	Vignier	1 volume dérelié, art Egypto-arabe, frontispice et rosace, pour le Sultan Bars(?) Bay 1422–1438 [s86.0029]	3500	3000
		1 miniature XVᵉ S., cavaliers arrivant devant un château-fort (inscription coufique) fond (terrain) or [s86.0136]	2000	2000 __ 5000
1912 Novembre 26	R. Meyer-Riefstahl	1 reliure persane cuir marron, XVIIIᵉ S., signée Mollah Mir Mohammed Asahaf 1197 H. = 1783 A.D. (no. 198) [s86.0021]		250
1912 Novembre 30	Demotte	1 miniature Behzad (?) ou Mir Said Ali, en couleurs, école [s86.0221]	8[8] 5	2.5
		1 miniature Dioscorides [s86.0097]	3.5 2.5	2
		1 miniature Dioscorides [s86.0098]	3.5 2.5	2
		1 petite [miniature] indo-persane	1.5 1 __ 16.5 11	1 __ ?7500 réglé échanges[9]

pour loyer 15 le 15 Février
15 le 15 Mars
20 le 29 Mars
50[10]
‾‾

7. The entry may refer to s86.0062, the only manuscript in the Vever Collection having six paintings and one *sarlawh* (a highly illuminated chapter heading with projecting lines).

8. Single- and double-digit figures refer to sums in the thousands.

9. Vever probably received these paintings in lieu of partial repayment of a financial loan that he made to Georges Demotte. See note 11.

10. The entry presumably refers to a financial loan of 50,000 francs that Vever made to Demotte earlier that year; it is not otherwise recorded in the ledger.

Date	Provenance	Acquisitions	Asking Price	Price Paid
		2 miniatures persanes, fin xvie S.? par Farrugh Beg (Février 1913) [s86.0230–31]	4	? 1000 $\overline{850}$ réglé échanges[11]
1913 Janvier	Claude Anet	1 miniature persane: un prophète en gloire (152.49) sur un trône, avec un ange agenouillé de chaque côté, page détachée d'un manuscrit qui devait être une *Histoire des Prophètes* — Vers le milieu du xve S. [s86.0161]	2500	
		1 miniature d'un *Khamsé* de Nizami representant Bahram Gur à la fenêtre d'un pavillon rouge — ornamentation de faïences, tiges fleuries, oiseaux, deux paons, etc., 2e moitié xvie S. [s86.0284]	2500	
		1 page du même manuscrit, Bahram Gur dans un pavillon avec la fille d'un des rois des sept climats — 2e moitié xvie S. [s86.0283]	2000	
		Payé 2500 à valoir le 26 février 1913 solde 2500 le juillet 1913[12]		5000 reste du 2500 payé en Juillet [19]13
1913 Mars	Demotte	Pour loyer d'argent du[13] 1 miniature au trait, prince assis, lisant, xvie S. [s86.0291]	? 5	
		1 miniature, 2 amoureux, fin xve S.?	? 3	? 3
1913 Mai 26	Léonce Rosenberg	8 miniatures persanes:		
		No. 963 — Portrait de Shah Tamasp jeune, lisant, attribué à Sultan Mohammad (1ère moitié xvie S.) [s86.0300]	2500	2300
		No. 964 — Princesse debout rajustant son diadème, école de Sultan Mohammad (milieu du xvie S.) [s86.0298]	2500	2200
		No. 965 — Page d'un Shah Nameh du xve S., conseil de guerre [s86.0144]	2500	2000
		No. 966 — Dessin au trait représentant un sujet de chasse (cavaliers) attribué à Behzad, commencement du xvie S. [s86.0290]	2500	1500
		No. 967 — Art Arabe. 1 personnage nimbé, debout, versant un flacon dans une coupe — page provenant d'un trait des automates par Philon de Byzance, fin xiie S. [s86.0108]	4000	3000
		No. 968 — Page d'un Nizami, par Mirak, xvie S., supplique [s86.0213]	2500	1800
		No. 969 — Page d'un livre du commencement du xve S. (daté 1417). Demeure seigneuriale avec inscriptions coufiques, personnages et arbres sur fond d'or [s86.0137]	1800	1200
		No. 293 — Page d'un Shah Nameh, xve S., combat singulier (voir le no. 965 du même livre) [s86.0146]	$\frac{2500}{20800}$	$\frac{2000}{16000}$ payé le 28 mai
1913 Juin 6	Léonce Rosenberg	3 dessins indo-persans au trait, portraits de[14] [s86.0436–38]	1800	1500 comptant le 16
1913 Juin 20	Demotte	1 miniature persane, début xvie S., no. 33 — ange soufflant trompette [s86.0219]	500	
		1 miniature, no. 53, ange à corps de cheval [s86.0217]	500	
		1 miniature, no. 69, ange [s86.0218]	500	1000 réglé échange

11. This entry must refer to another partial repayment that Demotte made to Vever.
12. No specific date is recorded for the entry.
13. The unfinished entry presumably refers to the loan recorded on November 30, 1912.
14. The entry was left unfinished.

Date	Provenance	Acquisitions	Asking Price	Price Paid
1913 Juin	Demotte	3 miniatures d'un Shah Nameh du XIIIᵉ S.	?60000	35000[15]
		1 [miniature] roi sur son trône[16]	20	10 8
		1 [miniature] Alexandre le grand construisant un mur d'acier [s86.0104]	15	payées 35,000 8 5
		1 [miniature] guerrier combattant à cheval (fond d'or et pins) [s86.0103]	15	comptant 8 5
		1 miniature du même livre (douleur de la mère) 23 juillet (pour avoir reporté fin 7 un effet de RS[17]) [s86.0100]	? 10	5 4
		1 miniature du même livre, 3 femmes (13 nov. 1913) [s86.0102]	? 10	5 4
		1 [miniature] (douleur du père) du même livre (29 mars, 1914) [s86.0101]	? 10	5 4
		1 miniature avec encadrement, animaux, XVIᵉ S.	2000	1 0.7
		1 miniature du même livre, poulets empoisonnés [s86.0106] (chacune des 7 miniatures du Shah Nameh du XIIIᵉ S. me revient ainsi à 5000 pièce)[18]		4
		3 miniatures achetées le 20.[19] Anges.	1000	0 5 0.3
				35000 comptant
1913 Juillet 3	Demotte	Petites miniatures coupée [sic] d'un manuscript fin XVIᵉ S.		
		Petites miniatures, pages de titres du même petit manuscrit (pour avoir cédé mon droit d'option sur une miniature du XIVᵉ S.)	2000	800 règlé
1913 Juillet 23	Demotte	(Pour loyer d'argent IX remboursable 1/2 15 nov, 1/2 15 [Dec.] [19]13[20])		
		1 miniature persane XVᵉ S. (moitié d'une page double d'un manuscrit, no. 7 expos.). Dans son jardin, un roi entouré de courtisanes, collationne—petit encadrement (voir la miniature du 12 [Dec.] [19]13) [s86.0142]	3000?	
		No. 75, 1 miniature, jeune prince assis, fond marron, XVIᵉ S. (provenant de Lord Curzon, Vice-Roi des Indes)	3000?	
		No. 30, [1] dessin, vieillard présentant une jarre de lait, début XVIᵉ S. [s86.0303]	2000?	
		No. 256, [1] Khamseh Nezami—manuscrit fin XIVᵉ S., ou début XVᵉ S., antérieur à 837 H. [s86.0033] 7 miniatures, 2 têtes de chapitres, 2 rosaces (rel[iure] laquée moderne); ensemble, 4 pièces	3000	règlé
		1 miniature de Shah Nameh XIIIᵉ S. (douleur de la mère)[21] [s86.0100]		
1913 Juillet 29	Vignier	1 miniature du manuscrit de 1417: minaret et jardin [s86.0138]	2000	1000 payable fin août
1913 Octobre 25	Léonce Rosenberg	Echangé 1 miniature Christ du XIIIᵉ S. allemand contre 1 miniature persane fin XVᵉ S., princesse au grain de beauté sur cheval noir, avec un personnage à genoux lui présentant 1 vase d'or, fond paysage [s86.0179] (miniature Christ 1800—persan 2000—espèces 200 comptant)	2500	2000

15. It is not clear how Vever arrived at these figures and the degree to which they actually represent sums paid.
16. See "Henri Vever, Art Nouveau, and Islamic Art," p. 39, n. 50.
17. The code RS equals fifteen (thousand). Vever acquired the painting on July 23, 1913, and so recorded it in the ledger.
18. A marginal note in the ledger states, "Marteau à payé chacune des 2 siennes 16500," referring to the price Georges Marteau must have paid for each of his paintings from the same manuscript.
19. The entry refers to the purchase on June 20, 1913.
20. The code IX equals forty (thousand). The entry refers to a second loan that Vever made to Demotte. For the first loan, see November 30, 1912, entry.
21. See June 1913 entry.

Date	Provenance	Acquisitions	Asking Price	Price Paid
1913 Novembre 13	Demotte	Pour loyer d'argent (ɪx) reporté 20 février (ᴀx) et 15 mars (ᴀx)²²		
		1 miniature du Shah Nameh xɪvᵉ S. (trois femmes)²³ [s86.0102]	?5000	2000 réglé
1913 Novembre 22	Tabbagh	1 miniature persane (les nuits) pavillon jaune (vert) xvɪᵉ S. [s86.0180]	1000	
		1 miniature persane (pavillon noir) [s86.0182]	700 / 1700	1000
1913 Novembre	Shemavon Malayan (Téhéran)	1 manuscrit persan xvɪᵉ S.	6000	3000
1913 Decembre 12	Demotte	1 page manuscrit d'une page double xvᵉ S., no. 8 expos. D. [sic], faisant face à la miniature de 23 juillet—elle représente un officier levant sa masse d'armes sur un individu—petit encadrement [s86.0143]	?3000	réglé
		1 miniature du Shah Nameh, poulets empoisonnés (voir juin)²⁴ (loyer d'argent ᴀx remboursable un mois environ) [s86.0106]		
1914 Janvier 21	Meyer-Riefstahl	1 plat de reliure arabe, no. 1394, xɪɪɪ–xɪvᵉ S.	500	300
		1 reliure arabe avec rabat, décor géomètrique, xɪvᵉ S., no. 1354	1000	700
		1 plat de reliure arabe, xɪvᵉ S., no. 1375	900	600
		1 [plat de reliure] assez détérioré, xɪvᵉ S., no. 1377	300 / 2700	400 / 2000
1914 Janvier 26	Minassiantz [sic]	1 miniature persane au trait (fatiguée), prince à cheval tenant un faucon, xvɪᵉ S.	600	300
		1 [miniature] indo-persane, jeune prince à cheval tenant un faucon—revers *écriture découpée*	200	125
		1 [miniature] indo-persane, jeune prince de profile, à mi-corps, *écriture découpée* en haut et en bas [s86.0455]	200 / 1000	125 / 550
1914 Février 9	Georges Tabbagh	1 miniature persane, jeune homme debout, tenant son turban à la main—Encadrement rinceaux (xvɪᵉ S.) [s86.0319]	5000	1500
		1 plat intérieur de reliure, arabesques découpées en or, sur bleu, vert, etc. (xvɪᵉ S.) [s86.0012]	5000 / 10000	1500 / 3000
1914 Mars 28	Demotte	1 page du Shah Nameh, xɪvᵉ S., miniature représentant la douleur du père, voir les miniatures du 17 [sic] Juin [s86.0101]		
		Loyer d'argent, billets (ᴀx) reporté jusqu'en Juillet	(valeur) (5000?)	réglé
1914 Juin 6	Demotte	1 miniature persane par Reza Abbassi, signée, jeune prince assis	5000	3500²⁵
		(Le Baron Maurice de Rothschild désirait vraiment cette miniature et a fait demander à plusieurs reprises de la lui céder) *Annulé le 8 juillet*. En compensation Demotte me donne 1 miniature xvɪᵉ S. d'un manuscrit, représentant la scène du Vizier et du Sultan visitant des ruines, avec la scène des hiboux qui parlent (miniature dont Demotte dit avoir refusé 7000 F de M. Homberg)???		

22. The code ᴀx equals twenty (thousand).
23. See June 1913 entry.
24. See June 1913 entry.
25. The entry, along with the sums shown, is crossed out in the ledger.

Date	Provenance	Acquisitions	Asking Price	Price Paid
1914 Juin 18	Léonce Rosenberg	1 miniature double page d'un Shah Nameh, commencement du xve S. No. 1364, audience du roi sous une tente, nombreux personnages [s86.0133.001–.002] *échangé contre:*	12000	
		1 miniature persanne, bataille fond or, no. 148 [@] 2000		
		1 miniature persane, charge de cavalerie, no. 172 [@] 2000[26]	4000	8000
		Espèces (*à verser* après la guerre)	4000	règlé le tout en x [*sic*] 1915 pour 3000 cpt au lieu de 4000
1914 Juillet 8	Demotte	ai consenti à annuler l'acquisition du 6 juin (Reza Abbasi) moyennant		
		1 miniature du xvie S., scène du Shah dans les ruines accompangé de son vizir qui explique le langage des hiboux (valeur ?? 7000) [s86.0214]	? 3000? règlé	

Addendum

	1907	1908	1909	1910	1911	1912	Totaux
Japon, Chine, etc.	32245	4513	10199	18099	17561	26105	108722
Persan		11735	7426	65550	22300	36942	143953
Livres, reliures	12438	5438	34843	10899	78471	38577	180646
Gravures, estampes	1490	50	23111	2136	9790	10295	46872
Dessins	368		4710		7400	3366	15844
Tableaux	13330	770	5881	15000	1400	2575	38956
Divers	7139	90	1292	10263	2953	400	22137
	67010	22576	87462	121947	139875	118260	577130

26. See October 26, 1910, entry.

Index

Typeset by Meriden-Stinehour Press, Lunenburg, Vermont
Printed by Meriden-Stinehour Press, Meriden, Connecticut
Color photography by Jeffrey Crespi
Edited by Jane McAllister and Kathleen Preciado
Designed by Carol Beehler